COLOR CHART

Ann Temkin

COLOR CHART: *Reinventing Color, 1950 to Today*

The Museum of Modern Art, New York

Published in conjunction with the exhibition *Color Chart: Reinventing Color, 1950 to Today*, organized by Ann Temkin at The Museum of Modern Art, New York, March 2–May 12, 2008

The exhibition is supported by Benjamin Moore Paints.

Generous funding is provided by Jerry I. Speyer and Katherine G. Farley and by the Glenstone Foundation, Mitchell P. Rales, Founder.

Additional support is provided by Cultural Services, Embassy of France in the United States and by The Contemporary Arts Council of The Museum of Modern Art.

Produced by the Department of Publications, The Museum of Modern Art, New York

Edited by Emily Hall, Anne Doran, Nell McClister, and Stephen Robert Frankel
Designed by Takaaki Matsumoto, Matsumoto Incorporated, New York
Production by Marc Sapir
Printed and bound by CS Graphics Pte Ltd., Singapore

This book is typeset in Jansen and Helvetica Neue. The paper is 157 gsm Gold East Matte

Published by The Museum of Modern Art
11 West 53 Street
New York, New York 10019

Distributed in the United States and Canada by D.A.P./Distributed Art Publishers, Inc., New York
Distributed outside the United States and Canada by Thames & Hudson Ltd, London

Library of Congress Control Number: 2007942475
ISBN: 978-0-87070-731-5

Cover: Jim Lambie. *ZOBOP!*. 1999. Vinyl tape on floor, dimensions variable. Installation view in the exhibition *Off the Wall*, Scottish National Gallery of Modern Art, Edinburgh, 2006

Printed in Singapore

CONTENTS

Artist texts by Ann Temkin (A.T.), Melissa Ho (M.H.), and Nora Lawrence (N.L.)

FOREWORD

The Museum of Modern Art is pleased to present *Color Chart: Reinventing Color, 1950 to Today* as the first exhibition in its history devoted explicitly to the subject of color in art. Concentrating on the art of the last sixty years, it brings together works of art that directly address the concept of "ready-made color," with the commercial color chart providing an apt symbol of the recognition of paint as a mass-produced and standardized commodity. Following a specific line of investigation rather than attempting a survey, *Color Chart* takes its place in a long tradition of exhibitions at The Museum of Modern Art to explore a particular theme or concept that transcends the boundaries defined by a single art-historical movement or generation. The most recent example is Kynaston McShine's memorable exhibition in 1999, *The Museum as Muse: Artists Reflect*, focusing on the role that the institution plays as an influence on works of art.

Such exhibitions represent a way of approaching art history that stands apart from the usual analysis of individual careers or movements. They are notoriously difficult undertakings that come to life as a curator performs the task of balancing initial assumptions or hunches for an overall argument with the individual voice of each work of art. Unlike a retrospective exhibition, which celebrates the achievement of a single artist, such ventures examine the way that important approaches and ideas develop and spread throughout far-flung artistic communities over a period of several decades. In the best of cases, they represent the beginning of a richly fertile line of inquiry rather than a conclusion.

We are most grateful to the Benjamin Moore company, which celebrates its 125th anniversary this year, for its generous support of *Color Chart*. A recurrent theme in this exhibition and the accompanying scholarship is the ideological and practical role of house paint in the work of contemporary artists; it is a pleasure to salute Benjamin Moore as a most fitting partner. Rarely if ever has a sponsor been directly invoked by a work of art in an exhibition, but indeed, viewers will encounter a set of paintings from Frank Stella's historic Benjamin Moore series of 1961–62, made at the time he famously wished "to keep the paint as good as it was in the can." We are deeply indebted to Jerry I. Speyer and Katherine G. Farley, who have made an important contribution to *Color Chart*. As always, we thank them for their vital role in encouraging adventurous curatorial initiatives that are not easy magnets for corporate funding. We express our appreciation to the Glenstone Foundation, Mitchell P. Rales, founder, for additional generous support. We have also benefited from grants provided by the Cultural Services of the French Embassy and The Contemporary Arts Council of The Museum of Modern Art.

The exhibition and the catalogue that accompanies it were conceived and

organized by Ann Temkin, The Blanchette Hooker Rockefeller Curator of Painting and Sculpture. She has based both her scholarship and her presentation on direct collaboration with the artists in the exhibition, and has invested the project with a spirit of fresh immediacy. We are especially grateful to those artists who created new work on the occasion of *Color Chart* and to all those who have been closely involved with the curator in working to develop the questions that have propelled this exhibition project. They have shared information and recollections that vitally enrich the art history of the last half-century.

Finally, on behalf of the Trustees and the staff of The Museum of Modern Art, I wish to thank the private individuals and museum colleagues who have allowed us to borrow precious works from their collections for this exhibition. In several cases their generosity has enabled us to re-assemble the components of long-separated series, to introduce works of art not yet seen in this country, and to provide a contextual setting that opens renowned masterpieces to new readings. Without the lenders, this exhibition would not have been possible.

Glenn D. Lowry
Director

This exhibition came into being as a result of my love for specific works of art, or bodies of work, and the common questions they posed to me. Over the course of several years I had noticed my consistent attraction to art that bore a striking relation to the commercial color chart. Not the color charts of art-school color systems, with their hierarchies of hues and values and chroma, but the ordinary columns and grids in a paint manufacturer's booklet or fan deck, laying out colors in no particular scientific order. I became curious about the role of the color chart as a player behind the scenes in contemporary art history, and wondered about its function as a reference or inspiration, consciously or not, for a wide diversity of artists. In 1998, for example, when I was curator of modern and contemporary art at the Philadelphia Museum of Art, we acquired *180 Colors* by Gerhard Richter; soon after, I began to talk with Ellsworth Kelly about showing the art he made during his stay in France (1948–54), including his collages of colored papers, which, like Richter's work of two decades later, distributed squares of color according to the laws of chance. In making these, I realized, Kelly and Richter eschewed the theories that dominated artists' discussions about color in the years before World War II—which led me to ask, What defines color *after* color theory?

At The Museum of Modern Art, one of our first major acquisitions to honor the opening of the new building in 2004 was Donald Judd's untitled sculpture of 1989, which arrived together with a diagram that enumerated the eight standard colors with which he told the fabricator to spray its sheet-aluminum units. And in 2005 we acquired Robert Rauschenberg's *Rebus*, of 1955, a combine that features across its center a long unbroken line of paint swatches ripped from a sample book. Judd and Rauschenberg could not be more different artists, and yet both were focusing attention on a standardized source of color. I was not interested in the simple question of color-chart iconography—that is, how many works of art look like a color chart—but in issues of structure and metaphor. The color chart could serve as an efficient sign for a kind of color that represented color after the palette, after theory, after mysticism, and all these other considerations that seemed to me anachronistic at the turn of the twenty-first century. Is the color chart a shorthand by which one could define an attitude toward color that appropriately characterizes the art of our time?

The exhibition was also prompted by a realization that although there are a great number of books and exhibition catalogues that treat the subject of color in early-twentieth-century art, the discussion seems to diminish greatly after 1960, among art historians and critics as well as among artists themselves. Most commentaries about color in art during the second half of the last century address the

exceptional circumstance, but not the state of affairs that governed most thinking in that period. Part of this has to do with the need to take seriously the work of postmodern artists whose engagement with color affects nonchalance. We are wrong to take them at their word: these are great artists, and even if their rhetoric was that of casual indifference, their choices were full of meaning. If their use of color was unspectacular, relating more to the quotidian than to transcendence, it still had specific reasons and an aesthetic philosophy behind it. As Briony Fer notes in her essay in this book, there was a conspicuous time lag between this use of color in art over the last forty years and any notice taken of its importance. Historians and curators can be complicit in the chromaphobia (the term coined by artist and writer David Batchelor) that renders color a second-class subject, despite, or perhaps because of, its inherent sensory attraction. My goal in organizing this exhibition was not to explain comprehensively the role of color in contemporary art, but to open windows onto a vast and important subject in which visual pleasure and intellectual insight are intertwined. I wanted to take an approach that reaches beyond critical discourse to reveal artistic process.

A multitude of staff members at The Museum of Modern Art have played key roles throughout the many months this complicated project has been in preparation. I am especially grateful for the support of my colleagues in providing the initial go-ahead for *Color Chart*, because unlike a proposal for a monographic exhibition, with its clear and specific subject, plans for an exhibition such as this one inevitably require of its sponsoring institution a substantial leap of faith. Glenn D. Lowry, Director, has been an enthusiastic advocate since the moment of its inception. I greatly appreciate the sage advice that John Elderfield, the Marie-Josée and Henry Kravis Chief Curator of Painting and Sculpture, has provided to me with warm generosity. Jennifer Russell, Senior Deputy Director for Exhibitions, Collections, and Programs, has been an essential presence, providing a voice of both reason and inspiration. Peter Reed, Senior Deputy Director for Curatorial Affairs, has kindly extended his counsel on many occasions. I would also like particularly to thank Klaus Biesenbach, Chief Curator of Media; Connie Butler, the Robert Lehman Foundation Chief Curator of Drawings; Christophe Cherix, Curator of Prints and Illustrated Books; Kathleen Curry, Assistant Curator of Drawings; Peter Galassi, Chief Curator of Photography; Kynaston McShine, Chief Curator at Large; Luis Pérez-Oramas, Estrellita Brodsky Curator of Latin American Art; Christian Rattemeyer, Associate Curator of Drawings; and Deborah Wye, Abby Aldrich Rockefeller Chief Curator of Prints and Illustrated books, each of whom has been the source of excellent questions and suggestions. The exhibition

is rich in works from the Museum's collection, and I am grateful to all the curators who have contributed loans of works from their respective departments.

I also would like to thank the members of the Board of Trustees of The Museum of Modern Art, led by Jerry I. Speyer, Chairman, and Marie-Josée Kravis, President. Their ready willingness to help in countless ways is a uniquely important resource for the Museum's curators. The Trustees have also made possible many recent acquisitions for the collection in tandem with the development of this exhibition. We are deeply appreciative of the generous contribution that *Color Chart* has received from Jerry I. Speyer and Katherine G. Farley. I also wish to express my gratitude to Benjamin Moore for its support of the exhibition, particularly Eileen McCloskey, and to Rona and Richard Roob for their help in facilitating this partnership. We are also extremely thankful for additional funding provided by Glenstone Foundation, Mitchell P. Rales, founder.

I gratefully acknowledge the kind support of the entire Department of Painting and Sculpture. Anne Umland, Curator; Cora Rosevear, Associate Curator; and Adele Nelson, Curatorial Assistant, have offered crucial assistance, and Sharon Dec, Assistant to the Chief Curator; and Mattias Herold, Department Manager, have helped in various administrative matters. My assistant, Lida Sunderland, and her predecessor, Wendy Vogel, have handled endless details of research, correspondence, travel, and calendar with expertise and good humor. Nicole Cosgrove, Samantha Friedman, and Eleonore Hugendubel all gave of their time as interns in the Department to provide superb research assistance to the project.

We have relied greatly on the talents and dedication of colleagues throughout the Museum. Michael Margitich, Senior Deputy Director for External Affairs; Todd Bishop, Director of Exhibition Funding; and Mary Hannah, Assistant Director of Exhibition Funding, have been indispensable allies in their dedicated pursuit of the necessary financial support. Thanks are due to several people in the Department of Marketing and Communications: Kim Mitchell, Director of Communications; Peter Foley, Director of Marketing; Zoe Jackson, Marketing Coordinator; and Meg Blackburn, Senior Publicist. James Gara, Chief Operating Officer, and Jan Postma, Director of Finance, have been friendly advocates of the exhibition. Maria DeMarco Beardsley, Coordinator of Exhibitions, and Jennifer Manno, Assistant Coordinator of Exhibitions, have guided this project with their usual good judgment and calm. We are most grateful for the expertise and resourcefulness of Ramona Bannayan, Director; Sacha Eaton, Senior Registrar Assistant; and Sydney Briggs, Associate Registrar for Collections, all in the Department of Collection Management and Exhibition Registration, and to Peter Perez, Foreman of the

Frame Shop. Mark Williams led the wonderful team of preparators entrusted with the installation of the exhibition. I also want to thank Ron Simoncini, Director of the Department of Security for his special support of this project.

We deeply appreciate the creativity and expertise of Jerome Neuner, Director, and Betty Fisher, Production Manager, in the Department of Exhibition Design and Production. The exhibition took form over the course of two years in which we worked closely together with them in the model room in the Museum's subbasement. Christopher McGlinchey, Conservation Scientist, long has nurtured a collector's passion for early color charts; he has shared his wealth of knowledge on the history of paint. As always, James Coddington, Chief Conservator; Anny Aviram, Paintings Conservator; Karl Buchberg, Senior Conservator; Scott Gerson, Assistant Paper Conservator; and Lynda Zycherman, Sculpture Conservator have been true collaborators in offering their expertise on matters of condition and the proper handling and display of all the works in the show. Milan Hughston, Chief of Library and Museum Archives, has been unstinting in his support, and Jenny Tobias, Librarian, has organized a fascinating exhibition in the Cullman Education Center that presents many of the splendid books chronicling the history of color studies. Wendy Woon, Deputy Director for Education; Laura Beiles, Associate Educator, Adult and Academic Programs; Elizabeth Margulies, Educator, Family Programs; Sara Bodinson, Associate Educator, Educational Resources; Sarah Ganz, Director of Educational Resources; and Allegra Burnette, Creative Director of Digital Media, have all enriched the project with auxiliary programs, texts, and tours. We also thank Michael Schepf, graphic designer, and Claire Corey, Production Manager, for their important contributions. In Imaging Services, Erik Landsberg, Head of Collections Imaging, Robert Kastler, Production Manager, and Roberto Rivera, Production Assistant, graciously provided much of the photography for this catalogue.

The Publications Department has worked with exceptional dedication to see this book through to completion. I am grateful to Christopher Hudson, Publisher; Kara Kirk, Associate Publisher; David Frankel, Editorial Director; and Marc Sapir, Production Director, for their extraordinary work on behalf of this project. I cannot adequately acknowledge Emily Hall, Associate Editor, who brought remarkable ingenuity and rigor to her task. We warmly thank Anne Doran, Nell McClister, and Stephen Robert Frankel, who joined the editorial process at the final stage, and Lynn Scrabis for her meticulous proofreading. We are very grateful to have had a wonderful working relationship with Takaaki Matsumoto, Amy Wilkins, and Hisami Aoki at Matsumoto Incorporated, who immediately entered into the spirit of the project and created a handsome design for this catalogue.

Three people have worked closely with me as trusted partners in this undertaking. I warmly thank Briony Fer not only for the beautiful essay she has written for this catalogue, but for her keen interest in the progress of the exhibition and the generous advice and insights she has provided throughout its development. Her role far exceeded that of contributing author. I also am greatly indebted to Melissa Ho, who carried out the extensive research that laid the groundwork for the checklist, contributed excellent texts to the catalogue, and was a constant source of sound ideas and valued opinions. Her intelligence and creativity have been integral to every phase of the planning process for both the presentation and this book. Finally, without Nora Lawrence, Curatorial Assistant, this exhibition could not have taken place. She has shouldered a vast array of complex administrative and diplomatic responsibilities, and also provided superb research and writing for this catalogue. Nora has displayed a professionalism and dedication that I have found nothing short of miraculous, and she has been a paragon of grace under pressure.

The two people who have lived with *Color Chart* at closest range are my husband and daughter, Wayne and Rachel Hendrickson, to whom I owe gratitude that cannot sufficiently be expressed in words.

Countless colleagues and friends beyond the Museum have been wonderfully generous in offering information, insights, and essential assistance with loans. We also have received invaluable help from many gallery directors and their staffs, as well as those working in the artists' studios. I would like first to express my gratitude to Ecke Bonk, who has been a greatly valued friend to this project. And while it would be impossible to thank all the others who deserve it, I would like to acknowledge the following: Doris Ammann, Geraldine Aramanda, Lucinda Barnes, Tiffany Bell, Marie-Laure Bernadac, Roberta Bernstein, Yve-Alain Bois, Annick Boisnard, Carly Busta, Amy Cappellazzo, Bettina della Casa, Michele Casamonti, Carolyn Christov-Bakargiev, Michael Clifton, Paolo Colombo, Lynne Cooke, Mary Dean, Kaayk Dibbets, Leah Dickerman, Maddelina Disch, Stephanie Dorsey, Caroline Dowling, Michel Durand-Dessert, Thierry de Duve, Dietmar Elger, Konstanze Ell, Anne Ellegood, Edy Ferguson, Bridget Finn, Susan Fisher, Erich Franz, Heiner Friedrich, Shelly George, Barbara Gladstone, Ann Goldstein, Marian Goodman, Brett Gorvy, Christoph Grunenberg, Madeleine Grynsztejn, Heather Harmon, Josef Helfenstein, Jon Hendricks, Robert L. Herbert, Kay Heymer, Matthew Higgs, Ghislaine Hussenot, Bradley Jeffries, Branden Joseph, Hiroko Kawahara, Dodie Kazanjian, Anton Kern, Minjung Kim, Suyeon Kim, Sandi Knakal, Marika Knowles, Mario Kramer, Suzanne Küper, Constance Lewallen, Sofia LeWitt, David Lieber, Joan LiPuma, Elsa and William Longhauser,

Dominique Lora, Bernard Marcadé, Andrea Marescalchi, Matthew Marks, Trina McKeever, Barbara McLanahan, Christine Mehring, Sigrid Melchior, Arianna Mercanti, Robert Monk, Jacqueline Matisse Monnier, Gloria Moure, Juliet Myers, Bob Nickas, Gabriel Orozco, Laura Paulson, Paula Pelosi, Neil Printz, Elena Querestani, Craig Rember, Patrick Resing, Thomas Resing, Anne Rorimer, Nan Rosenthal, Scott Rothkopf, Julie Salamon, Anne Marie Sauzeau, Christian Scheidemann, Peter Schjeldahl, Kim Schoenstadt, Jack Shear, Philippe Siauve, Susanna Singer, Sarah Smith, Nancy Spector, Rochelle Steiner, Mary Clare Stevens, Marianne Stockebrand, Sophie Streefkerk, Sarah Taggart, Michael Taylor, Susan Taylor, Vicente Todoli, Calvin Tomkins, Ben Vautier, Eva Walters, Alice Weiner, Rob Weiner, David White, Michelle Yun, Sandra Zalman, and Kate Zanzucchi.

We are supremely thankful to the private individuals and museum colleagues who have granted generous loans to the exhibition. Many of the works from Europe have never before been shown in the United States. Most of the objects we have borrowed are key fixtures of their collection displays and we understand well the difficulty of parting with them for four months. I would like especially to thank Jock Reynolds and Jennifer Gross at the Yale University Art Gallery for allowing Marcel Duchamp's *Tu m'* to travel to New York for the first time in thirty-five years, and Armin Zweite, Director of the Kunstsammlung Nordrhein-Westfalen, for allowing Gerhard Richter's *Ten Large Color Panels* to cross the Atlantic for the first time.

My final gratitude is reserved for all the artists in the exhibition, who have made the marvelous works of art that it is my honor to present in the Museum. They have been wonderfully willing to share with me their memories and reflections on the subject of color, and to offer invaluable insights into their artistic development and working processes. I would also like to express my thanks for the collaboration of those who have created new works specifically for this exhibition. The artists' interest and generosity during many long conversations and studio visits over the past three years have made this project a far more richly rewarding adventure than I could ever have imagined at its start.

Ann Temkin
The Blanchette Hooker Rockefeller
Curator of Painting and Sculpture

COLOR SHIFT

Ann Temkin

Fig. 1. The Muralo Company. Chart for Calcimo Wall Colors. c. 1900. The text reads, "They will work smoothly under the brush and will keep perfectly sweet in tins for years."

This exhibition takes as its point of departure the commercial color chart, an item that openly declares the status of paint as a factory-made commodity. The color chart possesses no higher truth than the materials that were required to make it, and no higher classificatory logic than those the manufacturer deemed useful for builders and contractors, decorators and designers, craftsmen and do-it-yourselfers. It invokes not the realm of fine art but rather the nonart purposes for which the overwhelming majority of paint in the world is made.

Color charts came into use by the 1880s, as a direct result of the mass production of ready-mixed paints for household use and the de-professionalizing of the handyman's or housepainter's job. During the last quarter of the nineteenth century and the first quarter of the twentieth, paint companies mounted ambitious campaigns to convince the general public that it could do its own painting. Advertisements suggested the pleasure and satisfaction that these tasks could give to the ordinary householder, and the ease with which he or she could acquire the necessary skills.

This broad new consumer base generated the need for cards, brochures, and catalogues presenting the full array of a paint manufacturer's colors. The earliest color charts included glued-in samples, made by applying paint to cardboard or thick paper that was then cut into units for the charts.[1] Their design established a format that, remarkably, has been retained to the present day: a set of individual color units arranged in rows and columns on a neutral field (figs. 1 and 2). The colors are unmodulated by any brushstrokes or other textures, so as to demonstrate how flat the paint will appear on the surface to which it is to be applied. Unlike that of a spectrum or color wheel, there is no necessary logic to the sequences of color ranges—it is simply a nonhierarchical list of what is available. In a color chart, black and white—usually referred to in color systems as the absence and combination, respectively, of all colors—are just two more colors (and, like all the other colors, are available in multiple shades).

The color chart serves as a lens through which to examine a radical transformation in Western art that took place midway through the twentieth century, when long-held convictions regarding the spiritual aspects and scientific properties of particular colors gave way to a widespread attitude that took for granted the fact of color as a commercial product. The artistic quest for personal expression, so often achieved through color, had been replaced by Andy Warhol's "I want to be a machine," and the mastery of a palette by Frank Stella's desire "to keep the paint as good as it is in the can." A contemporary position had evolved—one that might be called a color-chart sensibility—that set aside theories of relational color harmo-

ny just as it rejected the symbolic or expressive import of color choices, accepting color as a matter of fact, even happenstance.

Put differently, much of the most advanced art of the last fifty years has treated color as *readymade*, Marcel Duchamp's term for the mass-produced objects that he designated as works of art merely by selecting and then adjusting them in some way. The concept of the readymade reminds us that color itself had undergone a rapid transformation during the course of the nineteenth century from handmade product to synthetically manufactured, standardized, and commercially packaged commodity. Duchamp acknowledged this fact in the last oil painting he would make: *Tu m'* of 1918 (plate 1). In a complex and enigmatic composition that constituted a virtuosic summation of his own work to date, he included an echelon of painted, lozenge-shaped color swatches cascading from the upper-left corner. As Duchamp bid his own farewell to painting, he offered as his bequest to the future the notion of color as readymade.

Color Chart explores this legacy from 1950 to the present, as it was only after World War II that the consequences for art of mass-produced color became fully apparent. The exhibition examines the use by artists of ready-made color in two separate but related senses: color as store-bought rather than hand-mixed, and color as divorced from the artist's subjective taste or decisions. The works in the exhibition span numerous disciplines, mediums, and art-historical lines: the subject of color "after the palette" is addressed in paintings, sculptures, drawings, prints, video, film, and installation; color appears as colored papers, paint swatches, caviar and axle grease, auto enamel, and adhesive vinyl tape. The forty-four artists represented here do not by any means share a methodology that is typically considered Duchampian. For some, such as Ellsworth Kelly and Alighiero Boetti, color remains or remained a central concern throughout their careers. For others, including Richard Serra and Dan Graham, color has been a less obvious concern but makes an appearance in revelatory works.

Fig. 2. DuPont. Color chart for Duco paint. Mid-1920s

Today color charts, once the domain of the hardware or paint store, seem to be everywhere, broadcasting the easy availability and virtually infinite choice of color in products ranging from cars to cosmetics. In the age of digital color, every home and office computer offers a convenient world of ready-made color to its user, courtesy of the red, green, and blue phosphorus dots that coat the inside surface of a computer screen. The palette of thousands of colors that can be summoned by a single click is simply a somewhat more manageable selection from among the computer's nearly 17 million possible color combinations.

The color chart has largely supplanted the color wheel, which for three centuries embodied the attempt to organize color meaningfully and hierarchically according to spiritual or scientific theories.[2] During the course of the past century, those systems have come to be understood as reflecting the human desire for order more than any intrinsic truths about color. Classifications once considered immutable are now recognized as reflections of personal choice or historical context. For example, Issac Newton's decision in 1675 to identify the spectrum as seven colors rather than eight was based on his desire to make an analogy to the notes of the musical octave. So-called primary colors—a notion codified around 1600—have been variously considered in terms of three (red, yellow, blue) or four (plus green). The history of color, it turns out, abounds in subjectivities. In his *Remarks on Color*, written in 1951, Ludwig Wittgenstein succinctly noted that J. W. von Goethe's *Theory of Color* of 1810, arguably the most influential text of its kind, "really isn't a theory at all."[3]

The search for universal truths about color dates back to ancient analogies between color and the four humors or the four elements. But anthropological studies revealing vastly different, even contradictory practices of nomenclature among cultures indicate that any universality in the experience of color is an illusion. For example, many ancient and non-Western languages use a single term for what

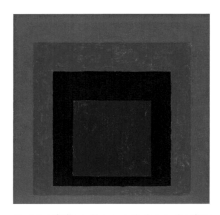

Fig. 3. Josef Albers. *Homage to the Square: Coniferous.* 1958. Oil on composition board, 18 x 17 ⅞" (45.6 x 45.4 cm). The Museum of Modern Art, New York. Gift of Jay R. Braus

Fig. 4. Richard Paul Lohse. *Fifteen Systematic Color Rows with Vertical Condensations.* 1950–58. Oil on canvas, 59 ⅛ x 59 ⅛" (150 x 150 cm). The Museum of Modern Art, New York. Gift of The Riklis Collection of McCrory Corporation

Westerners understand as unrelated colors, such as blue and yellow. Generalizations about the affective qualities of different colors—red as angry, blue as calm—are also now known to be culturally specific, and even highly variable within cultures. A contemporary awareness of color's historical and ideological contingency is reflected in the unsentimental, pragmatic quality of the commercial color chart. At the same time, the color chart as the foundation of standardization—evident in the success of international color-matching systems such as Pantone—is symptomatic of a global age in which cultural differences in color are being eroded no less than those in language and cuisine.

The color-chart sensibility of the artists whose works are presented in this exhibition extends from a set of profound questions about assumptions that not long ago had seemed certain: the possibility of individual genius or even originality, the inviolability of the unique handmade object, and the clear separation of art and life. In this context the color chart embodies the desanctification of color that accompanied the end of the idealism of such early modernists as Henri Matisse, Vasily Kandinsky, and Piet Mondrian. As this exhibition sets out to demonstrate, the color chart furnishes a compelling allegory for an approach to color adopted by those contemporary artists who disavow transcendent goals of truth or beauty while forging a new quotidian sublime.

Teachers and Students

"This is the most stupid thing I have ever seen; I dun't even vant to know who did it."[4] Such was Josef Albers's harsh pronouncement on the work of his student Robert Rauschenberg at Black Mountain College, North Carolina, in 1949. Rauschenberg's memory of Albers's impatience with him handily conveys—if with a bit of caricature—the degree to which the mid-century adoption of a color-chart sensibility discredited many decades of color pedagogy, of which Albers was a mighty exemplar. Nevertheless, Albers himself served as an important influence for a subsequent generation of artists whose de-skilling of color was in many ways a logical extension of his methodologies.

A veteran of the Bauhaus who fled Nazi Germany in 1933, Albers taught generations of American students to work with color relations, first at Black Mountain (1933–49) and later at Yale (1950–60). Albers's approach was an empirical one, rejecting the color theories that had been current in Europe during the early part of the century. His career of teaching and painting was founded on the principle that the perception of color depends entirely on adjacencies—that, in fact, color is "the most relative medium in art."[5] These ideas are exemplified in his series of Homage to the Square paintings, which he made between 1950 and 1976, the year he died (see fig. 3). Albers's pragmatism had tremendous repercussions for the artists who studied under him, as well as for those taught by his followers and those who read and used the compilation of his teachings published in 1963, *Interaction of Color*. But his attitude eventually seemed beside the point to an emerging avant-garde. Finally, as Rauschenberg summed up his own case, "In the exercises, seeing the clinical tricks that were involved in color, I met a lot of nice colors, but I couldn't justify with any idea what would be a better one or not."[6]

The profound difference in ideology between Albers's generation and Rauschenberg's is illuminated by an anecdote told by Gerhard Richter.[7] In 1972 Richter was in Venice for the Biennale, where he was showing his four paintings *180 Colors*, done in 1971, consisting of squares of color distributed as a grid by chance operations (page 91, fig. 2). Walking down a street during opening week, Richter saw across the way the seventy-year-old Swiss painter Richard Paul Lohse, a leading color theorist and practitioner of color-centered geometric abstraction (see fig. 4). According to Richter, Lohse caught sight of him and began to jump and shake like Rumpelstiltskin; he approached the forty-year-old Richter and hissed, "How could you *do* that?" The random juxtaposition of colors was for Lohse a heresy worthy of artistic excommunication.

Fig. 5. Ad Reinhardt. *Abstract Painting.* 1957. Oil on canvas, 9' x 40" (274.3 x 101.5 cm). The Museum of Modern Art, New York. Purchase

Fig. 6. Barnett Newman. *Ulysses.* 1952. Oil on canvas, 11' x 50" (337 x 127 cm). The Menil Collection, Houston. Gift of Adelaide de Menil Carpenter and Dominique de Menil

Fig. 7. Robert Mangold. *1/2 W Series.* 1968. Synthetic polymer paint on composition board, in two parts, each: 48 ¼ x 48 ¼" (122.5 x 122.4 cm), overall: 48 ¼" x 8' ½" (122.5 x 245.1 cm). The Museum of Modern Art, New York. Larry Aldrich Foundation Fund

For Rauschenberg, Richter, and their contemporaries, alternative role models did not necessarily come from the world of art. The ideas of John Cage, for example, greatly influenced artists, although his primary discipline was music. Cage taught classes at Black Mountain (where he met Rauschenberg) and later at the New School in New York, but he also disseminated his views through countless lectures and appearances in New York City and elsewhere. His advocacy of nonintention on the part of the artist, as well as his willingness to let the ambience of ordinary life infiltrate the sphere of art, were instrumental in the shift away from both geometric abstraction and Abstract Expressionism. His now-famous "Lecture on Nothing," first given in 1949 at the Studio School in New York's Greenwich Village, encapsulates the openness of his philosophy, which applied just as well to color as to sound:

> I begin to hear the old sounds—the ones I had thought worn out, worn out by intellectualization—I begin to hear the old sounds as though they are not worn out. Obviously, they are not worn out. They are just as audible as the new sounds. Thinking had worn them out. And if one stops thinking about them, suddenly they are fresh and new.[8]

Cage inspired artists as various as Rauschenberg and Kelly, whom he befriended in Paris in 1949, to approach their art without preconceived ideas. Like Duchamp, he gave license to a contemporary form of iconoclasm that gently but swiftly toppled long-heralded heroes and ideals. Cage's presence and influence were transatlantic, and his thinking had as much resonance for the American Minimalists as for Richter or Daniel Buren.

Ad Reinhardt and Barnett Newman were also instrumental in the shift toward a color-chart sensibility—despite the fact that they put enormous stock in the mystical profundity of color. Reinhardt's attitude was best expressed in the "black" paintings he made between 1954 and the year of his death, 1967. He deliberately made pictures that took a long time to see, sequestering nuanced color in "black" compositions that seemed at first glance empty rather than full (see fig. 5). There is no way to perceive, optically, the glowing color hidden in the black paintings without standing in front of them for several minutes, a commitment that for Reinhardt allowed a shift from an ordinary to an aesthetic state of mind.

Whereas Reinhardt distanced himself from the expressionism of the New York School, Newman in many ways shared the attitudes and goals of peers such as Mark Rothko and Clyfford Still, for whom color carried a fundamental emotional charge. Newman prided himself on the uniqueness of his palette (see fig. 6): its singularity was metaphorically equivalent to his uniqueness as an artist, and by extension, to the uniqueness of each and every viewer. To explain his position, Newman differentiated between the terms "color" and "colors": he was involved with "the color I make out of colors." Colors were something that "anybody can buy and squeeze . . . out of tubes," whereas color was what Newman created himself.[9]

Newman's point of view, like Reinhardt's, runs contrary to that of the artists in this exhibition. Yet their work was of great importance to the generation who came to prominence in the 1960s. The paintings of both Newman and Reinhardt, when divorced from their original intentions, offered models for what the next generation was trying to achieve. Although these two artists invested their work with feeling and spirit, their paintings were read as cool and objective; the evidence of the artist's hand in the making of the painting, apparent in the gestural bravura of Willem de Kooning and Jackson Pollock, and in Rothko's floating fields of color, seemed minimized, if not invisible. This misreading is apparent not only in the work of artists who used color in a nonexpressive, ready-made, or systematic way—for example, Stella, Dan Flavin, and Sol LeWitt—but also in restorations conducted by conservators who would repaint Reinhardt's or Newman's damaged paintings with a roller.

The mid-1960s was a period of extraordinary intellectual exchange among

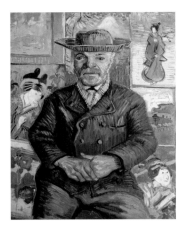

Fig. 8. Vincent van Gogh. *Portrait of Père Tanguy*. 1887–88. Oil on canvas, 25 ⅝ x 20 ⅛" (65 x 51 cm). Private collection

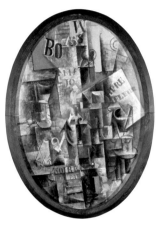

Fig. 9. Pablo Picasso. *Violin, Glass, Pipe and Anchor, Souvenir of Le Havre*. 1912. Oil on canvas, 31 ⅞ x 21 ⁵⁄₁₆" (81 x 54 cm). Narodni Galerie, Prague

artists. In New York, artist-thinkers such as LeWitt and Donald Judd, and many others as well, had an enormous impact on their peers and those slightly younger, both through their published writings and through the constant conversation that filled the small downtown art world. But color was virtually absent as a subject, even when present in the work itself. The rejection of Abstract Expressionism—whether by the Pop or the Minimalist artists—brought with it an attendant attitude toward color that equated it with excessive melodrama. Even Newman went through a period in the early 1960s of limiting his output to black paintings on raw canvas, and influential younger artists such as Agnes Martin and Robert Ryman intentionally restricted their palettes. Robert Mangold—one of the few painters to address the subject—spoke of how he wanted to use colors that evoked a bland office environment of steel file cabinets and manila envelopes (see fig. 7). Exhibitions with titles like *Black and White* and *Black, White and Gray* showed curators falling in behind the artists.[10]

The suppression of color, already evident in much painting of the mid-1960s, carried over into the beginnings of what would be known as Conceptual art. As LeWitt wrote in his "Paragraphs on Conceptual Art," published in *Artforum* in June 1967,

> Conceptual art is made to engage the mind of the viewer rather than his eye or emotions. The physicality of a three-dimensional object then becomes a contradiction to its nonemotive intent. Color, surface, texture, and shape only emphasize the physical aspects of the work. Anything that calls attention to and interests the viewer in this physicality is a deterrent to our understanding of the idea and is used as an expressive device.[11]

Color would nevertheless turn out to be ideally suited to the Conceptualist methodologies of seriality and system, in the sense that the placement of objective parameters on the use of color provided a perfect vehicle for demonstrating—even calling attention to—the objectivity of the artist. The Conceptual artists' preference for obtaining and using color designed for the general, nonspecialized customer would also underscore their desire for independence from the history of several centuries of bourgeois painting.

Shopping for Color

Until the nineteenth century, certain artists' colors were luxury goods of the highest order, often difficult to obtain and to make ready for use. The relative esteem accorded different pigments, usually imported from far away, corresponded to their rarity and consequent expense. Renaissance patrons specified in contracts the exact colors for the works they commissioned, and artists' guilds set harsh penalties for any attempts to cheat by using inferior paints. Only with the invention of oil paint, which could be mixed to produce new colors, did the gradual dissociation between a given color and its natural source begin. Nature was placed at an even greater remove when, in the mid-1800s, chemical companies began the synthetic production of paints. The bright Impressionist and Post-Impressionist palette was in part made up of newly invented colors, one no more or less intrinsically precious than another.

For centuries one of the artist's principal tasks had been mixing his own color. Oil paints were secured from an apothecary or a grocer, and came in animal bladders that the artist punctured to squirt paint onto a palette. It is possible that in their theoretical writings, artists long ranked *disegno* over *colore* precisely because the latter was so closely bound up with manual, messy work, an aspect of their occupation they wished to downplay. In the early 1800s, companies devoted to artists' materials—such as Winsor and Newton, established in London in 1832—began to

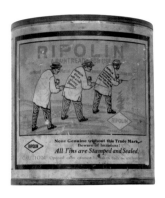

Fig. 10. Ripolin Lime Green paint, ⅛-gallon can, c. 1940

make their appearance, and in 1841, American portrait-painter John Rand invented the tin tube as a way of packaging oil paint. But the preparation of color was still often the work of a "color man," on whom an artist relied for paints that were vivid, durable, and free of adulteration. Among the most famous was "Père" Julien Tanguy in Montmartre, who had opened a shop in 1874, serving clients who included Renoir, Pissarro, Cézanne, and van Gogh (see fig. 8).

By the mid-twentieth century an artist had access to an unprecedented variety of premixed, prepackaged colors. For Albers, procuring paint was its own reward. As he explained to the visiting art critic Jean Clay in 1968:

> On this shelf alone I have eighty different kinds of yellows and forty grays. I have them sent from all over the place. In town yesterday I bought eighteen different reds. I can't finish that picture over there because I'm waiting for a blue to come from Paris.[12]

No matter how objective and rigorous Albers's practice was, his passion for the stuff of color bubbles over into these remarks. Although he never mixed his own paints, he compensated by obsessively tracking down and purchasing as many off-the-shelf colors as he could. This is borne out in his more than one thousand Homage to the Square paintings. Each bears on the reverse of its Masonite or Formica support, in Albers's handwriting, the full recipe for the composition on the front: the paint used for the white ground layer (color name and brand), those used for each of the concentric sections, and the varnish, with the colors noted as being applied "directly from the tube."

Few artists shared Albers's energy and commitment to shopping for color. In 1966, Darby Bannard, an abstract painter who had taught Stella at Princeton, lamented in the pages of *Artforum* the relative poverty of color in contemporary painting. He complained that artists settled for what the local art store offered, and were too lazy to go elsewhere or to mix anything beyond that. "Most paintings I have seen contain the same thirty or forty colors. In effect, therefore, the color range of the artist is set by the company from which he buys his paints."[13] Instead, he recommended purchasing commercial paints at a hardware store, where the paint-mixing machines offered "an extremely sophisticated system of color selection, more complex than that of any art paint company."[14]

By this time, however, for certain artists, the deliberate selection of a particular color—whether from an art-supply or a hardware store—would have associated with the color a personal taste, an expressive or descriptive need, or a decorative or harmonic goal. In contrast, found color held a greater attraction. The remainder bin was a preferred source for both Rauschenberg and Stella in the 1950s, incidentally assuring that their work would not bear the curse of a fashionable palette. Similarly, James Rosenquist made what he called his "wrong color paintings" with discards from his job as a billboard painter. "How," he asked himself, "could I make a beautiful, colorful painting with these low-value colors?"[15]

In fact, the use of commercial paint in works of art had begun much earlier in the twentieth century, as part of the ongoing avant-garde campaign to reject the trappings of accepted painting. The first appearance of vivid color in Analytic Cubism, outside the usual range of browns, grays, and ivories, was the blast of red, yellow, and blue at the top of Pablo Picasso's 1912 oval composition *Violin, Glass, Pipe and Anchor, Souvenir of Le Havre* (see fig. 9)—an introduction made even more conspicuous by the shine of Ripolin paint. Ripolin (see fig. 10), a commercial enamel manufactured for use on wood, plaster, and metal, was a medium that Picasso favored at various points in his career. Gertrude Stein quoted him as pronouncing Ripolin "the health of color," and Roland Penrose's notebooks tell of a 1955 visit to Picasso during which the artist extolled the virtues of Ripolin and declared that "the limits of oil paint from tubes had been reached."[16]

Fig. 11. Francis Picabia. *Veglione, Cannes, 1924.* 1924. Ripolin on canvas, 36 ⅝ x 28 ¾" (93 x 73 cm). Private collection

Fig. 12. Willem de Kooning. *Painting.* 1948. Enamel and oil on canvas, 42 ⅝ x 56 ⅛" (108.3 x 142.5 cm). The Museum of Modern Art, New York. Purchase

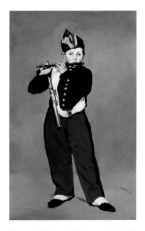

Fig. 13. Edouard Manet. *The Fifer.* 1866. Oil on canvas, 63 x 38 ½" (161 x 97 cm). Musée d'Orsay, Paris

Picasso's enthusiasm for paint in a can was shared by a number of his contemporaries. Commercial paint took a star turn in Duchamp's "assisted readymade" of 1916–17, *Apolinère Enameled* (page 43, fig. 3), made on a display card for Sapolin enamel. Francis Picabia chose Ripolin for his "monster paintings" of the mid-1920s, using the shiny, vivid paint to dramatize their provocative imagery (see fig. 11). Fernand Léger, an artist devoted to the idiom of the modern city and technology, considered Ripolin the perfect material for his work at a mural scale.[17] In a very different tradition, David Alfonso Siqueiros relied on Duco enamel for his outdoor murals in the 1930s, and taught workshops on using it to a group of New York artists, including Pollock.

The Abstract Expressionists—for whom Picasso, especially, was a constant, godlike presence—were well aware of such antecedents for their forays into commercial color. The presence of nonart materials in midcentury paintings by artists such as Pollock, de Kooning, and Franz Kline enhanced their work's revolutionary aura, while the low cost of commercial paint fit well with the bohemian stereotype they cultivated. It was an important part of their self-image: for the rest of his life, de Kooning (see fig. 12) kept the first five-gallon cans of zinc white and black enamel paint he had bought on the Bowery with Kline.[18]

In due course, nonart paint came to assume a role in the practice of many artists. Large-scale work in particular invited the use of commercial paint, as buying color by the tube would have been both absurdly inefficient and prohibitively expensive. In addition to being relatively cheap, house paint is designed to flow easily and to produce a smooth, opaque surface that conceals any evidence of the brush—a sought-after quality for the artist looking to attain the depersonalization of style so widely desired in the 1960s.

It is fitting that color charts were first made as part of a process of democratizing the task of painting. The color-chart sensibility that began to spread among artists in the middle of the twentieth century—after a delay of about seventy-five years from the debut of the first color charts—was very much tied to a rhetoric that favored the democratization of the realm of fine art. The reference point for these artists was to be ordinary life, industrial or consumer culture, rather than a transcendent realm apart. They positioned themselves and their work not as an elite fraternity but as part of the real world—as exemplified by the blunt utilitarianism of the housepainter's color chart.

Artists and Painters

The question of where exactly the difference between the housepainter and the artist lay reveals many of the anxieties and ambiguities that accompanied the development of modern art. The trade of painting as the perpetual "other" to the art of painting was a subject that had haunted the avant-garde for a century. Emile Zola defended Edouard Manet's *The Fifer* of 1866 (fig. 13) after it was dismissed by a fellow artist as a "tailor's signboard." Zola turned the insult into a compliment, saying that he agreed "if by that he means that the young musician's uniform was treated with the simplicity of a sign. The yellow braid, the blue-black tunic, the red breeches are here just large spots." Zola noted approvingly that Manet's flat handling of color had produced a canvas that was "acutely real."[19]

Renewed accusations that an artist was no more than a painter accompanied the rise of abstraction in the early twentieth century. When Aleksandr Rodchenko showed his three paintings *Pure Red Color, Pure Yellow Color, Pure Blue Color* (fig. 14) in the *5x5=25* exhibition in Moscow in 1921, a critic wondered why the exhibition did not include an advertisement for the artist's sign- and fence-painting services.[20] Thirty years later, a critic for the *New York Herald Tribune* observed that the paintings in Newman's second show at the Betty Parsons Gallery appeared to be "handsomely painted walls against which pictures would probably look beautiful."[21]

Artists have made this persistent misreading of modern art into a fruitful source

Fig. 14. Aleksandr Rodchenko. *Pure Red Color, Pure Yellow Color, Pure Blue Color.* 1921. Oil on canvas, three panels, each: 24 ⅝ x 20 ¹¹⁄₁₆" (62.5 x 52.5 cm). A. Rodchenko and V. Stepanova Archive, Moscow

Fig. 15. Mick Stevens. Cartoon published in *The New Yorker*, November 20, 2006

Fig. 16. László Moholy-Nagy. *Telephone Picture EM 2.* 1922. Porcelain enamel on steel, 18 ¾ x 11 ⅞" (47.5 x 30.1 cm). The Museum of Modern Art, New York. Gift of Philip Johnson in memory of Sibyl Moholy-Nagy

for new approaches. Once art had been divorced from ideas of self-expression and spiritual content, it was worth asking what made it art at all. It obviously did not depend on the kind of paint the artists employed. Instead it rested in their ambitions and intentions and the ultimate use to which the work of art was put. The finer the line between art and non-art, the clearer was the importance of the parameters of the artwork and the institutions and conventions that supported it, including the ritual of the opening party (see fig. 15).

The blurring of the line between the tradesman and the artist, or between applied and fine art, has its roots in the movements of the late 1910s and the 1920s that envisioned the integration of art, daily life, and the environment: Russian Constructivism, de Stijl, and the Bauhaus. It was assumed that an artist should work for the sake of society, not for himself, and should produce objects for the ordinary person rather than luxury goods. Many of these artists saw themselves as instruments of social change, agents for the integration of art into the daily life of the ordinary individual. A radical streak more Dada than Constructivist in tone was embedded in the practical concerns and utopian aspirations of these artistic programs. Jean (Hans) Arp and El Lissitzky, in their 1925 publication *Kunstismen/Isms of Art*, under the heading of Suprematism, declared that with the simplified production of works of art, now "nobody can do better than order his works by telephone from his bed, [from] a common painter."[22] They probably had in mind the enamel paintings that László Moholy-Nagy had made in Berlin three years earlier (see fig. 16):

> In 1922 I ordered by telephone from a sign factory five paintings in porcelain enamel. I had the factory's color chart before me and I sketched my paintings on graph paper. At the other end of the telephone, the factory supervisor had the same kind of paper divided into squares. He took down the dictated shapes in the correct position. (It was like playing chess by correspondence.)[23]

Lucia Moholy-Nagy later wrote that her husband's account hyperbolized the event, which had indeed involved a factory, but nothing more than Moholy-Nagy's comment that "I even could have done it by telephone."[24] Even if so, the value he placed on the anonymous hand remains, as does his instinctive association between what he was doing and modern technology. Painting by hand felt old-fashioned in the age of the telephone. A desire for objective and collective production was bound up with a conviction—one might say an anxiety—that art had to keep up with technological advances. Theo van Doesburg echoed the logic expressed by Moholy-Nagy's telephone paintings in his manifesto for what he called "Art Concret" in 1930: "Typewriting is clearer, more legible, and more beautiful than handwriting. We do not want artistic handwriting."[25]

These art-historical movements held great interest for artists in the 1960s who wanted to establish a new objectivity. And although there no longer were grand collective visions to which they contributed their talents, their own work echoed that of these predecessors in terms of a downplayed signature, the use of industrial materials, and the presence of art in contexts more often associated with daily life. Buildings gathered appeal as the ground for a work of art. Both Kelly and Richter imagined their colored grids at architectural scale, an aspiration that has been realized fully in the case of both artists only later in their careers (see figs. 17 and 18). At one level this was a rejection of canvas, which had become no less a symbol of obsolete attitudes than the palette. At another, it reflected a will to break down categories such as architecture, painting, sculpture, drawing, and performance. By the late 1960s LeWitt in New York, Niele Toroni in Paris, and Blinky Palermo in Düsseldorf were all drawing or painting directly on the wall.

For many artists of the 1960s, paint became as expendable as canvas. For Palermo, the department-store fabric counter was the ideal supply shop, offering

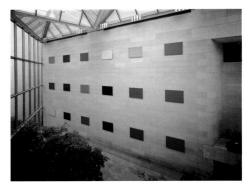

Fig. 17. Ellsworth Kelly. *Color Panels for a Large Wall.* 1978. Oil on canvas, eighteen panels, each: 48 x 68 ½" (121.92 x 173.99 cm), overall: 36 x 75' (10.97 x 22.86 m). The National Gallery of Art, Washington, D.C. Purchased with funds provided and promised by The Glenstone Foundation, Mitchell P. Rales, Founder

Fig. 18. Gerhard Richter's abstract stained-glass window for Cologne Cathedral. 2007. Colored glass. 75' 5 ½" x 29' 6 ⅜" (23 x 9.02 m)

wide bolts of cotton for "cloth paintings" of one, two, or three bands of unmodulated color. LeWitt, who made his first wall drawings with graphite in 1968, branched into Koh-I-Noor colored pencils the following year, choosing the three primary colors and black as the entirety of his palette. Once Ed Ruscha decided to take a break from paint in 1970, he explored in printmaking the potential of organic substances and manufactured products as fine-art mediums. For Buren, the vendors of striped awning canvas at the Marché St. Pierre in Paris offered all the color he needed for works that were at first stretched paintings but were later applied directly to surfaces in settings that might or might not be art-related. For all these artists, an analogy to a workman was not an insult; on the contrary, it provided an apt metaphor for their goals. As Buren observed to an interviewer, a plumber who comes to fix a dripping tap "fixes it quite independently of his state of mind."[26]

Unsurprisingly, automobile paint has a significant presence in the history of ready-made color. It offered possibilities of colors that were far brighter and more industrial in appearance than those offered by oil or house paint; it too connected the world of art to that of the everyday consumer, narrowing the divide between the gallery and the salesroom, art and life. In 1958, Richard Hamilton, an avatar of Pop art, sprayed car paint on a section of his painting *Hers Is a Lush Situation* (fig. 19). His logic was simple: "It's meant to be a car, so I thought it was appropriate to use car color."[27] A year earlier, John Chamberlain had begun to use painted metal from automobile scrap yards to make sculptures, which allowed him not only to incorporate found color as an integral part of the sculptures' structure but to have a palette as American as that of Jasper Johns's red-white-and-blue flags. In the early 1960s Chamberlain was inspired by Los Angeles artists such as Billy Al Bengston to use automobile lacquer in paintings that in turn inspired New Yorkers such as Judd.

Car colors continued to fascinate European artists as well. In 1967 Michel Parmentier in Paris and Boetti in Turin each decided to use automobile paint to make paintings, the former using a single color in stripes, the latter a wide range of colors for monochromes. And in the mid-1970s, both John Baldessari in Los Angeles and Jan Dibbets in Amsterdam turned the camera on the parked car as a subject for photography in and about color. For most of these artists, the non-art materials they chose joined forces with a noncompositional methodology to make art that looked more anonymous than personal, seemingly a product of chance rather than deliberation.

"Brand New in the World"

For artists born after World War II, and who came of age in the 1970s, '80s, and '90s, the distinction between fine artists' paints and other materials has lost much of its ideological significance. Today it is taken for granted that an artist works with anything he or she wishes—that a Pantone chart or a computer program might be an essential accessory, and that chance operations, borrowed sources, and arbitrary systems are legitimate and meaningful ways to work with color. The same is true for color created and composed (or non-composed) on the computer: the circumstances of its origin are incidental rather than a matter of interest.

Yet, far from acting as a constraint, a ready-made approach to color has opened the way to new opportunities. The celebration of color in the late work of artists such as LeWitt and Judd demonstrates this phenomenon within the arc of a single career. Neither artist recanted the principles he articulated in the mid-1960s, but two decades later each recognized and acted on the expansive possibilities contained therein, shedding the suspicion of virtuosity that was so much part of the mid-century avant-garde aesthetic. After a gradual evolution throughout the 1980s to a wider range of colors, mediums, and compositions, LeWitt in the 1990s began to create wall drawings in acrylic paint. The brilliant color and gloss of the acrylic, often coupled with monumental scale, gives the late drawings (see fig. 20) a vivid theatricality unprecedented in his earlier work. In 1984, Judd, whose sculptures,

Fig. 19. Richard Hamilton. *Hers Is a Lush Situation*. 1958.
Oil, cellulose, metal foil, and collage on panel, 32 x 48"
(81 x 122 cm). Private collection

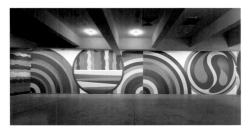

Fig. 20. Sol LeWitt. *Wall Drawing #918 (Irregular vertical
bands and horizontal bands)*. 1999. Latex paint, 13 x 29'
(3.96 x 8.83 m) as installed

though optically seductive, had previously featured only one or two colors—generally a Plexiglas or industrial paint color and that of a metal—ventured into polychromatic territory with spectacular results.

The same increased exuberance is visible in the later work of Europeans such as Boetti and Buren. Boetti expanded his use of ready-made color to Italian embroidery yarns that came in dozens of hues. The Afghani women who made his embroidered works known as *Tutto* (Everything) were to follow their own discretion in distributing the colors throughout the composition, obliged only to use abundant color in each work (page 109, fig. 4). Buren, still loyal to his stripes but not necessarily to the awning fabric and its seven-color palette, has developed his color in parallel fashion. For every one of these artists, it is as if sheer pleasure made a return by proving its compatibility with a system that initially had seemed Spartan in its implications.

The evolution of such 1960s-generation artists during the 1980s and '90s is mirrored in the work of those who came of age in the 1970s. In the practice of artists such as Katharina Fritsch, Mike Kelley, and Sherrie Levine, a new tolerance for chromatic opulence is wedded to an a priori acceptance of ready-made color and its implications. Most of them had learned color theory in school, yet when they came into their own, during the primacy of Conceptualism, color, like painting, was off the table. Even though color had a prominent place in the art of the 1970s, the critical rhetoric suppressed that fact, privileging the cerebral over the sensual. It was only well into their own careers that the next generation felt able to indulge what earlier would have seemed an illicit love of color. They came out of the closet as colorists, much as Judd and LeWitt had.

Nevertheless, the anxiety of influence was once again at work. Just as artists at mid-century had to distinguish themselves from their predecessors, so did the artists who positioned themselves as part of the Conceptual tradition have to set themselves apart from the first wave of Conceptual artists. As Fritsch recalls, in reference to her own milieu in Germany, there had to be "somewhere to go" after Richter's Color Charts.[28] Accordingly, her generation found a new place for subjectivities in their work. In part this is because the temporal distance from the art of mid-century shows it to be less absolute than the rhetoric that surrounded it. Despite their own declarations, it is clear that an earlier avant-garde—even as they spoke of the artist as a machine or chose an office or a laboratory or a street as a metaphor for the studio—had brought to their work profoundly individual sensibilities and styles that have become more evident over time.

For the successors to these artists, therefore, personal narratives as well as sociopolitical context can be invoked as color is thickened with layers of reference. In the 1960s, for example, the grid was considered a neutral, objective template, a desirable corrective to the theatricality of the Abstract Expressionists. In late-twentieth century art, the grid is intentionally adulterated, its suggestion of elementary purity a foil for new superimpositions. These might include Kelley's use of kitsch men's-magazine covers as the basis for chromatic harmonies in his Missing Time Color Exercises (see plates 77 and 78), or Byron Kim's panels of different flesh tones, which make implicit references to the genre of portraiture and the history of racial classifications (see plate 75).

Ready-made color has a host of new meanings and potentials for the generation of artists working in the 1980s and after. The modernist myth of originality seems to have lost much of its remaining allure, and the connection between the artist's hand and the product known as the work of art is often nonexistent. New work does not pretend to independence from what preceded it. Damien Hirst is happy to make spot paintings that openly evoke Richter's color charts, that exist in more than 600 versions on individual canvases, and that are made by an army of assistants (see plate 84). The aura of the unique object has also evaporated, as ever-changing incarnations of installations or editions of photographs or videos overcome the primacy of a single authoritative configuration. Jim Lambie's *zobop!* floors (see cover of this

catalog and plate 87) marshal vinyl tape into colored patterns that change from one installation to the next and are of no importance to what is considered the composition of the work. They superficially recall the Op art of the 1960s, but whereas those paintings were calculated to elicit specific optical effects, Lambie aims only for a casually composed profusion of color.

For other artists, the computer pixel as a source of ready-made color lends itself to endless manipulation. Angela Bulloch invented her pixel boxes in 2001 (see plate 88) to provide a unit for making art; each one marches through the 256-color palette of a Macintosh operating system, much as Richard Serra's 1971 film *Color Aid* (plate 57) paraded through the 220 sheets in a box of Color-aid paper. Cory Arcangel's *Colors*, (2005; plate 89) transforms the photographic imagery of the 1988 movie of the same name, about L.A. gangs, into an abstract work of colored stripes. He converted a one-pixel-high strip from each frame of the film into a stripe that stretches from the top to the bottom of the image. Having taken the title of the film as an invitation, Arcangel produced a work of art that provides just that (accompanied by the film's original soundtrack). Abstraction is made from figuration, which is shown to be as arbitrary and malleable as the click of a mouse or the push of a button permits.

New technologies will continue to transform artists' approach to color just as the first availability of synthetic paints did over a century ago. In the past two decades, Photoshop and Epson have joined, if not sidelined, Winsor and Newton, Crayola, and Color-aid as names immediately associated with color. These changes parallel a historical trajectory in which color has come to be identified less with nature than with culture. While the original referent for color was of course the natural world—flora, minerals, sky, sea—over time the ratio of natural to artificial color in our lives has steadily decreased. But this is not necessarily cause for lament. As Judd wrote in 1991, "There is much more to be done; in fact color is almost brand new in the world."[29]

Notes

1. The earliest color charts were made to be presented in counter books available for consultation in the store. Not until after World War II would color reproduction reach a level of accuracy that enabled the printing of paint cards and catalogues, thus making them available in quantities that allowed individual consumers to take them home.

2. Note that the mixing of colors to create a variety of new colors was made possible by the development of oil paint in the 1400s. On the relationship of color charts and color wheels, see David Batchelor, *Chromaphobia* (London: Reaktion Books, 2000), p. 104ff. On the general history of color, see John Gage, *Color and Culture: Practice and Meaning from Antiquity to Abstraction* (Berkeley: University of California Press, 1999).

3. Ludwig Wittgenstein, *Remarks on Color*, ed. G. E. M. Anscombe, trans. Linda L. McAlister and Margarete Schättle (Malden, Mass., and Oxford: Blackwell Publishing, 1977), p. 11.

4. Josef Albers, as quoted by Robert Rauschenberg, (mimicking Albers's German accent), in Calvin Tomkins, *Off the Wall: Robert Rauschenberg and the Art World of Our Time* (Garden City, N.Y.: Doubleday, 1980), pp. 31–32.

5. Josef Albers, *Interaction of Color*, 1963 (reprint ed. New Haven and London: Yale University Press, 2006), p. 1.

6. Robert Rauschenberg, quoted in Emile de Antonio and Mitch Tuchman, *Painters Painting: A Candid History of the Modern Art Scene, 1940–1970* (New York: Abbeville Press, 1984), p. 88.

7. Gerhard Richter, conversation with the author, Cologne, February 3, 2006.

8. John Cage, "Lecture on Nothing," in *Silence*, 1961 (reprint ed. Hanover, N.H.: Wesleyan University Press [University Press of New England], 1973), p. 117.

9. Barnett Newman, conversation with Frank O'Hara, transcript of *The Continuity of Vision*, Channel 13, WNDT-TV, 1964, p. 2. Produced by Colin Clark, directed by Bruce Minnix. The Barnett Newman Foundation archives, New York.

10. "Robert Mangold and Urs Rausmüller: A Talk on December 5, 1992, in New York," in Christel Sauer and Urs Rausmüller, *Robert Mangold* (Schaffhausen, Switz.: Hallen für Neue Kunst, and Paris: RENN Espace d'Art Contemporain, 1993), p. 53. The two exhibitions cited were at the Jewish Museum, New York, in 1963, and at the Wadsworth Atheneum, Hartford, in 1964.

11. Sol LeWitt, "Paragraphs on Conceptual Art," *Artforum* 5, no. 10 (Summer 1967): 83.

12. Albers, quoted in Jean Clay, "Albers: Josef's Coats of Many Colors," *Réalités* (March 1968; English-language ed., August 1968): 68.

13. Darby Bannard, "Color, Paint and Present-day Painting," *Artforum* (April 1966): 35.

14. Ibid., p. 36.

15. James Rosenquist, quoted in Walter Hopps, "Connoisseur of the Inexplicable," in *James Rosenquist: A Retrospective* (New York: Guggenheim Museum, 2003), p. 5.

16. Gertrude Stein, *The Autobiography of Alice B. Toklas* (New York: Harcourt, Brace, 1933; Modern Library, 1993), p. 191, and Roland Penrose, *Visiting Picasso: The Notebooks and Letters of Roland Penrose*, ed. Elizabeth Cowling (London: Thames and Hudson, 2006), p. 111.

17. When Fernand Léger wrote to Katherine Dreier about his first solo exhibition in the United States in 1925, he foresaw commissions for new versions of particular paintings that "can be executed in any size whatsoever and in mural *materials* (*Ripolin* or another kind). These are architectural paintings. All the others are easel paintings." Léger, letter to Dreier, August 1, 1925, quoted and trans. in Robert L. Herbert, Eleanor S. Apter, and Elise K. Kenney, eds., *The Société Anonyme and the Dreier Bequest at Yale University, A Catalogue Raisonné* (New Haven and London: Yale University Press, 1984), p. 400.

18. See Mark Stevens and Annalyn Swan, *De Kooning: An American Master* (New York: Alfred A. Knopf, 2004), p. 246.

19. Emile Zola, "A New Manner in Painting: Edouard Manet," in *La Revue du XIXᵉ siècle* (January 1, 1867), reprinted in May 1867 as a pamphlet, *Edouard Manet, étude biographique et critique*; quoted in George Heard Hamilton, *Manet and His Critics* (New Haven: Yale University Press, 1954), p. 101.

20. See Aleksandr Lavrent'ev, "On Priorities and Patents," in *Aleksandr Rodchenko* (New York: The Museum of Modern Art, 1998), p. 58. I thank Mr. Lavrent'ev for informing me that the text to which he referred in this article is Bahwam, "Karandashom," *Teatralnaja Moskva* no. 2 (November 3, 1921).

21. Emily Genauer, "Art and Artists: Super-Realistic Old and Nearly Blank Modern Art Both 'Fool the Eye,'" *New York Herald Tribune*, May 6, 1951, section 4, p. 5.

22. Jean (Hans) Arp and El Lissitzky, *Kunstismen/Isms of Art* (Erlenbach, Switzerland: E. Rentsch, 1925; Rolandseck, Germany: L. Müller, 1990), pp. 9–10. The trilingual volume uses "Anstreicher" and "peintre de décors" in German and French, more precise than the English "painter."

23. László Moholy-Nagy, *The New Vision* and *Abstract of an Artist*, 1947 (reprint ed. New York: Wittenborn, Schultz, 1949), p. 79.

24. Lucia Moholy-Nagy, *Moholy Nagy Marginal Notes: Documentary Absurdities . . .* (Krefeld, Germany: Scherpe, 1972), pp. 75–76.

25. Theo Van Doesburg, "Base de la peinture concrète," in *Numéro d'introduction du groupe et de la revue Art Concret* (Paris, 1930), the only issue published, quoted in George Heard Hamilton, *Painting and Sculpture in Europe, 1880–1940*, 6th ed. (New Haven: Yale University Press, 1993), p. 325.

26. Daniel Buren, in "Daniel Buren: Napoli, 1972–1983," in Achille Bonito Oliva, *Dialoghi d'artista* (Milan: Electa, 1984), p. 187.

27. Richard Hamilton, quoted in Jo Crook and Tom Learner, *The Impact of Modern Paints* (London: Tate Gallery, 2000), p. 71.

28. Katharina Fritsch, conversation with the author, June 15, 2006.

29. Donald Judd, *Josef Albers*, exh. cat. (Cologne: Distel, in association with The Chinati Foundation, 1991), p. 23.

COLOR MANUAL

Briony Fer

One of the few constants in the history of color is the conflicting opinion about how it works: at one pole color is meant to be subjective, intuitive, expressive, translating into a language of aesthetic feelings and emotions; at the other it is objective, scientific, systematic. In modernism, dreams of a truly universal and scientific color theory were pitched against a sensual utopia of chromatic excess, but in reality, of course, the oppositions were never so clear-cut. The desire for a system often led to the most sensual, impure results, just as the myth of color's much-vaunted freedom from rule-bound convention has often produced the most formulaic and exhausted of modernist experiments. This essay is an attempt to say something not about the essence of color but about how color works, by which I mean less the mechanics of its production than how color affects us as spectators, which often flies in the face of what we expect or think we know. If color is supposedly so direct and immediate, then it is striking how difficult it is to discuss, and if color is so systematic, then why is it so hard to contain within a given system? Our failure to create a totalizing theory highlights both color's weakness and its strength—which is that color is not entirely free from rules, but neither is it entirely systematic. Instead, the *work* of color, I shall suggest, turns out to be counterintuitive rather than intuitive.

It is easy to be nostalgic about color. But it is worth recalling the fraught history of color under modernism, marked as it was by a series of crises that dramatized anxieties about the relevance of art in modern culture, as much in periods of chromatic excess as in those of achromatic austerity.[1] If color were thought of as the aesthetic value par excellence (with pure color equaling pure art), then it also had the power to tip over into something that was not art at all but rather decoration or design. When Aleksandr Rodchenko made his three monochromes, each in one of the primary colors—red, yellow, blue—in 1921 (page 23, fig. 14), it was to mark the death of easel painting, but his iconoclastic act was only the most extreme point in an often rocky and precarious history in which color could be art's most authentic or most compromising component in almost equal measure. The greatest trauma took place at the very moment of modernism's disintegration, in the 1950s and '60s. That color's part in that story is so often overlooked is symptomatic only of the fact that we continue to find ourselves in the grip of its long crisis, with repercussions still playing themselves out to this day. What is interesting from the perspective of art's contemporary concerns is how color has turned against color—how color becomes the greatest weapon against the formulaic strictures that once beset it. These include the delusion that freedom is a brush laden with colored paint and moving around a canvas in a spontaneous gesture or, for that matter, the equally idealized visions of a liberated, digital-color future. The conventional oppositions

between color's supposed objectivity or subjectivity don't really fit contemporary experiences; it is a mark of how deeply rooted they are that they continue to be applied to art. But there is no reason to think that new technologies are any less subject to fantasy. After all, what could be more mechanized and instrumental than the spectacular chromatic pleasures of late capital—from digitalized imagery to the virtual world of the Internet?

Nothing would seem to be so systematic as the standardization of color that we see in the color chart. Yet this rationalization of color comes to operate not only *in* but *as* a space of desire. At times the numbers and the names of colors may even offer an alternative poetics, as an older category of the expressive—the affective vehicle for emotion—comes to seem formulaic and instrumental, betraying not so much the uniqueness of an individual subjectivity as the industrial production of feeling. Born of the industrialization of color, the color chart would bear the seed of its own technological breakdown. This was the greatest paradox of the color chart itself as it became the focus of a radical revision of ideas about color from the 1950s on. The stakes were high. It was, after all, improbable that color be used against color to fight art's greatest threat: its own irrelevance.[2] It could easily have failed, allowing art to fall into further critical impotence; instead it faltered but became more powerful in the process. One hardly needs reminding that some of the century's fiercest and most articulate diagnosticians were not on its side. Theodor Adorno, for instance, identifying the ideal of blackness as one of contemporary art's profoundest impulses, warned, "Radical art today is the same as dark art: its background color is black. Much of contemporary art is irrelevant because it does not take note of this fact, continuing instead to take delight in bright colors."[3] Adorno's implication is that there is something almost infantile in the sublimatory pleasures offered by color. Yet it turned out that it was, in part at least, nothing less than the infantile—by which I mean a realm of infantile experience driven by desire, as destructive as it might be comic—that would save color from irrelevance, something no amount of black foreboding could do, laden down as it would always tend to be with heavy and brooding symbolism. If color had come to seem like art's greatest irrelevance, then it also proved a surprisingly effective means to save it from itself.

It is in this context that the color chart becomes a resource of immense resilience and possibility. Far from simply celebrating the kaleidoscopic effects of modern pleasure, the color chart lays out color in arrays both dazzling and austere, standing at the same time for modern culture's enchantments and disenchantments. This is matter-of-fact color, after all, color that is literally what it is, without symbolic or expressive baggage. As David Batchelor has put it, "The color chart is to commercial color what the color circle is to artists' colors."[4] We don't say that a certain blue in a color chart is a melancholic or sad blue: it is just blue. Color-chart color is color that is relentlessly indifferent to us. The amplitude of color as we might wish it to be may seem impoverished when so rigorously controlled by the format of the grid, yet while denying one kind of pleasure, the chart undoubtedly yields others of its own. It is not cynical, nor is it "color," in overly knowing scare quotes, but an intoxicating mix of understatement and excess. These responses coexist not as contradictions but as part of what color has become. The point is not to lament what color once was or what it might have been; instead, color becomes a means to engage critically with the very conditions that threatened its survival in the first place. From this perspective of such adverse cultural circumstances there must always be an edge of bleakness to the claim that color is miraculous.

One of the notable things about color's role in art over the past century is that the way it has been used—and perceived—has been slow to change. The vicissitudes of color, shifting between the chromatic and the achromatic, are complex and interwoven. The renunciation of color reached its highest point at the moment of Conceptualism, and the fallout from that renunciation is still with us, which has

meant that the color innovations that emerged even within Conceptual art have been largely ignored. You could say the same about Donald Judd's earlier engagement with color, like the way he used pink and red Plexiglas, which was not thought to be the most remarkable aspect of the work when it first appeared—far more the industrial materials than the ecstatically industrial colors. There were exceptions, of course, but still it has taken a long time for Judd to be recognized as one of the century's greatest colorists. Even more pointedly one could cite Marcel Duchamp's *Tu m'* (1918; plate 1), his last painting, the full chromatic impact of which was deferred until Robert Rauschenberg's artistic encounter with it in the early 1950s, when he made *Rebus* (1955; plate 8) and *Small Rebus* (1956; page 61, fig. 2). That is to say that Duchamp's massive reinvention of color waited more than thirty years to be internalized and so intimately registered in every loving and inspired touch of Rauschenberg's Combines. Let's face it: Judd's comment that "the most interesting thing about Warhol is the color" has taken a long while to register as well.[5] Far from being immediate, the historical effects of color seem on the contrary to be subject to lapses in time and, more often than not, delayed. The snail's pace of the impact of Ellsworth Kelly's work on color is a good case in point.

Kelly's color was contemporary and urban, extracted and abstracted from an observed world of heightened vividness. Certainly Kelly in Paris around 1950 could be seen as a scavenger, collecting color like any ragpicker—from a poster, a gutter, the stripes on a cabana, an advertisement. The great collection of paper fragments and drawings that he would accumulate over the years (see fig. 1) laid out, overlaid, juxtaposed, and cut out any number of made and found color samples and shapes. His interest in basic materials, like newspapers or old letterheads or exhibition invitations, not only betrays a compulsion to use everything at hand as a vehicle for drawing but is also the same impulse that had led him to buy up a stock of gummed colored papers of the kind used by children in kindergarten. From this abundance of ready-made color he made the multicolored grids that are the Spectrum series (see plates 2 and 3), as well as a host of other works, including numerous smaller collages (see plate 4). The whole process taps into an infantile impulse that can be tracked back to Dada subversions, which becomes even clearer when you think that he was actually making grids of cut-up brushstrokes at the same time (see fig. 2)—and that the squares of flat color and the squares of fragmented brushstrokes seem to mirror each other in some way. It shows how powerful Jean (Hans) Arp's model of chance was for Kelly, as well as the paper world that Arp made his art out of, now translated into vivid, contemporary color. Broken up in this way, the brushstrokes become unstable, frenetic, discontinuous—and the same could be said for the grids of plain colored squares.

The Spectrum series reaches back even further into the European avant-garde imagination to become Kelly's version of *Un Coup de dés*, a Mallarméan game of chance. As you look at the surfaces of these small colored squares, they immediately open onto an abyss. Kelly's technique was to set in play a game plan of his own devising: to assign numbers randomly to the colors in order to distribute the squares on numbered grids regardless of any preference he might have. The significance of counting extends to the titles that Kelly gave several of these works, with their deadpan notation of the numbers of squares in the dimensions. The titles only enhance the effect of a vertiginous fall into color: a simple statement of fact will immediately collapse when confronted by color like this, just as any attempt to figure out a system will surely lead to losing your footing. The more you look, the less the images look like a grid, let alone a regularly ordered grid, and the more they look like a swarm of color. The more ordered the grid looks, the more disordered it feels.

By the mid-1950s color was caught between the legacy of historical avant-gardism, represented most clearly in the United States by Josef Albers's Bauhaus system, and the possibility of a radically reconfigured serial model of art that was

Fig. 1. Ellsworth Kelly. *Tablet #64.* 1960s. Ink and pencil, 15 ½ x 21" (39.4 x 53.3 cm). The Menil Collection, Houston

already in formation. The collage techniques of both Kelly and Rauschenberg are situated precisely on that cusp, in some ways the swan song of a now-obsolete set of beliefs about color, in other ways contributing to the major structural changes that were to come: the gridlock of an expressive model ruptured by the gridlock of the color chart. And as it turns out, the more technical the grid comes to look, the less technical it actually is. Even though they come at it from different angles, both Kelly and Rauschenberg share a recognition that color works like a color swatch or sample; that is to say, it works indexically rather than symbolically or iconographically or expressively.[6] When Rauschenberg, in both versions of *Rebus*, attached a whole long line of color swatches to the horizontal midpoint of his canvas, what was he doing except making visible this certain—and ultimately seismic—shift? The whole puzzle is an elaborate choreography of readymade color as an equivalent of the other traces and fragments incorporated into the work—not least the photographs he used, which are themselves imprints of the world onto light-sensitive paper.

It is as if what Rauschenberg understood in the Duchamp—and we can even see it as a direct response to *Tu m'*, which he had recently seen at the Sidney Janis Gallery, New York—was the centrality of the color swatch, even over and above the long shadows cast by the Readymades, and the fact that everything can be accommodated to its logic. The scraps and fragments, as John Cage points out, "unfocus" attention and break up the "over-all where each part is a sample of what you find elsewhere."[7] Color, far from being decorative or added on or superfluous, is precisely what it appears: an internal measure or yardstick. That these fragments still act as a measure of distance should come as no surprise; the vivid patches and dribbles of painterly color have to be offset in some way, and the color swatches intervene to stop the possibility of reading the gesture as unmediated or impulsive. The conjunction demonstrates the sheer absurdity of the mythic spontaneity of splattered paint, posing a series of questions: What would it be to hold a color chart up to those gestural marks? How to calibrate this kind of sensibility when what had previously been taken to be raw and exhilarating energy now looks more like a set of conventions? And what if, just to add a sting in the tail, those conventions now re-emerge as if newly minted?

This is color speaking to color in about as explicit a way as you will find. The reversals and acrobatic turns that are brought into play are mirrored in the balletic movements of gymnasts in a photograph embedded along the horizontal axis of *Small Rebus*. The most poignant of these switches is the way a family photograph relates to the color swatches. Supposedly one is "personal" and the other "impersonal," but of course from the point of view of the spectator these qualities are completely reversed. Nothing makes figures in old photographs seem more like strangers than to insert them into an artwork; rather than make them closer, this is a sure way to make them seem distant. Here, on the other hand, the color swatches, which are apparently indifferent to us, become the trigger for a strange kind of intimacy. And the connection between the color sample and the photograph, as two sides of the same coin, is the most intimate that *Rebus* sets up, demonstrating it not just once but twice in the work's two versions, as if to insist on it. A color swatch is as much like a photograph as a photograph is like a color swatch: a sample, a square or rectangle, a self-contained fragment, standard-size, and so on.

When Gerhard Richter came to make his Color Chart paintings in the mid-1960s (see plate 28), it was in response, he said, not to contemporary developments within abstraction but to Pop and to Andy Warhol in particular.[8] He started out basing the paintings on sample cards, a format that allowed a grid of color to compete with dance-step diagrams and paintings-by-number as an instrument of the blankest indifference, all the more so because of the privileged place color has traditionally occupied in the rhetoric of expression. The fact that they start out as pictures *of* a color chart gives them what Benjamin Buchloh has called "their ironic

Fig. 2. Ellsworth Kelly. *Brushstrokes Cut into Forty-Nine Squares and Arranged by Chance.* 1951. Ink and collage, 13 ¾ x 14" (34.9 x 35.6 cm). The Museum of Modern Art, New York. Purchased with funds given by Agnes Gund

ambivalence."[9] The second group, produced in the early 1970s (see plate 29), elaborated on the basic serial format, taking the three primaries and progressively mixing them. Both series were closely related to the other generic types of painting Richter was producing at the same time, like the black-and-white paintings after photographs or, later, the gray paintings as well as the "artificial jungles," in which he mixed and blended the colors instead of keeping them separate. He said that what he wanted to achieve in all of these paintings was a "beautiful meaninglessness."[10]

However large the Color Chart paintings, they are always incomplete in the sense that a color chart never contains every possible color variation, only ever a selection made according to certain decisions and choices. No one shows more powerfully than Richter that the color chart, with its modular grid of identical-sized units, only seems to be about a strict repetition of the same but is really about maximum differentiation. Of course the one cannot exist without the other. In fact the samples are only a selection made by the artist from the enormous range of available colors, which itself is surely only a sample of the even greater range of possible colors. There are an infinite number of potential colors, from which even the largest is only a minuscule and partial selection. Richter insists, countering assumptions that we may have about the deadpan literalness of ready-made color, that the Color Chart paintings reach for "the boundless, the meaningless, in which I place so much hope."[11] This sounds more sublime than banal, but the point must be that it is not a question of one or the other but of a boundlessness that can only be represented through something as seemingly indifferent as the color chart.

To make a thing of "beautiful meaninglessness" is a feat of the imagination. It has to be worked for, despite the given format of the color chart itself. The number of permutations and variations Richter devises—all the different sizes, the vertical or horizontal formats, some with wider white vertical bars dividing the colors, others with the colors more closely stacked—suggests that the color chart offers him a remarkably elastic template to work with, suggests even that the more rigid the control of the grid, the more variable what goes on within it. A precarious balance is struck between control and chance. The colors were chosen at random and meticulously painted in gloss paint by the artist himself, with a team of assistants on the larger works (page 91, fig. 3); the height of the small rectangles is half the width, and no colors repeat. Yet the effect of all this, however mechanical it looks to the eye, is to increase the effects of chance. Rather than formulaic, it is open-ended and serial—in theory it could extend indefinitely. Richter describes it as analogous to "the generation of a thing through blind, random motor activity."[12] Although the Color Chart paintings negate—and effectively defeat—the possibility of a metaphorics of painting, they are also generative of a new way of thinking about the activity of painting.

To place hope in meaninglessness is to look to a future rather than merely back at a past. Not only has the color chart, in Richter's hands, been torn from the grip of rationalization, it has also been prized from the mnemonic structure that underpinned Rauschenberg and Kelly's collage aesthetic, however extreme the limits to which they pushed it. For Richter the temporality of the color chart is radically transformed. When he reflects that "if I had painted all the possible permutations, light would have taken more than 400 billion years to travel from the first painting to the last," he is talking about a kind of duration that stretches out into infinity.[13] Rather than an additive model based in collage, the kinds of multiplications involved here become nothing short of mind-boggling, both spatially and temporally. And even though from a certain point of view all color charts must, as I have suggested, be a reduction, Richter's paintings, even the smaller ones, make it a ground for proliferation. This is a concertina effect, through which even a strip of monochromatic grays will turn one color into many shades of one color.

At work here is not pure color as such but color as pure difference, stretched out to infinity. This could have so easily gone in the direction of the sublime, risk-

Fig. 3. Hélio Oiticica. *Invention No. 4*. 1959–62. Oil and resin mixtures on wood fiberboard, 11 ¾ x 11 ¾" (30 x 30 cm). César and Claudio Oiticica Collection, Rio de Janeiro

ing yet resisting the leap into immateriality, but instead the color chart locates color in commerce, links it irrevocably to trade, to the workshop, to the car salesroom, to the hardware store. The nod in the direction of Pop is simply a recognition of the mass matrix of color. Blinky Palermo's *Stoffbilder* (see plates 31 and 32) are paintings made out of cotton fabric bought from a department store. Flat and textureless, the bands of colored material echo Mark Rothko's classic format in only the broadest terms, missing what is most crucial in that type of painting: the complex furrows and edges filled with painted incident in between the bands. Instead of a world of nuance, of fine splatterings, of indeterminacy in those edges, ready-made color offers a way of being outside this kind of aesthetic decision-making. Palermo kept on making the *Stoffbilder*, in lots of different color combinations, as if mass-producing them. Both Palermo and Richter shared a desire to tread the fine line between art color and commodified color. They took the same risk: that art will simply come to reflect or mimic the kaleidoscopic miracle that is modern consumption. The real miracle is that their work does not do so, although part of its critical edge is how close it comes. It is always a near thing that color fetishism does not simply substitute for commodity fetishism, to the point where at times it seems as if the friction between them becomes a condition of color's survival as a transgressive medium.

Richter was not alone in dismissing Albers's color theory, saying that the effectiveness of his Color Chart paintings was that they were directed against the cultish religiosity associated with Albers and the neo-Constructivists.[14] But I think the problem many artists of that generation had with Albers's kind of color was not that it was too fetishistic but that it was not fetishistic enough. It seemed to be under the spell not of color but instead of the ideal system and the quasi-scientific rhetoric, the kind of discourse that seemed like an exhausted hangover from Bauhaus aesthetics. In the European context, at least, Lucio Fontana had brought color into the world of ersatz modern culture far more effectively (and Richter noted that the two artists who had the most impact on him at the 1959 Documenta were Fontana and Jackson Pollock). No doubt the 1960s generation of artists was unconvinced by what felt like the tired orthodoxies of Albers's color theory, but in retrospect this seems to sell Albers short. Alongside the didacticism there was something provisional and inventive in the exercises he used in his teaching, in his insistence that color is relational, in his interest, as he put it, in the intervals between colors, and in the odd mixture of the modest scale of his paintings with his obsessive overproduction (he made more than a thousand of them). The paintings are positioned oddly between theoretical objects and art objects in a way that is more interesting now, rather than less. Once we accept that color theory is not an article of faith, the effects of color can seem more open. In Brazil in the 1950s, for example, Hélio Oiticica built a radically experimental color project precisely out of the legacy of Constructivism rather than against it, pushing color to new limits in a culture, as the critic Mario Pedrosa memorably put it, "condemned to modernity." Pedrosa could see in Albers's Homage to the Square series "an unheard-of lived experience."[15] It was the sheer extremity rather than the rational ideal of the system that could play out in Oiticica's own meticulous and laborious pursuit of chromatic ecstasy. Every shift in tone in the yellows and oranges and reds of his Invention of Color series (see fig. 3), each panel differently textured and comprising at least two colors, has the cumulative effect of increasing volatility despite the standard monochrome format.

The history of color is intimately bound up with the history of chance as it had been articulated within modernism by Stéphane Mallarmé through Cage and Samuel Beckett. One of the most frequent points of connection has been between colors and numbers. Counting and coloring—from painting by numbers (see plates 10 and 11) to counting the numbers of squares in a color chart—intertwine at some basic level that is not about the math. There is no mathematical relation-

ship between numbers and colors (unlike between numbers and musical notes in harmonics, for example), only an elaborate and vast sea of numbers that have been invented to create a fictional system. Like the color chart, numerical sequences offer ready-made serial systems for encoding information, and so it is not surprising that the combination should come to occupy such a prominent place in the artistic imagination by the mid-1960s. Once a numerical system was set out, the accidental and random effects of matching and mismatching color could very quickly come into play. The nicely "dumb" effect of what seems like the most elementary listing of colors belies the elaborate scrambling of serial and sensual that is the experience of much of this work—not because the sensual and the serial are opposites but precisely because they are not.

Jasper Johns had already shown how easily numbers slipped into alphabets and into body parts and into colors. Following his example, in the late 1950s Ed Ruscha had done a series of very small works on paper in which he took on the orthodoxies of what he saw as art-school color, which "was giant brushstrokes, it was color splashing."[16] He reduced color splashing to a few small splats on notebook paper (fig. 4), using dyes instead of paints so they splashed well. The process was repetitive and mechanical. This is familiar ground, a way of thinking your way out of gestural painting, and Ruscha had obviously looked very hard at Johns and Rauschenberg. But selecting colors still seemed like an aesthetic choice. When Ruscha started making food prints in the late 1960s, what he liked about the process was precisely that he didn't have to make a choice: "Hey, I had no choice in the selection of color for the food prints—how do you alter the color of caviar or axle grease?"[17] For the substances contained within his *Stains* portfolio, of 1969 (see plate 51), he simply listed the name of the product and its make, beginning with "Los Angeles Tap Water" and running through most everything he might find in his kitchen and bathroom cupboards as well as his garage—from "Nail Enamel (L'Oreal Coffee Caramel)" to glue to bacon grease to egg yolk to Worcestershire sauce to urine to blood. This is not all about color, but sometimes colors appear on the list, like "Pepper (Yellow)," but only in the same descriptive spirit as "Apple Juice (Tree Top Pure)" or "Sperm (Human)."

What is the pleasure in all of this—for surely there is pleasure in this work of negation? To be able to say something about this is to say something about color by a side door, which is perhaps ultimately the best way to approach it. In part it is the rampant absurdity of the carnivalesque slippage between the natural and the artificial, the organic and the inorganic, and in part the ridiculous extravagance of the nil color of a clear liquid like water or bleach on a white page. You can't tell, of course, which are the natural colors and which are the chemical ones from the way they look. Warhol's color might, for Roland Barthes, have looked "chemical," and Ruscha's actually are chemicals.[18] They look delicate and fragile, but they might be toxic. Although all paint has a chemistry, here chemical color goes hand in hand with lethal transparency. Initially it is tempting to think that a language of "hot" and "cool" colors, as well as the clichés of hot colors as sexy and cool colors as detached, should reflect a thermometer of desire. In practice, the possibilities of corrosive beauty and benign repugnance are much more intensely evocative of desire and the anxieties that attach to it. That intensity comes to focus on the idea of color as leftover, perhaps all the more so because traditionally color is so caught up in the discourse of the artwork's origination. Think, for example, of the delicate stains of Morris Louis, enacting the coming-into-being of painting itself. On the other hand, the aesthetic possibilities of residual waste that continue to preoccupy artists connect directly to color's historical capacity to pervert itself.

In this context color samples and color leftovers suddenly come into a greater proximity to each other than they normally would, making distinctions between newness and oldness count for little. And what also becomes clear is that it is the sample book as much as the color chart that defines the new attitude to color.

Sample books offer a prehistory to the modern color chart and at the same time represent something archaic already present in it. The slightly absurd gothic brocade of the box containing Ruscha's stains is not quite the kind of sample book I mean, but it nonetheless suggests an antiquated throwback that is still present in more modern ordering systems. Rather than the color wheel, which is, strictly speaking, the color chart's most direct precursor, or the palette, which is its earlier studio incarnation, there is something about the sample book that is much more fundamental: its origin in commerce. Wonder is no stranger to the enchantments of the sample. For example, W. G. Sebald, in his novel *The Rings of Saturn*, marvels at the pattern books of Norwich weavers in the early nineteenth century, listing the wondrous fabrics from silk brocades to bombazines "of a truly fabulous variety, and of an iridescent, quite indescribable beauty as if they had been produced by Nature itself, like the plumage of birds."[19] At one level this is obviously much closer to an older model of art. It sounds much more like Denis Diderot in his wonderfully titled essay "My Feeble Ideas about Color," writing of the true artist "pulling from the stuff of creation—birds and coloristic nuances and their plumage," than the modern color chart.[20] And yet the residual effects of the commercial sample book betray some of the infantile pleasures that still attach to the industrial grid, like Alighiero Boetti's sample card of materials sent out as an invitation to a gallery show he had in Turin in 1967 (page 108, fig. 1). The hardware store is not only a repository of relics-in-the-making but also of tactile experience.

When I was thinking about how to write this essay, I talked to my father, an old architect, who at ninety-four has lived most of the last century. He told me he had kept his sample books of British Standard Colours.[21] He got them from a dusty garage; the cobwebs needed to be blown off. He talked about the colors with love: 4056, 9098, the numbers standing in for the colors, as I remember them from my own childhood. He—and so we—used only the numbers to describe them, never the names. These were the colors our house was painted in, the colors that defined a wall or an alcove against all the white and brick and glass. The house, a small modernist utopia, is still partly painted in 4050. This is a man who would not have kept his love letters but who kept his color samples, and the intimacy of those numbers is remarkable to me now, as it was then. I realize that it is hard for this not to sound overly personal and autobiographical—precisely what we might assume color-chart color resists. My point is not to be nostalgic but to suggest that there is no reason why it should be exempt from—and on the contrary has every reason to play out and work through—an infantile terrain of separations and pleasures. Just because the color chart is rooted in a desire to rationalize and standardize, it does not follow that its aesthetic effects are either rational or standard.

Technologies of color and fantasies of infantile experience are not necessarily mutually exclusive. Didn't Yves Klein start out in 1954 with a sort of sample book (plate 6), albeit one meant to advertise himself rather than the colors? A number of "monochromes" were fixed to the leaves of luxury paper in an expensive-looking edition. This seems eccentric, correlating with little else in the early 1950s, and precocious, which is precisely the persona that Klein projects. Ruscha's *Stains* or On Kawara's diary of the daily process of producing his date paintings (see plates 33–36) could not be more different—the self-erasure of those works starkly contrasting with Klein's rampant self-promotion. Yet there is something extravagant in the basic logic at stake here that does connect. Klein made it his business to name, under each monochrome-colored panel, the place he was in—Tokyo, London— advertising his international movements with not a little of the tone of a Jules Verne fantasy: around the world in so many colors. The model of the sample book invites this kind of dispersal of color through many variations. It seems to play out precisely the kinds of regressions that I have been suggesting, here in a rampant exploration not so much of the world as of Klein's own narcissism.[22] His self-celebration smacks uncomfortably of the art-world show-off (in which he was

Fig. 4. Ed Ruscha. *Sweetwater.* 1959. Ink and letterpress on paper, 22 ½ x 17 ½" (57.2 x 44.5 cm). Private collection

ahead of his time). This could not be more different from the critical self-efface-
ment of artists like Kawara and Boetti, but the underlying logic of dispersal and dif-
ferentiation through color in their work is not unlike Klein's—although of course it
is precisely this that he will abandon by 1957 in favor of IKB, his own branded color
blue. Kawara, at least for the first few years, included photographs of the cities in
which he found himself and where he made his date paintings. Each monochrome
panel was painted a different color, with the date painted at the center in the identi-
cal place and accompanied by a photograph. The apparent simplicity of a Kawara
painting works on all these levels: a now-almost-residual relationship to a photo-
graph, a temporal relation to a particular day, a chromatic relation to place and date.
The more rigorously the format is maintained—so much so in Kawara's case that
he could eventually dispose of the photographs, which had become superfluous—
the more pronounced the possibilities of endless chromatic differentiation. This
now spreads temporally, as if you could imagine a color chart in which dispersal is
not just through space but also through time.

Commercial trade names expand color's geography beyond that suggested by
traditional artist's colors like Raw Sienna or Burnt Umber (so called because it came
from Umbria). In a series of monochromes that Boetti began in 1967 (see plates
37–43), he painted each a single color and placed its name dead center in raised
letters: Saratoga White, Sahara Beige, Cannes Blue. The names and the colors are
taken from color charts produced by the automobile industry; they are the hard,
modern, glossy, urban colors—car and motorbike colors—then in production in
the Turin-based factories of Fiat, Maserati, and Ferrari. In a move that draws on
the historical example of Piero Manzoni's synthetic white Achromes (1957–63),
Boetti combines the fantastic with the everyday, linking the often clichéd invocation
of foreign places with the equally exotic dart of a Vespa flashing by on a street. In
the sheer simplicity of a monochrome panel with a color name written across it, an
imaginative world of teeming and fragmentary thoughts opens up. The tighter the
tautological knot, it seems, the wider the geographical reach and the more absurd
the dispersal of the names of places. Boetti set into motion a game of multiplica-
tion—of both sense and distance.[23] The color chart provides its own atlas, just as
world atlases have traditionally defined nation states and their politics of power and
colonization through color. The point is not just the geographical distances but the
leaps and expanses traveled in a mental atlas, the sudden proximity between unlike
things and places and colors. There is a kind of frenetic mobility that is exacerbated
by the proliferation of the works (Boetti made more than fifty), the full impact of
which is seen in both the literal and mental spaces between them as much as, or
even more than, in each one.

If matching colors is a central function of the color chart, then Boetti uses it
to set up a game of mismatching. Rather than specifying a color with precision, the
artist lets confusing signals blur what seems to be a concise proposition. There is
one panel spray-painted in a metallic green with the name "Ascot Green" (Verde
Ascot) in raised letters across it (c. 1968; plate 38). Colors are hard to describe; is
this a greenish blue or a bluish green? Language struggles to be specific. Color
names are handy after all, short-circuiting the imprecision of the in-between, iden-
tifying the "ish" colors. But there is something in the palpable effect of the color
that will also always escape the generic name, whether it is the name of a commer-
cial color or a hand-mixed artist's color. Specifications can never be specific enough
to be adequate to experience, and the more readymade and standard the color,
the more impressive the gulf between that readymadeness and the anything-but-
readymadeness of experience's multiple and contradictory effects. One of the most
striking mismatchings to emerge is between color in general and color in particular,
in the difference between the ish-ness of color and the is-ness of color.

Boetti, like many other artists in thrall to the color chart, may have chosen not
to mix his paints but mixed in other things, like language. The color names he uses

Contrary to what has been said about me, Mondrian and Matisse did not interest me when I was in Paris. Mondrian could not be seen in Paris and when I did see [his paintings] in Holland in 1963, I thought their structure too rigid and intellectual.

—Ellsworth Kelly, 1969[1]

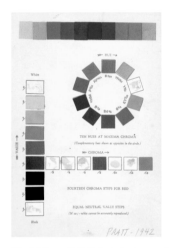

Fig. 1. Ellsworth Kelly's student copy of the *Munsell Book of Color,* c. 1942. Kelly arranged the row of colored squares across the top, independent of the book's color exercises.

Ellsworth Kelly's *Colors for a Large Wall* (1951; plate 5) appears to be a fully self-evident work, a masterpiece whose narrative begins and ends with its square grid of sixty-four individual monochrome panels. On the contrary, however, it represents the culmination of a long adventure begun in Paris in early 1951 and continuing in Sanary, in the south of France, at the end of that year. For several months in Paris, Kelly had immersed himself in creating a suite of eight large collages, each titled *Spectrum Colors Arranged by Chance* (1951; plates 2 and 3). They were composed of hundreds of small squares of colored paper distributed across a supporting sheet in predetermined patterns, with the placement of individual colors assigned randomly. *Colors for a Large Wall* is based on an eight-by-eight-inch collage made with thirty-six colored squares left over from that ambitious project (1951; plate 4).

The bold means used in all of these works—chance operation, ready-made color—were instrumental to Kelly's invention of himself as an artist during those years in Paris. He was well versed in color theory; it was only six years earlier, at Pratt Institute in Brooklyn, that he had been trained in Albert Munsell's color system (fig. 1). Yet his decision to go to Paris in 1948 was a decision to leave that and the rest of his education behind. To qualify for funds from the G. I. Bill of Rights, Kelly enrolled at the Ecole des Beaux-Arts, but he rarely attended class. His allergy to dogma also distanced him from the geometric abstraction of the Salon des Réalités Nouvelles, the dominant artistic force in postwar Paris. Kelly needed new masters and found them in artists who advocated the use of chance rather than relational rules and deliberated composition. In Paris he struck up friendships with John Cage and Jean (Hans) Arp, both of whom provided liberating inspiration in their unorthodox methodologies for finding and making art.[2]

The Spectrum collages were made with the French colored papers that Kelly had been working with during the previous year.[3] The front of the sheets was bright and glossy, and the back was gummed for adhesion. Kelly was delighted by his fortuitous discovery of these papers at a local art-supply store, and he purchased a wide variety of colors. He initiated the Spectrum project when he realized that his collages and paintings primarily juxtaposed a single color with white; he decided he "wanted to find out about color" anew.[4]

"Canned chance," a phrase from one of Marcel Duchamp's fragmentary notes from the 1910s, aptly describes Kelly's approach to these works.[5] The first one was based directly on his painting *Seine* (1950); like the painting, the collage suggests a shimmering reflection on the water. Subsequent collages all featured distinct mathematical systems for the distribution of squares in the composition. Each enabled the mapping of the numbers one through eighteen onto the hundreds of square

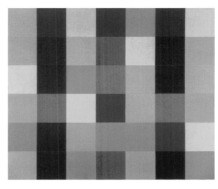

Fig. 2. Ellsworth Kelly. *Sanary.* 1952. Oil on wood,
51 ½ x 60" (130.8 x 152.4 cm). Dallas Museum of Art.
Marguerite and Robert Hoffman Collection in honor
of Dr. John R. Lane

units Kelly had outlined on the supporting sheet of paper. After randomly assigning numbers to the eighteen colors that comprised his palette, he went about gluing the colored squares onto the places dictated by their numbers. He worked with one color at a time, filling all the squares for each number before going on to the next, so that the overall result would remain a mystery until the end. Using this process he created eight collages, the first a horizontal rectangle and the others approximately 3 feet square (except for the eighth, which is slightly larger at 44 by 44 inches).[6] The first three collages are on a white ground, the next three are on a black ground, and the last two have no black or white exposed at all.

When Kelly left Paris to join friends in Sanary, in November 1951, he brought along the leftover squares in an envelope. Shortly after his arrival he used them to make two collages: first what was to become a study for *Sanary* (fig. 2), and then *Colors for a Large Wall* (plate 4). For the latter, he penciled a grid of sixty-four units, a structure he chose for its chessboard-like neutrality, onto a sheet of paper and arrayed the squares "very, very quickly, without thinking." Because only thirty-six colored squares remained, twenty-eight spaces remained empty and white.[7] Each row has three to six colors, with several repeating (black appears ten times), although squares of the same color are never adjacent.

Kelly's great gambit was to convert this tiny collage into the largest painting he had yet made, with the square-inch papers translated into square-foot canvases painted with oils to match the paper colors. He had not intended the collages to be studies for paintings, and the 64-unit one, in particular, perplexed him. After he made the collage, it was several days before he decided to ask the cabinetmaker who worked downstairs to make him sixty-four stretchers. The resulting painting's modular format—a grid of individual paintings comprising a whole (plate 5)—was an extraordinarily bold innovation, yet it was in part a practical decision: Kelly did not have the means to store or ship a large-scale canvas.

Kelly's move to such a large painting was based on his ambition to invent a public art for the modern era. More than a year earlier he had written to Cage:

> My collages are only ideas for things much larger—things to cover walls. In fact all the things I've done I would like to see much larger. I am not interested in painting as it has been accepted for so long—to hang on the walls of houses as pictures. To hell with pictures—they should be the wall—even better—on the outside wall—of large buildings.[8]

The same month he made *Colors for a Large Wall*, he applied to the Guggenheim Foundation for a grant to produce a small book he called *Line Form Color* (its mock-up employed the same gummed papers found in the Spectrum collages). The book, he said, would "be an alphabet of plastic pictorial elements, aiming to establish a new scale of painting, a closer contact between the artist and the wall, providing a way for painting to accompany modern architecture."[9] The statement spoke less to the book, which the foundation declined to sponsor, than to *Colors for a Large Wall*, the painting that laid out the path for the artist's future. Kelly considered it his *Demoiselles d'Avignon*, a pivotal work in his oeuvre.[10] The painting was both the culmination of his close involvement with chance procedure and ready-made materials and the point of departure for his ongoing exploration of color and form in the following decades. —A.T.

2. Ellsworth Kelly
Spectrum Colors Arranged by Chance II. 1951
Cut-and-pasted color-coated paper and pencil on
four sheets of paper
Overall: 38 ¼ x 38 ¼" (97.2 x 97.2 cm)
The Museum of Modern Art, New York. Purchased
with funds given by Jo Carole and Ronald S. Lauder

3. Ellsworth Kelly

Spectrum Colors Arranged by Chance III. 1951

Collage on paper

39 x 39" (99 x 99 cm)

Private collection

4. Ellsworth Kelly
Study for *Colors for a Large Wall*. 1951
Collage
7 ⅞ x 7 ¾" (20 x 19.7 cm)
Private collection

5. Ellsworth Kelly

Colors for a Large Wall. 1951

Oil on canvas on sixty-four wood panels

7' 10 ½" x 7' 10 ½" (240 x 240 cm)

The Museum of Modern Art, New York. Gift of the artist

I espoused the cause of pure color, which had been invaded by guile, occupied and oppressed in cowardly fashion by line and its manifestation: drawing in Art. I aimed to defend and deliver it, and lead it to triumph and final glory. —Yves Klein, 1956[1]

Fig. 1. Yves Klein and Harry Shunk.
Yves Klein's Leap into the Void. 1960.
Gelatin silver print, 13 ¹¹⁄₁₆ x 10 ⅞"
(34.8 x 27.6 cm). Private collection

Yves: Peintures, a small booklet that Yves Klein produced in 1954, at the age of twenty-six, places commercial colored paper at the service of an audacious art prank. The booklet, subtitled "10 Planches en couleurs," presents ten horizontal rectangles of thin, colored paper, each glued onto a page of heavy white paper approximately 9 ½ by 7 ½ inches. The rectangles come in a few different sizes and in varying degrees of matte and glossy finish. The format does much to lead one to believe that this portfolio reproduces untitled paintings by the artist "Yves": the tipped-in "plates" centered on the page, the legends below naming "Yves" as the artist and indicating a city, a year (between 1950 and 1954), and dimensions. Nevertheless, a reader would have sound cause for suspicion. The booklet is unbound and oddly unanchored, lacking not only a last name for the artist and titles for the paintings, but also any indication of a sponsoring fine art gallery or publishing house. Stranger still, the customary catalogue preface in support of the artist here takes the form of three pages of empty ruled lines signed at the end by "Pascal Claude." In fact, the absence of text mirrored an absence of paintings: the paintings that were supposedly reproduced by the colored sheets existed only in Klein's imagination.[2]

Klein and his friend Claude Pascal made *Yves: Peintures* in Madrid, using the printing shop of a friend's father and funds from Klein's aunt. The colophon explains in French that the booklet was printed on the presses of the master printer Fernando Franco de Sarabia at Jaen 1, Madrid, on November 18, 1954, in 150 numbered copies and asserts "All rights reserved for all countries. Copyright by the author."[3] The cities named in the captions—London, Paris, Tokyo, and Madrid—accurately chronicled the peripatetic existence of Klein, the son of two artists, over the last few years. During several years primarily devoted to judo rather than art, he had experimented with monochrome painting, although never at the sustained rate or scale suggested by *Yves: Peintures.*[4] In November 1954 Klein made his final move back to Paris, where he immediately used the booklet to introduce himself to other artists and art-world personalities. And he retroactively fulfilled its promise: some months later he would have a show of actual monochrome paintings (also titled *Yves: Peintures*), and by 1957 he would have achieved fame as Yves le Monochrome.

What to make of this venture, the visual equivalent of a fraudulent résumé, on the part of a young artist new in town? As a simple prank the booklet would not continue to fascinate. What is compelling, however, is that the problematic ambiguities of *Yves: Peintures* look forward with uncanny precision to the deep contradictions of Klein's brief (he died of a heart attack in 1962) but intense and prolific career. Whereas he made grand, mythologizing claims for himself and his work,

RÉCOLTE DE LA TOMATE PAR DES CARDINAUX APOPLECTIQUES
AU BORD DE LA MER ROUGE
(Effet d'aurore boréale)

Fig. 2. Alphonse Allais. *Apoplectic Cardinals Harvesting Tomatoes at the Red Sea.* Plate 19 from Allais, *Album Primo-Avrilesque*, Paris: P. Ollendorff, 1897, facsimile reprint Paris: Bellenand, 1962

Fig. 3. Yves Klein. *Blue Monochrome.* 1961. Dry pigment in synthetic polymer medium on cotton over plywood, 6' 4 ⅞" x 55 ⅛" (195.1 x 140 cm). The Museum of Modern Art, New York. The Sidney and Harriet Janis Collection

he also conspicuously undercut those claims, whether by the preposterous quality of his own prose, the pretentious officialism of the patent for International Klein Blue paint, or the sheer absurdity of his 1960 *Leap into the Void* (fig. 1; like the paintings in *Yves: Peintures*, a work existing only in the form of a supporting document). The author of *Yves: Peintures* was not acting in a purely satirical fashion, as were the nineteenth-century French cartoonists who mocked the modern art of the Salons with sketches of monochromes justified by ridiculous captions (a red rectangle was "apoplectic cardinals harvesting tomatoes at the Red Sea"; fig. 2). But neither was he sincere in traditional modernist terms, as any creativity or spirituality for which the monochromes might have been a vehicle resided in a few cents' worth of colored paper.

Yves: Peintures is a chapter of a history of what might be called "found monochromes," which transpose the tradition of the readymade with that of monochrome painting (fig. 3). Found monochromes pointedly question the much-vaunted metaphysical element of the monochrome tradition. What is the difference between a rectangle of colored paper or some grains of pigment and an aesthetically fulfilling object? What is the spiritual content of a monochrome, and where does it reside? In the color? In the texture? In the gesture? In the soul of the artist as it is somehow infused in the work? In the wishful expectations of the spectator? These are questions that Klein's work continues to ask as it reveals the unexamined assumptions underlying the purported value and power of abstract art. —*A.T.*

6. Yves Klein

Yves: Peintures. 1954

Printed and collaged paper

Each sheet: 9 ⅝ x 7 ¹¹⁄₁₆" (24.5 x 19.5 cm)

Menil Collection, Houston

YVES - MADRID, 1954

YVES A TOKIO, 1953 (DELUX)

YVES A PARIS, 1955 (DELUX)

YVES A PARIS, 1955 (DELUX)

YVES A TOKIO, 1955 (DELUX)

YVES A LONDRES, 1955 (DELUX)

Cette édition illustrée de
10 planches en couleurs
a été achevée d'imprimer
sur les presses du maître
imprimeur Fernando
Franco de Sarabia à Ma-
drid, Juan, 1, le 18 novem-
bre 1954.

Il a été tiré cent cinquante
exemplaires numérotés
de 1 à 150.

EXEMPLAIRE N.°

Tous droits réservés pour tous pays

PROPRIÉTÉ DE L'AUTEUR

My choice of colors evolved in a manner similar to the way I found geometric elements (lines, squares, circles . . .); it was a very natural process. This was the decisive criterion: each and every element used must be defined in a way that is precise, simple, and obvious (to common sense). —François Morellet, 1999[1]

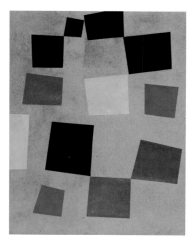

Fig. 1. Jean (Hans) Arp. *Squares Arranged According to the Laws of Chance*. 1917. Cut and pasted paper, ink, gouache, and bronze paint on colored paper, 13 ⅛ x 10 ¼" (35.2 x 25.9 cm). The Museum of Modern Art, New York. Gift of Philip Johnson

The creation of *Random Distribution of 40,000 Squares Using the Odd and Even Numbers of a Telephone Directory* (1960; plate 7) was a family affair. Over the course of several evenings in 1960, after returning home from his office, François Morellet enlisted his wife, Danielle, and his eldest son, Frédéric, to read him numbers out of the phone book in the town of Cholet, France, where they lived.[2] (They skipped the identical two-digit prefix for each number.) Starting from the beginning of the book, they read him nearly seven thousand phone numbers—about forty thousand digits. As they read, Morellet marked the results on a canvas he had prepared with a grid: "On a surface of one meter by one meter, I painted 200 horizontal and 200 vertical lines, creating 40,000 squares with a 5 millimeter length of side."[3] Working steadily from left to right, Morellet marked a square with a cross for each even number that Danielle and Frédéric read, and left a square blank for each odd number. Then he painted all the crossed squares blue and the blank squares red, switching paints from blue to red and back as he went, rather than completing all of one color at once, and then all of the other.[4]

That Morellet used impersonal criteria to determine the placement of red and blue in *Random Distribution* is characteristic of his artistic oeuvre. In the early 1950s, years before American Conceptual artists like Sol LeWitt began their self-reflexive analyses of the foundations of art, Morellet was working in France with strategies of system and chance to create paintings that challenged the compositional arrangements of artists who had preceded him:

> A system for me is like a rule or a very concrete game which exists before the actual work and thereby determines its development and execution. I chose this term because it describes an attitude which I highly value, that of artists who do not identify with what they are creating. The system makes it possible to have fewer subjective decisions and to give the work itself the opportunity to present itself to the viewer.[5]

Jean (Hans) Arp's Squares Arranged According to the Laws of Chance collages (see fig. 1), begun in 1915, were inspirational models for Morellet, who was striving to remove any mark of subjectivity from his own paintings, and were direct precedents for works such as *Random Distribution*.[6] As Arp did for his collages, Morellet has frequently assigned his paintings straightforward and descriptive titles that bluntly state the geometric shapes or colors within, such as *32 Rectangles* (1953; fig. 2). But behind this apparent simplicity, Morellet shows us, lies the possibility for endless variation: in how many ways can an artist arrange thirty-two rectangles?

Fig. 2. François Morellet. *32 Rectangles.* 1953. Oil on wood, 31 ½ x 31 ½" (80 x 80 cm). Collection Lenz Schönberg, Munich

Random Distribution was the culmination of several years' thought about color and demonstrates Morellet's intellectual engagement with a specifically Parisian artistic trajectory. Morellet and Ellsworth Kelly, then working in France, were introduced to each other in 1952.[7] Both artists were using chance mechanisms as an organizational principle for colors on a grid. In the 1950s both artists were also creating works—such as Kelly's *Red Yellow Blue White* (1952; page 97, fig. 3) and Morellet's *Blue, Yellow, Red* (1956)—that repeatedly tested different arrangements of the primary colors, evincing the skepticism that the artists felt toward the possibility of ideal composition. Morellet found Piet Mondrian's utopian Neo-Plasticism both inspirational and deplorable when he first saw an example of it, reproduced in a book, in 1952. "The first encounter went very badly," he recalled. "I was shocked, dumbfounded by the simplicity of the work, which I saw to be a deliberate provocation. . . . I felt forced, however, to open the book occasionally while passing by, if only to vent my anger. This took at least ten times and ten days . . . before I was convinced, conquered, overwhelmed."[8] Morellet adopted the simple geometric forms and basic colors of Neo-Plasticism but not the ideal of universality in which Mondrian situated his practice.

Humor is integral to Morellet's art, unlike Mondrian's and Kelly's, as the absurdist and openly proclaimed justification for color in *Random Distribution* reveals. That he has mined the local phone book for its colors shows that there is a treasure trove of chromatic strategies in every household. —*N.L.*

7. François Morellet
Random Distribution of 40,000 Squares Using the Odd
and Even Numbers of a Telephone Directory. 1960
Oil on canvas
40 9/16 x 40 9/16" (103 x 103 cm)
Collection Danielle and François Morellet

At that time surplus paint fit my budget very well. It was like ten cents for a quart can downtown, because nobody knew what color it was. I would just go and buy a whole mass of paint, and the only organization, choice, or discipline was that I had to use some of all of it and I wouldn't buy any more paint until I'd used that up. —Robert Rauschenberg, 1970[1]

Fig. 1. Robert Rauschenberg. *Collection.* 1954. Oil, paper, fabric, wood, and metal on canvas, 6' 8" x 8' x 3 ½" (203.2 x 243.8 x 8.9 cm). San Francisco Museum of Modern Art. Gift of Harry W. and Mary Margaret Anderson

Robert Rauschenberg's habit of buying unlabeled paint for his Combine paintings of the mid- to late 1950s certainly stemmed in part, as he said, from budgetary constraints. But it was also true that his artistic viewpoint did not afford him the luxury of intentionally selecting colors. He had attempted that in the early 1950s and, he felt, failed. In first the White paintings, and then, successively, in the Black, gold-leaf, dirt, and Red paintings, Rauschenberg had believed the color sufficiently uninteresting to protect the paintings from being read in symbolic or expressionist terms, but the critics of the time proved him mistaken.[2] So, by nature resourceful, he went in the opposite direction and embraced any and all colors.

To describe the appearance of the Combine paintings, Rauschenberg coined the term "pedestrian color," which denoted "a general no-color" created by throngs of people in a street, with no one color standing out despite the great variety of clothing, objects, and surroundings.[3] This approach to color matched the resolutely urban character that his work had assumed by the end of 1954. The early Combines featured an unbridled heterogeneity that created juxtapositions on the canvas as unlikely and yet as normal as those found in any one downtown block. The remaindered paints were as random and unprecious as the salvaged news clippings, art reproductions, photographs, children's drawings, and objects with which he populated the works. As John Cage remarked, "Beauty is now underfoot wherever we take the trouble to look."[4]

Rauschenberg and Cage's attitude was profoundly democratic in spirit. No image, object, or color was inherently better than another, and all were allowed to coexist in a painting at an equal level. Heterogeneity had an ethical value over and above uniformity or hierarchy. Rauschenberg was operating at the opposite pole of Josef Albers's notion of colors having roles to fill, jobs to perform. "I didn't want painting to be simply an act of employing one color to do something to another color," he said, "like using red to intensify green, because that would imply some subordination of red."[5] Similarly, directing a viewer's focus to one spot or another, or sending the gaze from one area to another, was uncomfortably authoritarian. The painting's freedom translated into the viewer's own.

Such a freedom is strongly felt in *Rebus* (1955; plate 8), a three-part painting made on studio drop cloths and later mounted on canvas. Description of the painting's surface strains the powers of inventory: a reproduction of Sandro Botticelli's *Birth of Venus* (c. 1485), comic strips, a drawing by Cy Twombly, political posters, photographs of a running athlete, and much more. Paint arrives in strokes, stains, blobs, and drips, each as independent as the collaged elements around it. Lined up across the center of the painting are 117 samples from a paint-sample book, their

Fig. 2. Robert Rauschenberg. *Small Rebus.* 1956. Oil, graphite, paint swatches, paper, newspaper, magazine clippings, black-and-white photograph, U.S. map fragment, fabric, and three-cent stamps on canvas, 35 x 46 x 1 ¾" (88.9 x 116.8 x 4.5 cm). The Museum of Contemporary Art, Los Angeles. The Panza Collection

identity emphasized by the double slots for the wire or metal rings that would have bound them together. Like the drop cloths on which the painting is made, the paint swatches elevate a humble behind-the-scenes accessory to a starring role. Most of all, they announce the painting's color as a commercial product rather than a gift from nature. Although they are in some places arrayed in clusters determined by color family, the samples are not a spectrum and bear no suggestion of a natural order. They neither come from nor lead anywhere, and what Cage said of the whole painting is true of them: "This is not a composition. It is a place where things are, as on a table or on a town seen from the air: any one of them could be removed and another come into its place through circumstances analogous to birth and death, travel, housecleaning, or cluttering."[6]

Rauschenberg had emphasized the fact of paint as a store-bought commodity in several of his earlier Combines. *Paint Cans* (1954) is so named because it features four of them. The streams of paint in works such as *Collection* (1954; fig. 1) and *Short Circuit* (1955) invoke the metal tubes from which they were squeezed. *Rebus* finds a far earlier antecedent in Marcel Duchamp's *Tu m'* (1918; plate 1), which Rauschenberg had seen in New York in the exhibition *Dada, 1916–1923*, at the Sidney Janis Gallery in spring 1953. *Tu m'* is the first painting to introduce the presence of paint samples, here represented by a painted echelon cascading from the upper-left corner. With *Rebus* Rauschenberg one-ups the master, taking his cue from the inventor of the readymade and incorporating actual color swatches into the painting, doing away with the need to paint them.

Rebus is unique among the Combines in that it exists in a second version, made the following year. *Small Rebus* (fig. 2), just over one-third the size of *Rebus*, features a new cast of characters, among them three-cent stamps, a fragment of a map of the United States, and a family photograph. The only motif directly carried over from its predecessor is the horizon line of paint samples. This time they are longer and narrower, with unbroken edges, and they occupy a proportionately larger area of the painting. Amid the other imagery, the paint samples in both *Rebus* and *Small Rebus* conjure the atmosphere of the studio as directly as a self-portrait of the artist holding a palette. With a casualness not to be mistaken for thoughtlessness, Rauschenberg has employed them in a breathtaking celebration of pedestrian color. —*A.T.*

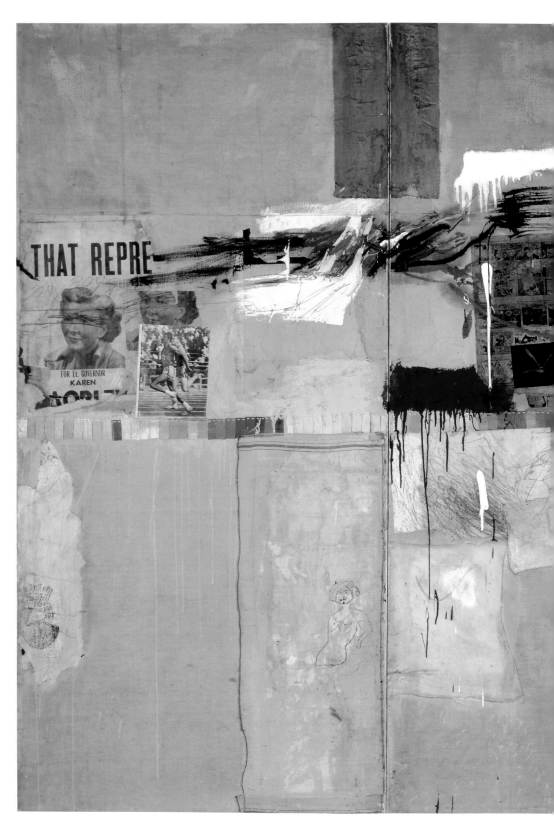

8. Robert Rauschenberg
Rebus. 1955
Oil, synthetic polymer paint, pencil, crayon, pastel, cut-and-
pasted printed and painted papers, and fabric on canvas mounted
and stapled to fabric
Three panels, overall: 8' x 10' 11 ⅛" (243.8 x 333.1 cm)
The Museum of Modern Art, New York. Partial and promised
gift of Jo Carole and Ronald S. Lauder and purchase

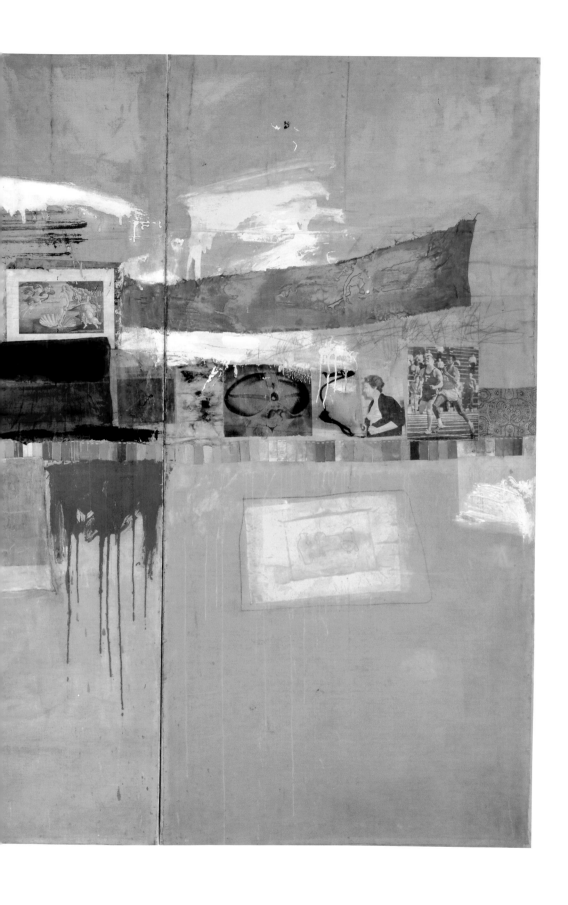

Because what's interesting to me is the fact that it isn't designed, but taken.

It's not mine. —Jasper Johns, 1977[1]

Fig. 1. Jasper Johns. *False Start*. 1959. Oil on canvas, 67 ¼ x 54" (170.8 x 137.2 cm). Private collection

An artist's palette is often used as a metonym for the artist, with his or her way of working with preferred colors neatly summarizing the artistic personality. This truism may explain Jasper Johns's early attitude toward color: the tendency to equate certain colors with a certain artist contravened his desire for distance between himself and his work. The noncolor gray, avoiding "all the emotional or dramatic quality of color," offered one solution.[2] An alternative was a set of received colors, such as those of the American flag. Another possibility would be to use colors so common as to deprive their association of interest, such as the primaries (red, yellow, blue) and the secondaries (orange, green, violet) and, perhaps without added risk, black, white, and brown.

Color became a fertile field of investigation in Johns's work not so much as an expressive question as a cerebral one. With the painting *False Start* (1959; fig. 1), colors appeared as "things the mind already knows"—not so different from such objects as targets or flags, or such signs as letters and numbers—for the very reason that they appeared not only as bold, brushy areas of paint but most strikingly as words.[3] And yet as the work's disjunctions become apparent, one's engagement with the painting converts "already knows" into "doesn't know at all." The stenciled names cite neither the colors in which they are painted nor those on which they sit. In overlapping passages, and by mixing white into color in a de Kooning-esque fashion, Johns demonstrates that there is no "blue" but blues, no "red" but reds, and so forth. What first seems very simple is in fact very complicated, what first seems clear, ambiguous. Vision and speech are confused as one reads the painting, and Johns says that his interest in the color names came as a way of admitting sound into the work, of expanding beyond the visual to the aural—an aspect that carried over to subsequent paintings bearing the words "red," "yellow," and "blue."[4]

The notion of color as a concept rather than a matter of personal expression is underscored in Johns's first portfolio of lithographs; *0–9* (1960–63; plate 9). The project began when Tatyana Grosman, publisher of Universal Limited Art Editions, gave him three lithographic stones in early 1960 as an enticement to start making prints. On the first stone he made a zero and then added a frieze of two rows of digits, zero through four and five through nine. Johns worked on the series through 1963, using the same stone to make the numbers one through nine, so that each new image bore traces of those prior. He made the entire set of ten digits, in editions of ten, in three versions—black, gray, and ten colors—continuing his habit of complementing colored works with noncolor versions (*False Start*, for example, was followed by the slightly smaller *Jubilee* [1959] in grays, black, and white; the lithograph *False Start* [1962] was printed in colors and black and white).

Fig. 2. Jasper Johns. *According to What.* 1964. Oil on canvas with objects, six panels, overall: 7' 4" x 16' (223.5 x 487.7 cm). Private collection

Johns wanted to make the colors in the colored version of *0–9* as incontrovertibly self-evident as the numbers themselves, but he admits that when he went shopping for inks his idea of an ordinary, unremarkable red (or any other color) proved elusive.[5] In the end he had to concoct special mixes of ink to arrive at what he wanted: something that did not look like it was something he had wanted. It was yet another instance of the "flashlight problem" for an artist who preferred to abstain from the process of choice:

> I had this image of a flashlight in my head and I wanted to go and buy one as a model. I looked for a week for what I thought looked like an ordinary flashlight, and I found all kinds of flashlights with red plastic shields, wings on the sides, all kinds of things, and I finally found the one I wanted. It made me very suspect of my idea, because it was so difficult to find this thing I had thought was so common. . . . It turns out that actually the choice is quite personal and is not based on one's observations at all.[6]

The sequence of the colors in the numbers zero through nine is repeated in the vertical color chart that occupies the center of the painting *According to What* (1964; fig. 2). Johns explained the sequence to John Coplans in 1971, discussing in a straightforward manner a logic that is anything but:

> Yellow, green, blue, violet, red, orange are right out of the spectrum, but adding and subtracting—yellow plus blue equals green; minus yellow equals blue; plus red equals violet; minus blue equals red; plus yellow equals orange; plus black equals brown; minus orange equals black; plus white equals gray; minus black equals white. The only place where there is any disturbance in the order is with the brown, which always seems to me to be a separate color.[7]

The color chart in *According to What*, a work that in many ways serves as a summation of Johns's concerns of the prior decade, advertises the artist's detached, matter-of-fact use of color. Although the painting shares little of the messy randomness of Robert Rauschenberg's early work, it similarly accepts color as an element that does not express or denote. But Johns's hope that the schematized palette would free him from personal association fell victim to his success; limitation, too, can become autographic. Already in 1962 Frank Stella had expressed *Jasper's Dilemma* with two side-by-side compositions of concentric squares rendered in colors and in grays; in 1966 Barnett Newman's first of four paintings entitled *Who's Afraid of Red, Yellow, and Blue* was originally dedicated "to Jasper Johns."[8] Johns was indeed stuck with a signature palette, though one that his later work would resist. But meanwhile a new generation of artists followed Johns's lead in transferring color from an emotional to a conceptual zone. —*A.T.*

9. Jasper Johns

0–9. 1960–63, published 1963

Portfolio of lithographs printed in color and in black

Ten lithographs, each composition: approx. 16 1/16 x 12 3/16"

(40.8 x 31 cm); each sheet: approx. 20 1/2 x 15 1/2" (52.1 x 39.4 cm)

The Museum of Modern Art, New York. Gift of the Celeste and

Armand Bartos Foundation

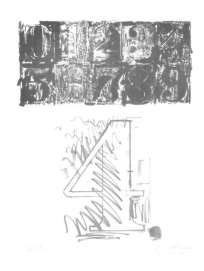

What's great about this country is that America started the tradition where the richest consumers buy essentially the same things as the poorest. You can be watching TV and see Coca-Cola, and you can know that the President drinks Coke, Liz Taylor drinks Coke, and just think, you can drink Coke, too. A Coke is a Coke and no amount of money can get you a better Coke than the one the bum on the corner is drinking. All the Cokes are the same and all the Cokes are good. Liz Taylor knows it, the President knows it, the bum knows it, and you know it. —Andy Warhol, 1975[1]

Fig. 1. Commercial package for Venus Paradise pencil-by-number kit. c. early 1960s. Collection The Andy Warhol Museum, Pittsburgh

Read "Liquitex" for "Coke," and Andy Warhol's approach to paint is made manifest. Warhol's use of paint in the early 1960s celebrated it as an artificial product, mass-produced and standardized, setting the tone for the paintings he would make with it. The significance of his subjects in early 1962—Campbell's Soup, Coca-Cola— was not so much those products' identities as food or drink but as commercial brands produced by big corporations and conveyed to a vast public via sophisticated packaging and advertising campaigns. It matters not only that you are drinking Coke but that you want to do so because you saw it advertised on television. Warhol began using Liquitex in 1962, seven years after its invention. Made in Cincinnati by Permanent Pigments, it was the first acrylic emulsion artists' paint; relative to oil, this synthetic product was inexpensive, easy to use, and quick drying. Warhol's paintings of that period generally employ it straight out of the tube.[2] The president could use it, Liz Taylor could use it, he could use it, and you could, too.

This consumer's version of the democratic ideal is mirrored in Warhol's much-professed antipathy for a personal signature in his paintings ("I think it would be so great if more people took up silkscreens so that no one would know whether my picture was mine or somebody else's.").[3] The Do It Yourself paintings of mid-1962 (plates 10 and 11) make a sharply subversive comment on the modernist glorification of originality, epitomizing Warhol's notion of the Everyman artist. These paintings celebrated the idea of universal artistic proficiency by taking as their model the popular kits widely marketed in the United States in the 1950s.[4] Subject matter, line, and color choice in a paint-by-number kit are all left to the manufacturer, but any consumer could create a work of art to hang in his or her home simply by following the numerical code and applying the correct colors.

Warhol made five such paintings, four of which are based on a Venus Paradise set of "pre-sketched drawings" sold to complement Venus Paradise colored pencils (fig. 1). The package exhorted the would-be artist to "just follow the numbers!" and promised "no water! no brush! no mess!" When Warhol turned a presketched drawing into a painting (for example, "Autumn Scene" into *Do It Yourself (Landscape)* (1962, plate 11), however, he allowed himself artistic license in the assignment of numbers and colors. He supplied numbers to the unpainted areas by transferring Letraset numbers onto the canvas, again taking care to avoid any trace of personal handwriting. The paintings were necessarily left incomplete in order to reveal their do-it-yourself nature, and their state of incompletion skewered yet another myth of modernism: the magic of the unfinished work. Art historians often celebrate incomplete work as particular testimony to a painter's genius, idealizing it all the more because the final product is invisible and unknowable. Here, Warhol utterly strips

the unfinished of its alluring mystique; the empty sections are merely waiting to be filled in by rote procedure.

Warhol's Do It Yourself paintings constituted a relatively brief episode in his work, perhaps too transparent a metaphor for his newly elaborated aesthetic position. Or perhaps they quickly led to their own logical conclusion: they were among the last that the artist hand-painted before turning to the more efficient practice of making paintings by means of silkscreened photographs.

The best thing about Warhol's work is the color.[5]

Donald Judd made this characteristically blunt pronouncement in his review of Warhol's first New York exhibition, presented at the Stable Gallery in November 1962.[6] The show included, among several paintings of Marilyn Monroe, two sets of four small Marilyn paintings, each twenty by sixteen inches (plates 12–17). These were unofficially known as "the Marilyn flavors," a designation whose source remains unclear but that was later codified in several of the works' titles (*Lemon Marilyn*, *Mint Marilyn*, etc.).[7] The equation of colors and flavors conflates the senses of sight and taste, much as the Campbell's Soup Can paintings did, as well as giving a breezy inflection to paintings that had been prompted by the tragedy of the actress's suicide barely three months earlier. At the same time that the nomenclature of flavors emphasizes the paintings' seriality, it plays down their seriousness, treating them like so many Popsicles or Life Savers.

The Marilyns are among Warhol's first silkscreen paintings, following those of Troy Donahue, Warren Beatty, and Natalie Wood. Their source was a cropped publicity still of Monroe in the 1953 film *Niagara*.[8] In making these paintings Warhol first screened a preliminary print of the image onto the primed canvas, a contemporary equivalent of a classical underdrawing, and then applied both the background color and the local color by hand.[9] Warhol later explained this painting process: "And then it needs to be more spaced, so I take my little blue brush and I blue it over there, and then I take my green brush and I put my green brush on it and I green it there, and then I walk back and I look at it and see if it's spaced right."[10] A final black silkscreen of the image was printed over the color.

In the Do It Yourself paintings, contour lines precisely and clearly contain color. In the silkscreened portraits the opposite is true. Here the misalignment, surfeit, or shortage of color relative to an outlined area is what gives the painting its personality. Warhol's silkscreen process strongly emphasizes color as an independent agent, both in the autonomous background and the descriptive areas. Roland Barthes's observation that the color of Pop was "chemical" could not be more apt; Warhol's color in the Marilyns was every bit as artificial as the flavorings might be in the treats that the cherry, lemon, and mint of the titles suggested.[11] This artificiality paralleled that of the cosmetics with which Monroe would have painted her own face and hair. By painting her pancake makeup, lipstick, eye shadow, and hair dye, Warhol in effect squared the concept: artificial color was used to depict artificial color. Judd's enthusiasm for Warhol's chromatic choices bespeaks his recognition that Warhol's aims matched his own, if not in imagery then in the matter of color: it should be unmistakably of no other time and place than its own. —*A.T.*

10. Andy Warhol
Do It Yourself (Flowers). 1962
Acrylic, pencil, and Letraset on linen
69 x 59" (175.3 x 149.9 cm)
Daros Collection, Switzerland

11. Andy Warhol

Do It Yourself (Landscape). 1962

Acrylic, pencil, and Letraset on linen

69 ¾ x 54 ⅛" (177.2 x 137.5 cm)

Museum Ludwig Cologne. Donation Ludwig

 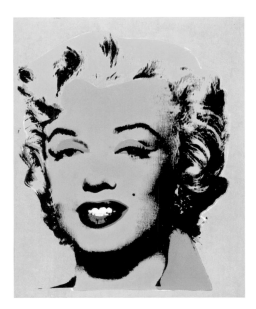

12. Andy Warhol
Cherry Marilyn. 1962
Silkscreen on synthetic polymer paint on canvas
20 x 16" (50.8 x 40.6 cm)
Collection Pier Luigi and Valentina Pero, Milan.
Long-term loan to Kunstmuseum Liechtenstein

13. Andy Warhol
Green Marilyn. 1962
Silkscreen on synthetic polymer paint on canvas
20 x 16" (50.8 x 40.6 cm)
National Gallery of Art, Washington, D.C. Gift of
William C. Seitz and Irma S. Seitz, in Honor of the
50th Anniversary of the National Gallery of Art

14. Andy Warhol
Mint Marilyn. 1962
Silkscreen on synthetic polymer paint on canvas
20 x 16" (50.8 x 40.6 cm)
Collection Jasper Johns

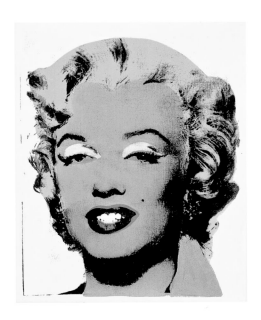

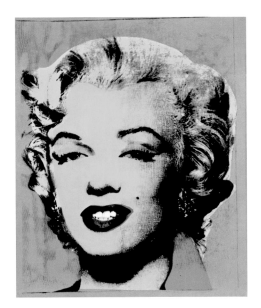

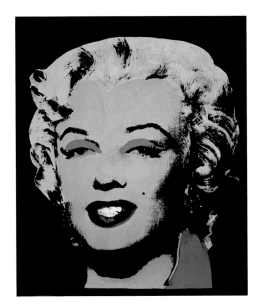

15. Andy Warhol
Lemon Marilyn. 1962
Silkscreen on synthetic polymer paint on canvas
20 x 16" (50.8 x 40.6 cm)
Private collection, courtesy Christie's

16. Andy Warhol
Blue Marilyn. 1962
Silkscreen on synthetic polymer paint on canvas
20 x 16" (50.8 x 40.6 cm)
The Art Museum, Princeton University. Gift of
Alfred H. Barr, Jr., Class of 1922, and Mrs. Barr

17. Andy Warhol
Liquorice Marilyn. 1962
Silkscreen on synthetic polymer paint on canvas
20 x 16" (50.8 x 40.6 cm)
The Stephanie and Peter Brant Foundation,
Greenwich, Connecticut

FRANK STELLA *(American, born 1936)*

I knew a wise guy who used to make fun of my painting, but he didn't like the Abstract Expressionists either. He said they would be good painters if they could only keep the paint as good as it is in the can. And that's what I tried to do. I tried to keep the paint as good as it was in the can. —Frank Stella, 1964[1]

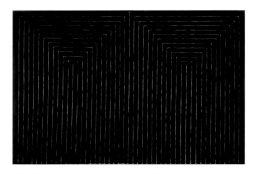

Fig. 1. Frank Stella. *The Marriage of Reason and Squalor, II.* 1959. Enamel on canvas, 7' 6 ¾" x 11' ¾" (230.5 x 337.2 cm). The Museum of Modern Art, New York. Larry Aldrich Foundation Fund

Frank Stella's 1961 Benjamin Moore paintings, which mark the advent of the artist's first exploration of color after his Black, Aluminum, and Copper paintings of the previous two years, are his most direct salute to the can he so famously invoked in a 1964 radio interview. He chose for this project the alkyd wall paint produced by Benjamin Moore, a company founded in 1883 in Brooklyn, New York. Alkyd resin, a form of polyester that produced an even, matte surface, had become common shortly before World War II and by the early 1960s was the standard for house paint. Stella decided to employ the six primary and secondary colors, all of which (except purple) were available ready made in a can. (He mixed red and blue to produce a purple tone; it has since faded to gray.)[2] This wall paint did not advertise its urban-industrial origins as openly as the company's metallic paints, but like them it was obviously far removed from the vibrant colors of nature in a rainbow or a bouquet of flowers. Instead, Stella said, "it had the nice dead kind of color that I wanted."[3]

Stella was no stranger to house paint. He had supported himself painting apartments during his first six months in New York, in 1958. Mainly for budgetary reasons, he made his paintings of that time with commercial black enamel and the tint colors used by housepainters. He bought out-of-fashion colors for a dollar per gallon from the cellars of paint dealers on Essex Street. Like Robert Rauschenberg, who was also relying on remaindered paint in those days, Stella saw the lack of choice as an advantage: "A lot of problems were sort of solved. You could get only certain kinds of colors and thus certain kinds of things were given—so I worked with those."[4] By the end of 1958 he had settled on using only black enamel, and the Black paintings gave way to the Aluminum, and then to the Copper (see figs. 1 and 2). For the last series Stella used a product with which he often had painted the bottom of his father's fishing boat in Ipswich, Massachusetts.

Stella was well aware of the use of non-art paint by artists such as Willem de Kooning and Jackson Pollock. But they did not keep it as good as it was in the can; they dripped it, swept it, layered it, mixed it, each finding a uniquely individual way to activate the paint on the canvas. Stella's antipathy to Abstract Expressionism, the reigning artistic movement when he was starting to paint as a student at Princeton University, came less from the work itself than from the heroic rhetoric surrounding it. "I began to feel very strongly about finding a way that wasn't so wrapped up in the hullabaloo," he said, "or a way of working that you couldn't write about."[5] His solution was the use of regulated patterns that could be diagrammed beforehand, the opposite of the improvisatory drama staged on the Abstract Expressionist canvas. Stella's predetermined patterns also allowed him to force illusionistic space out of the work, and "the remaining problem was simply to find a method of paint

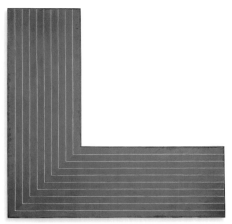

Fig. 2. Frank Stella. *Creede II.* 1961. Copper oil paint on canvas, 6' 10 ¾" x 6' 10 ¾" (210.2 x 210.2 cm). Collection the artist

application which followed and complemented the design solution. This was done by using the housepainter's technique and tools."[6]

Stella began the Benjamin Moore paintings when he was nearing the end of the Copper series. As usual, he started with diagrams that neatly outlined the six patterns he would use—a cross, horizontals, angles, a maze, concentric squares, and diagonals —and assigned a color to each pattern (red, yellow, blue, orange, green, and purple, respectively). The various designs provide the sense of a progressive lesson and range from utterly basic (horizontals and diagonals) to motifs from previous work (angles, the cross, the squares) to new motifs (the maze). In contrast to the paintings them-selves, the titles are richly evocative: five of them name Civil War battles, and the sixth (*Delaware Crossing,* 1962) invokes the American Revolution.[7] Stella made six large paintings, each one seventy-seven inches square, each in a single pattern and color. In addition, he made thirty-six twelve-by-twelve-inch paintings in which each of the six patterns (and respective titles) was painted in each of the six colors.

This reach for utter simplicity was successful enough to deflect any sales when the paintings were shown at the Galerie Lawrence in Paris in November 1961. Even compared with his previous work, they forswore interesting expression: the canals of raw canvas between the bands of color were narrower, the alkyd paint did not bleed at all, and the color showed no fluctuations in intensity. According to art historian and critic Robert Rosenblum, "Within the relative scale of possible reduction in Stella's art, these works of 1961 approach most closely the point of rock-bottom."[8] Stella put the same thought differently: "They were certainly the clearest statement to me, or to anyone else, as to what my pictures were about—what kind of goal they had."[9] Stella did find an admirer in Andy Warhol, who in 1962 asked Stella to paint him a set of miniatures that reiterated the patterns and colors of the large paintings.

Stella continued to use Benjamin Moore's alkyd house paint in a series of large paintings, known as the Concentric Squares and the Mitred Mazes, in 1962–63 (plate 18). *Gran Cairo* (1962; plate 19) uses the concentric-square format Stella devised for the Benjamin Moore series, but instead of painting a monochrome, he used the six primaries and secondaries in a pattern that seems to inhale and exhale color, with bands of the six tones progressing, from the center to the perimeter of the painting, from red to purple, then through the six from purple to red, and once again from red to purple. Although the concentric composition reiterates the painting's flat picture plane, it also evokes a pyramid seen directly from above. Stella alludes to this in its title, the name given by Spanish explorer Francisco Hernández de Córdoba to the first city he encountered in the Yucatán in 1517. —*A.T.*

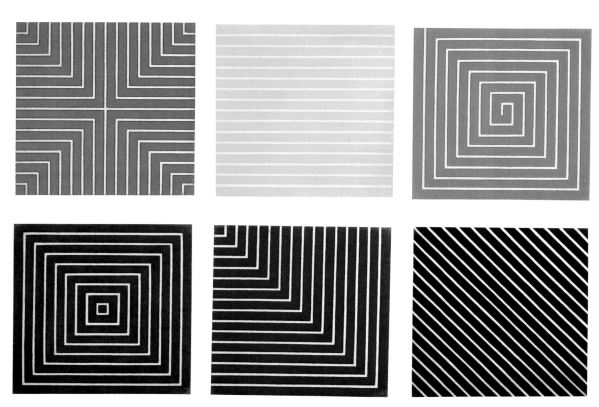

18. Frank Stella

Delaware Crossing, Palmito Ranch, New Madrid, Island No. 10,

Hampton Roads, and *Sabine Pass*. 1962

Alkyd (Benjamin Moore flat wall paint) on raw canvas

Six canvases, each: 12 x 12" (30.5 x 30.5 cm)

Brooklyn Museum. Gift of Andy Warhol

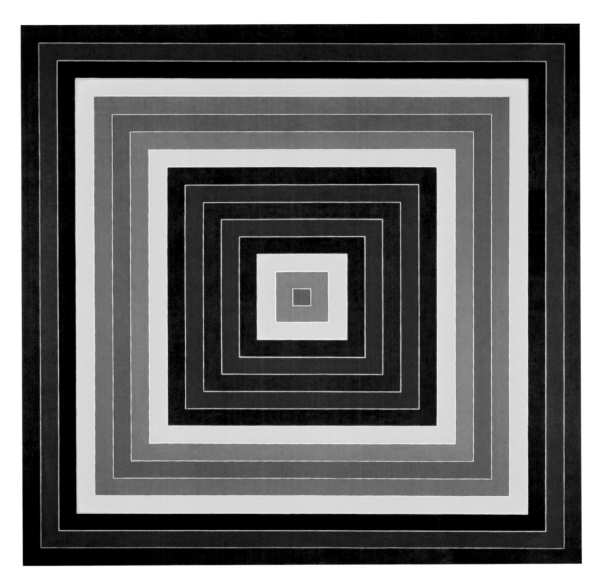

19. Frank Stella
Gran Cairo. 1962
Alkyd on canvas
85 ¼ x 85 ¼" (216.5 x 216.5 cm)
Whitney Museum of American Art, New York. Purchase,
with funds from the Friends of the Whitney Museum of
American Art

JIM DINE *(American, born 1935)*

These paintings are highly autobiographical, as is everything for me. The Color Charts are potent objects of memory. —Jim Dine, 2006[1]

Fig. 1. Jim Dine. *My Long Island Studio.* 1963. Oil on canvas with painted wood, four panels, each: 8' x 48" (243.8 x 121.9 cm), overall: 8' x 16' (234.8 x 487 cm). Collection John and Kimiko Powers

Jim Dine's Color Chart paintings of 1963 have their origin in his childhood, when the artist spent after-school hours and summers first playing and later working in his grandfather's hardware store in Cincinnati and his father's store across the Ohio River, in Kentucky. He identifies his early years with those stores and their tools, machines, and endless supplies and gadgets, and his long and ongoing romance with house paint and color charts began there. Dine remembers venerating the charts, collecting, dissecting, and sorting these "jewel lists."[2]

Unlike most artists associated with the Pop movement, Dine has been adamant about the autobiographical roots of his work and the location of its meaning in his personal environment. Although Pop always has been associated with cool, impersonal art, Dine's work refuses such characterization. Instead, as the critic and curator Alan Solomon pointed out as early as 1964, "His pictures should always be regarded as projections of himself, and vice versa."[3] Dine's second solo show at the Sidney Janis Gallery, in 1964, focused on the implied self-portrait with an emphasis on the palette, as well as the introduction of the artist's now-signature bathrobe. The palette is more readily legible as an artist's alter ego than the color chart, but it is the color chart that links Dine's past and present, and it dominated the exhibition in the form of *My Long Island Studio* (1963; fig. 1), a 16-foot-long painting that mimicked a studio wall. The wall, actually painted on bed sheets, shows a huge, eight-panel color chart that provides a base for other features, such as a small, twenty-five-color grid, the outline of a palette, a trompe l'oeil paint rag, actual paint sticks, and an area of dripped paint typical of what might be left after a painting was removed from the wall.

Red Devil Color Chart No. 1 (1963; plate 20) is one of several smaller Color Chart paintings that exemplify the deliberate tension between the generic and the personal in Dine's early-1960s work. It presents twenty-four unmixed Red Devil house-paint colors in a grid of four columns and six rows against a background of white sizing. The arrangement of the colors is random, done without reference to any specific chart; the distribution does not permit the various hues to cluster or relate to each other in any particular way. This uncompromising anonymity of the chart is contradicted by the color names, painted in black in messy handwriting not without smudges and misspellings and featuring an indifferent use of capitalization and the hurried abbreviation "Chin" for Chinese. Dine has observed that without the writing on a Color Chart painting, "Clement Greenberg would have seen it as just another modernist picture," but chances are its apparent ineptness would not, in any event, have pleased the critic.[4] The rectangles of glossy paint are uniform in the manner of a color sample, yet they sometimes inexplicably drip into the color name

Fig. 2. Jim Dine. *Wall Painting for Sylvia Guiray.*
1966–67. Enamel on canvas, 35 x 14' (10.67 x 4.27 m).
Shown installed at Expo 67, Montreal

below. Such accidents both in the samples and the handwriting are vital constituents of a deliberate awkwardness that gives the painting its provocative individuality.

Dine continued to explore the use of house paint and color charts in various mediums during the 1960s and 1970s. The most spectacular example was his contribution to the U.S. Pavilion at Expo 67 in Montreal, which was sited in an enormous Buckminster Fuller geodesic dome.[5] Contemporary art was displayed on vertical sailcloth panels hung from the dome's ceiling, 200 feet high. The twenty-two artists in the exhibition, organized by Alan Solomon, had to produce works of a size and scale that could survive this vast setting. Dine's *Wall Painting for Sylvia Guiray* (1966–67; fig. 2) was a 35-by-14-foot enamel on canvas. Taking a stand as audacious as the one that marked his 1959–60 Happenings, Dine rolled house paint onto the canvas in a purely abstract composition that juxtaposed two vertical bands of color. He asked a sign painter to add a text in the lower-right corner, in stenciled black capital letters: "These 2 panels have been painted with Sherwin Williams speed paint Sher-Will-Glo. The colors are brilliant cerise and flame pink. —Jim Dine, Ithaca, NY, 1967." —*A.T.*

20. Jim Dine
Red Devil Color Chart No. 1. 1963
Oil on canvas
7' x 60" (213.4 x 152.4 cm)
Collection Alice F. and Harris K. Weston

JOHN CHAMBERLAIN *(American, born 1927)*

Kline gave me structure. De Kooning gave me color. But I only agreed with him because the auto color was the same. It had nothing to do with being derivative. De Kooning knew about the color of America. The color of America is reflected in their automobiles. —John Chamberlain, 1990[1]

Fig. 1. John Chamberlain. *Essex.* 1960. Automobile parts and other metal, 9' x 6' 8" x 43" (274.3 x 203.2 x 109.2 cm). The Museum of Modern Art, New York. Gift of Mr. and Mrs. Robert C. Scull and purchase

John Chamberlain's vivid polychrome sculptures of the late 1950s and early 1960s received their ready-made color from the car fragments and metal scraps the artist obtained for free from junkyards. Chamberlain deliberately sought colored metal pieces, so that color would serve as an integral part of and signpost for the structural elements of the work (see fig. 1). But although color was very important to the sculptures, it was only one of many considerations the artist took into account when assembling the forms. Then, in early 1963, after having made sculpture for more than five years, Chamberlain decided to concentrate on color through a series of 12-by-12-inch paintings on Masonite that provided a uniform framework for chromatic explorations (plates 21–26). He chose as the format a monochrome field in which floated, at the left and right sides of the painting, two grids, based on a small metal template he found in a junkyard, of nine small squares in three rows of three.

Chamberlain used for these paintings Ditzler automobile enamel, a product that Pittsburgh Plate Glass Company made for the Ford Motor Company from 1950 to 1971.[2] (Ditzler, founded in 1902, was the first manufacturer of colors for the automotive industry in Detroit; it was acquired by P.P.G. in 1928.) He wanted to make a painting by a process through which the color materialized rather than its being selected a priori, and to do so he dropped a tiny amount of color into a clear lacquer, creating a very pale liquid that he sprayed onto the Masonite squares in dozens of coats so that the color gradually intensified through the accumulation of layers. He then placed the gridded template over the painting, painted the squares, and continued to add more layers of lacquer; as a result the squares seem to float under the surface. Working on several paintings at a time, Chamberlain made no particular effort to match or contrast the squares and the field. As he told Guggenheim curator Diane Waldman, in a 1971 joint interview with Donald Judd: "There is no bad color, there's no color decision to reject because everything is colored."

> DW: But isn't that essentially a part of your thinking, even in the early sculptures? In other words, that there was no color relationship that was inherently bad.
> JC: Well perhaps, but I didn't know it as well as I did after I did these paintings.[3]

The series was begun in New York and continued over a couple of years, including a summer in Embudo, New Mexico, and a period during which Chamberlain and his family lived in Topanga Canyon, in Los Angeles. Chamberlain recalls that the initial idea had to do with "going to California a couple of times" and so becom-

Fig. 2. Billy Al Bengston. *Gregory.* 1961. Lacquer and synthetic enamel on composition board, 48 ⅛ x 48 ⅛" (122 x 122 cm). The Museum of Modern Art, New York. Larry Aldrich Foundation Fund

ing aware of the "finish fetish" work of Billy Al Bengston (see fig. 2).[4] The series changed slightly over time; Chamberlain added metal flake to the paint for a sparkly texture, switched from Masonite to Formica supports, and oriented some of the paintings on the diagonal. He also made some seventeen-inch squares, as well as eight paintings at 48 inches, with metal elements affixed. All of these variants shared titles containing the names of popular music groups, thus pairing two quintessentially American products (and in the case of the Motown sound, two specifically hailing from Detroit).

Chamberlain's paintings were not well received when he showed them at Leo Castelli Gallery in 1964 and 1965, although Judd was an immediate and exceptional advocate. During the 1971 conversation with Waldman, Chamberlain cited Judd's admiration for the paintings with the same gratitude a parent might feel toward a relative who doted on his or her plainest child. Judd explained the general negative reaction to the paintings as a possible result of confusion caused by the geometry of the square grids, which critics read as a bad marriage of Pop and post-Mondrian geometric abstraction.[5] Not confused himself, Judd had meanwhile begun to exploit the luminescent possibilities of auto enamel for his three-dimensional objects. *—A.T.*

21. John Chamberlain
Elvis. 1963
Auto lacquer on Masonite
12 x 12" (30.5 x 30.5 cm)
Private collection, New York

22. John Chamberlain
Dion. 1963
Auto lacquer on Masonite
12 x 12" (30.5 x 30.5 cm)
Private collection, New York

23. John Chamberlain
Joey Dee. 1963
Auto lacquer on Masonite
12 x 12" (30.5 x 30.5 cm)
Private collection, New York

24. John Chamberlain
Orlons. 1963
Auto lacquer on Masonite
12 x 12" (30.5 x 30.5 cm)
Private collection, New York

25. John Chamberlain
Marquees. 1964
Auto lacquer on Formica
12 x 12" (30.5 x 30.5 cm)
Private collection, New York

26. John Chamberlain
U.S. Bonds. 1965
Auto lacquer on Formica
12 x 12" (30.5 x 30.5 cm)
Private collection, New York

Florentine Red (Rosso Fiorentino) and Klein Blue (Yves Klein) are just two examples of colors that were both generated and "baptized" by a specific artist. This doesn't apply to me as I have no offspring, neither children nor colors. But I have decided to adopt some colors, all of them in fact. Untitled (Plakat Carton) *is proof of this: all of the colors that were hidden inside a catalogue now look out at us, while living neatly lined up in the windows of a house or rather (literally) within the space of an artwork.* —Giulio Paolini, 2007[1]

Fig. 1. Giulio Paolini. *Untitled.* 1961. Tubes of paint on panel, wadding, and tempera on paper mounted on polyethylene, 11 ⅞ x 10 ¼" (30 x 26 cm). Private collection, Milan

Untitled (Plakat Carton) (1962; plate 27) was made at the outset of Giulio Paolini's career, well before he would become known as one of the foremost Italian artists of his generation and an important international figure in defining Conceptual art. In 1962 he was just twenty-two and had been making art for two years; he had trained as a graphic designer and still supported himself as one. As an artist Paolini was an autodidact, alert to contemporary art only through what he read in magazines and not yet friends with other artists. He had nothing to unlearn.

In 1960 he began to explore systematically the various components of studio practice. He started not with the mark, not with any element of so-called personal style, but with the rudimentary elements that go into that strange thing Western culture calls "painting." Paolini had no interest in the new materials or technologies which were then catalyzing movements such as kinetic art or Op art. He was interested in the centuries-old tradition of fine art; growing up in Genoa and Turin, he had been nurtured on this tradition since earliest childhood.

His investigation began with works that featured the typical supports of a two-dimensional work of art: the canvas or the sheet of paper. Paolini presented these elements in an isolated and unadorned manner, referring to nothing but the stretcher that accommodated them. Wrapped in transparent polyethylene, these works are neutral specimens from the realm of art making; the then-recent work of Jasper Johns, whom Paolini admired, was by comparison lushly warm and expressive. An untitled Paolini work from 1961, for example, moors a piece of primed canvas to a stretcher with long stitches of thread, much like a sail to a jib. Askew on the stretcher's axis, it is presented in a fashion too odd to be merely didactic but too basic to be easily recognized as art.

It was not long before Paolini turned his attention to the matter of color. He had admired the wondrous blue paintings on view at Milan's Galleria Apollinaire in the 1961 exhibition *Yves Klein Le Monochrome: Il nuovo realismo del colore.* Paolini's own form of realism involved, in three different works, the presentation of three paint tubes (with attendant color samples; fig. 1), a can of paint (fig. 2), and finally just the sample cards themselves. For all its ordinariness, *Untitled (Plakat Carton)* is fashioned with care and deliberation. It is made on a wooden stretcher across which thin, transparent bands of polyethylene have been laid. The squares of colored cardboard, cut from a German paint company's samples, are each affixed to the bands with two small staples. Paolini inscribed the first square with the words "Plakat Carton," a ready-made subtitle from the source of the samples, typed rather than written to avoid any sense of authorial personality. Although the samples did not originate in a grid, Paolini chose the grid format for its neutrality.

Fig. 2. Giulio Paolini. *Untitled.* 1961. Can of paint, stretcher, and
polyethylene, 8 ⁵/₁₆ x 8 ⁵/₁₆" (21 x 21 cm). Collection the artist

He does not recall that he took care with the sequence; it starts off at the top with
the family of yellows, oranges, and reds, but such groupings do not continue into
the center and bottom of the grid.[2]

As a final step, Paolini encased the work in a sheet of polyethylene, which he
folded around the sides of the stretcher and secured on the reverse. The polyeth-
ylene is employed, as it was in his other works of this time, to achieve the effect of
levitation, to communicate the notion of a void in which these colors exist. These
are not colors attached to one particular painting or effort, it says, nor one place or
time. Rather, in all their concreteness as art-supply samples and all their modesty as
printed cardboard, they are enduring signs of the eternal richness of color. —*A.T.*

27. Giulio Paolini

Untitled (Plakat Carton). 1962

Colored cardboard squares, stretcher, and polyethylene

11 ¹³⁄₁₆ x 11 ¹³⁄₁₆" (30 x 30 cm)

Anna Paolini Piva Collection, Turin

Colors match the same way as the right bingo numbers will. For it is quite difficult to cross five different numbers on a bingo board such as not to make their combination convincing. However, any sequence of numbers is always right and credible if it is the correct one at bingo. —Gerhard Richter, 1969[1]

Fig. 1. Gerhard Richter. *Sketches (Color Charts).* 1966. Four color-sample clippings, proportions and measurements marked, each mounted on paper and signed, overall: 26 ¼ x 20 ⅜" (66.7 x 51.7 cm). Städtische Galerie im Lenbachhaus, Munich

When Gerhard Richter began what he regards as his mature body of work, he confined himself to using grays, black, and white. Each painting was based on an amateur photograph, an item he described as "free of all the conventional criteria I had always associated with art. It had no style, no composition, no judgment. It freed me from personal experience."[2] Much the same could be said of the color charts that he had around his house in 1966, acquired from Düsseldorf shops such as Sonnen-Herzog, which was devoted to housepainters' supplies, and Feltmann, to carpentry materials. He recalls simply noticing a color chart one day and realizing that "it looks like a painting. It's wonderful."[3] The charts provided an answer to a question that Richter already had in mind: not only how to dissociate color from its traditional descriptive, symbolic, or expressive ends, but also how to avoid the dogma that surrounded geometric abstraction. He found that "the beautiful effect of these color patterns was that they were so opposed to the efforts of the Neo-Constructivists, such as Albers, etc."[4] Made immediately following *Ema (Nude on a Staircase)* (1966; Museum Ludwig, Cologne), his only painting to date based on a color photograph, the color charts provided a point of departure that he could accept as conceptually legitimate for his first sustained exploration of color.

The identification of the color chart as a model left Richter with a host of decisions. The eighteen Color Chart paintings of 1966 include anywhere from 2 to 192 color units, and vary in size from 27 ⁹⁄₁₆ by 25 ⅝ inches to the monumental 8 by 31 feet of *Ten Large Color Panels* (plate 28). With a single exception Richter used enamel to paint the color units, a paint differentiated by its gloss from the white primer that surrounds it. He painted his third Color Chart, *192 Colors*, in oil, but it seemed to him too lush, and he returned to enamel for his next work. Richter freely composed the Color Charts, experimenting with a variety of formats for both the color units and the overall paintings, except for one painting that closely copies a chart of six shades of yellow.[5] In most, the distribution of the colors has an arbitrary, anticompositional feeling to it. Colors are arranged as autonomous units, much as a house-paint chart might offer a diverse menu of nongradated hues. Three are made using only gray-scale colors, a fact that Richter has credited to the impact of Minimalism, but which also has roots in his all-gray work of 1963–65.[6]

Six pages in Richter's *Atlas* (see fig. 1), an ongoing compendium of studies and source material that he began in 1964, reveal the artist experimenting with excerpts from the actual charts. The color samples in these collages include citations of color names and numbers, surprising reminders that these elements are absent from the finished paintings.[7] It is obvious that the key issue for Richter was that of proportion and scale, both within the confines of the canvas and beyond it,

Fig. 2. Gerhard Richter. *180 Colors.* 1971. Oil on canvas, 6′ 6¾″ x 6′ 6¾″ (200 x 200 cm). Private collection

Fig. 3. Gerhard Richter and an assistant working on a color chart painting, 1973

and several sketches relate the samples both to the human figure and to the interior of a room. Richter's ambition to position the Color Chart paintings in an architectural context is apparent in the size of *Ten Large Color Panels*.[8] The charts in this work, the last in the series, are unusually explicit about their source, with a format echoing the columns of a paint chart, even employing a wider margin at the right, where the color name and code would have been cited.

The five years subsequent to the Color Charts brought the making of a vast range of paintings, including many which could be considered their inverse: works that concentrated on gray, with its capacity "to make 'nothing' visible."[9] In 1971 Richter returned to color as the subject of his paintings but changed his approach from the principle of the readymade to that of conceptual system. He sent to the 1972 Venice Biennale four paintings, each titled *180 Colors*, square paintings of about 6 feet by 6, divided into twelve columns and fifteen rows of color rectangles (fig. 2). The derivation of the colors was wholly mathematical; Richter mixed each of the three primary colors twice in order to obtain twelve basic tones and then gradated those twelve tones seven times in a lighter direction and seven times in a darker direction. The resulting 180 colors (the original twelve plus eighty-four darker grades plus eighty-four lighter grades) were numbered and then assigned to gridded units on the canvas by drawing the numbers from a box. "I found it interesting," he said, "to tie chance to a totally rigid order."[10] The four paintings feature the same 180 colors, all in different random arrangements in the grid. As Richter would later say of his gray paintings, "I intended them to look the same but not to be the same, and I intended this to be visible."[11] The illustration in the Biennale catalogue presented the four paintings abutted against each other, echoing the architectural implications of *Ten Large Color Panels*.[12]

In 1973 Richter made a set of four large, rectangular paintings with 1,024 colors, again using similar mathematical procedures for mixing colors and chance operations for color placement. He now worked with permutations in multiples of four, adding gray to the three primaries that were the starting point for his tonal mixtures: "The multiplier four was necessary because I wanted to keep the image size, the square size, and the number of squares in a constant proportion to each other."[13] Richter was not finished; during 1973–74 he made a total of twenty-six color paintings in a variety of shapes and sizes, including grids of 4, 16, 64, 256, 1,024, and 4,096 units (see plate 29). These employed green as the fourth base color rather than gray, and they were made with and without white interstices between the color units. This massive project involved the collaboration of many assistants (fig. 3), fully in keeping with Richter's view of the paintings as impersonal and objective.

This very objectivity, however, invokes its own opposite; Richter's method of random order implies all the untried systems, all the unmixed colors, all the unpainted paintings. The finite dimensions of the Color Charts have as their necessary other an inexhaustible and inexpressible boundlessness. —*A.T.*

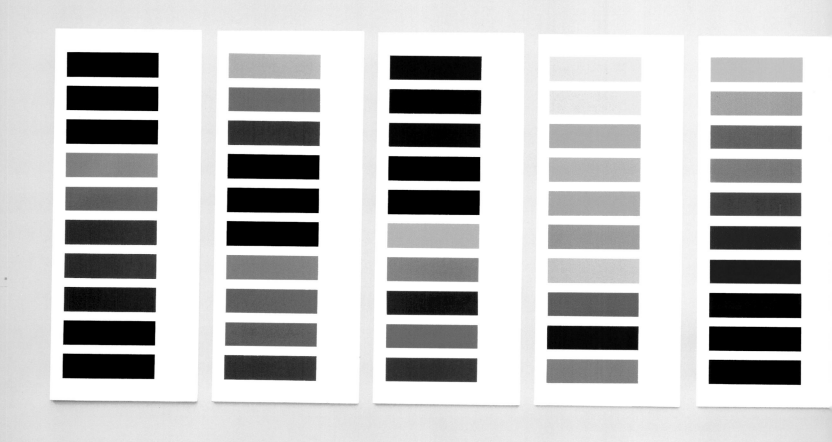

28. Gerhard Richter

Ten Large Color Panels. 1966/71/72

Lacquer on white primed canvas

Ten panels, each: 8' 2 ⁷⁄₁₆" x 37 ⅜" (250 x 95 cm);

overall: 8' 2 ⁷⁄₁₆" x 31' 2" (250 x 950 cm)

Kunstsammlung Nordrhein-Westfalen, Düsseldorf

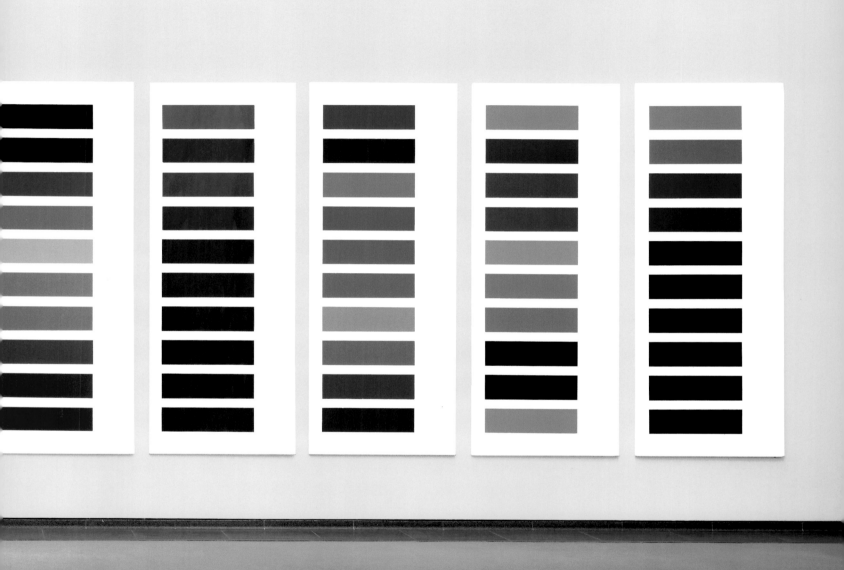

29. Gerhard Richter
256 Colors. 1974
Lacquer on canvas
7' 3 ⅜" x 13' 7" (222 x 414 cm)
Collection Steven and Alexandra Cohen

And while others were toiling at I don't know what, he sewed two pieces of fabric together and then had the day off. —Sigmar Polke on Blinky Palermo, 2001¹

Fig. 1. Blinky Palermo. *Flipper.* 1965.
Oil on canvas, 35 x 27 ⅜" (89 x 69.5 cm).
Pinakothek der Moderne, Munich

Fig. 2. Sigmar Polke. *Mao.* 1972. Synthetic
polymer paint on cloth on cotton fabric,
hung from loops around a wood pole,
overall, including pole: 12' 3" x 10' 3 ½"
(373.5 x 314 cm). The Museum of Modern
Art, New York. Kay Sage Tanguy Fund

In 1966 Blinky Palermo began to make his *Stoffbilder*, or "cloth pictures"—"paintings" made from lengths of fabric bought at Düsseldorf department stores (see plates 31 and 32). The works present the fabric stretched like an artist's canvas, but there is not a trace of paint on them. The composition is the juxtaposition and relative proportion of two or three horizontal bands of the material's own intense color, united by tight, machine-sewn seams. The fabric extends over the sides and onto the back of the stretchers, enhancing the works' impact as objects rather than images. Over the course of seven years, despite a harsh self-editing process, Palermo made and preserved almost seventy *Stoffbilder*, the largest body of work in his fifteen-year career.

Palermo was devoted to painting at a time and place where this was an exceptional position to take. Although he had begun his studies at the Kunstakademie Düsseldorf with the painter Bruno Goller in 1963, the following year he switched to the class of Joseph Beuys. In 1966 Beuys selected Palermo to be his master student, a coveted honor in the academy system. The selection was an unlikely one, given Beuys's low estimation of painting as a fertile medium; he famously told his students that they had already made a mistake when they went to buy stretchers and canvas.² With the *Stoffbilder* Palermo was able to both make the mistake and not: he went and bought fabric (although not the kind meant for artists), but then he did not do anything to it that would have made it a conventional painting—indeed, he did not paint anything. Palermo also used fabric in combination with wood in the sculptural objects that he continued to produce alongside the cloth paintings. One of the most important of these objects, *Blue Disk and Stick* (1968; plate 30), found its rich color in yet another nonartistic source: thick adhesive tape. The blue tape engulfing the disk and the stick functions much like the fabric in the *Stoffbilder*, asserting its ready-made identity at the same time that the work's sublime beauty transcends it.

Beuys gave Palermo the freedom to pursue his own vision; his fellow students Sigmar Polke and Gerhard Richter gave him the shared interests he needed. Palermo became close friends with Polke and Richter soon after he arrived at the Kunstakademie, and their individual responses to American Pop art as a liberating force were especially influential. Palermo's own reaction is seen in the painting *Flipper* (1965; fig. 1), in which what appears to be pure geometric abstraction is in fact a design appropriated from a pinball machine at a favorite Düsseldorf bar. His introduction to the ready-made potential of department store cloth is generally credited to Polke, who had been painting on patterned fabric backgrounds since 1964 (see fig. 2) and whom Palermo joined on shopping expeditions to the

Fig. 3. Ellsworth Kelly. *Red Yellow Blue White*. 1952. Dyed cotton on panel, twenty-five panels, each: 12 x 12" (30.5 x 30.5 cm), overall: 60" x 12' 4" (152.4 x 375.9 cm). Private collection

Fig. 4. Alighiero Boetti. *Mimetico*. 1967. Canvas-backed camouflage fabric, 10 ¾ x 7 ½" (27 x 19 cm). Courtesy Monika Sprüth Philomene Magers, Cologne

department stores Karstadt and Kaufhof. Palermo never shared Polke's interest in the figurative element provided by the kitschy patterns, yet even the monochrome fabrics possess a reference to their factory origins, artificial rather than organic in character.[3] Like Donald Judd's Plexiglas, the fabrics provided contemporary colors that were inseparable from their material.

Palermo's first cloth paintings date from 1966, the same year as Richter's Color Chart paintings. The closeness of the two artists was such that Richter's wife, Ema, sewed the seams of many of Palermo's cloth paintings. Their respective projects set up a fascinating dialogue, with each artist turning for pictorial inspiration to mass-produced color intended for commercial or domestic use. Both were interested in reducing the number of decisions they had to make by virtue of ready-made source material, and in finding an entry into abstraction that avoided the dogma of their predecessors. In each case the results are far less automatic than they might appear to be. Palermo's early cloth paintings experimented with a variety of formats and fabrics, as well as with vertical rather than horizontal bands of color. The mock jealousy behind Polke's jest about Palermo's easy road belied the care and complexity of his friend's process. Palermo made all the choices, both of the shades of the fabrics and the proportions of the work, intuitively rather than systematically. He would place different lengths of fabric on the floor and test various combinations until he found one that satisfied his sense of tone and proportion. Beuys, a theoretician planted firmly in the German tradition, acknowledged that "he's not the sort of person, or painter, who'd write down a theory or follow any kind of theoretical plan."[4]

Ever since the *Stoffbilder* were first shown, their bold, direct color has prompted comparisons with the paintings of Ellsworth Kelly. Yet Kelly only took advantage of ready-made color for a short period of time, during his stay in France in the early 1950s. An interesting antecedent for Palermo's work is indeed found in Kelly's *Red Yellow Blue White* (originally titled *Bon Marché*) (1952; fig. 3), a five-part work made with cotton fabric, but this experiment represents a path that Kelly did not pursue and, like the rest of his early work, was virtually unknown in the 1960s. Palermo's more relevant peers of the time are Daniel Buren and Alighiero Boetti. In 1966 those two artists also went shopping for ready-made fabric for their work; Boetti chose a material produced for camouflage (see fig. 4), and Buren the striped canvas that graced the awning of every French café. Like Palermo, they were talented shoppers who thrived on the paradox of a romance with color in what then seemed a post-Romantic age. —*A.T.*

30. Blinky Palermo

Blue Disk and Stick. 1968

Wooden beam, plywood disk, and adhesive tape

Beam: 8' 2 ¹³⁄₁₆" x 3 ⅞" x 2 ¹⁵⁄₁₆" (251 x 9.8 x 7.5 cm),

disk: ½ x 24 ¹³⁄₁₆" (1.3 x 63 cm)

Private collection

31. Blinky Palermo
Untitled. 1969
Dyed cotton mounted on muslin
6' 6 ¾" x 6' 6 ¾" (200 x 200 cm)
Westfälisches Landesmuseum für Kunst und Kulturgeschichte, Münster

32. Blinky Palermo

Untitled. 1970

Dyed cotton mounted on muslin

6' 6 ¾" x 6' 6 ¾" (200 x 200 cm)

The Museum of Modern Art, New York.

Gift of Jo Carole and Ronald S. Lauder

Fig. 1. On Kawara. *Code.* 1965. Color pencil on paper, six sheets, each: 11 x 8 ⅛" (28 x 20.5 cm). National Museum of Modern Art, Tokyo

Since January 1966 On Kawara has been making the paintings in his Today series, in which each canvas's sole image is a hand-lettered date recording the day it was made (see plates 33–35), and each painting is a single segment of an ongoing work that remains unfinished as long as Kawara continues painting. There is a strongly calendrical element to the work: each is painted in a single day, and the artist will not return to it any time thereafter. The painting evokes the place of its making by the language in which the month is written; until recently it was Kawara's practice to accompany each work with a newspaper from the city in which it was made.[1] To a casual observer the Today paintings seem to exist in only a few colors, much the way they have only a few standard sizes, but this is not so; the color of each painting is as unique as the day it chronicles. Using Liquitex acrylic paints, Kawara creates a new color mixture for each painting, applied in two layers atop a consistent two underlayers of raw umber. With rare exception, the titanium white used for every inscription over the course of forty years has not encountered the precisely identical background color twice.[2]

From the moment Kawara started the Today series, he decided to document it in his Journals, a set of notebooks that clarify and heighten the systematic nature of the undertaking (plate 36). These are generic black ring binders, one for each year, filled with the ordinary acetate-covered sheets of black paper used for photo albums or scrapbooks. The year is embossed in gold on the notebook's spine. The Journals, of which he has made a few sets, share the archival impulse of Gerhard Richter's *Atlas,* begun in 1964; but where *Atlas* is an assembly of notes and sources, Kawara's Journals function more strictly as an index. Each year's volume has several categories: a calendar that marks those days on which he has made a painting; "Paintings," a total indicating the year's works and their dimensions; "Colors," a record of the exact shade of each painting; "Places," which covers the period 1966–72, when Kawara included photographs of his environment (images he either shot himself or selected) in the many cities where he traveled and worked; and "Subtitles," consisting of a phrase that might refer to his daily life or the news. Since a winter stay in Stockholm in 1973, spent mainly in darkness and solitude, he has given up the photographs, and simply uses the day of the week for each subtitle.

The "Colors" section of the Journals presents a miniature but complete replication of the Today paintings. Great care goes into this section's making. When Kawara has finished a painting, he applies a swath of its paint mixture to one block in a sheet of paper gridded in pencil for just this purpose. He then cuts a small rectangle from that block and glues it in the Journal's color chart, a grid of five rows across and ten down. Under each color is a number for its sequence in that year

and a letter indicating the size of the painting. The early Journals lay out his initial experimentation with color; the first painting—dated "Jan. 4, 1966"—is in cerulean blue and is followed by various blues, greens, reds, and blacks. No meaning is attached to color choice. Eventually Kawara narrowed his colors almost exclusively to varieties of dark gray, which now constitute the vast majority of his date paintings. The immense range of grays adds focus not only to the shade itself but to the variable of the different fabrics beneath (never identical, although Kawara always orders the same type) and to the shimmering effect of light across the surface of the painting. Each gray is as unique as each day.

Kawara's Japanese heritage may play a part in his exacting view of color; the language has far many more names for different colors than does English, and the Japanese are accustomed to making finer distinctions among them. But it is probably Kawara's transnational way of life that informs his longstanding interest in translation and codes, a fundamental aspect of the Today series and his cataloguing of it in the Journals. His work immediately previous to the Today series reflects this fascination with color as code: a six-part drawing from 1965, *Code* (fig. 1), uses strokes of red, blue, and yellow pencils to translate model love letters from a writing manual. For Kawara, color need neither express nor reveal anything to harbor meaning and feeling. The notion of classification, embodied in a calendar, only underscores the infinity of that which cannot be spoken or shown. —*A.T.*

33. On Kawara
"Today" series. 1966–
January 24, 1967
Liquitex on canvas
18 x 24" (45.7 x 61 cm)
Collection the artist

34. On Kawara
"Today" series. 1966–
March 18, 1967
Liquitex on canvas
18 x 24" (45.7 x 61 cm)
Collection the artist

35. On Kawara
"Today" series. 1966–
June 21, 1967
Liquitex on canvas
18 x 24" (45.7 x 61 cm)
Collection the artist

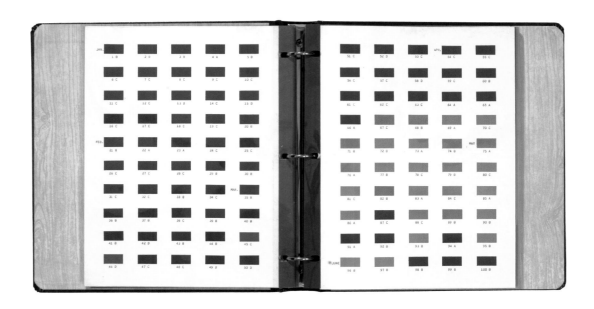

36. On Kawara

Journals. 1966–2000

Ring binders containing typewritten paper, photographs (1966–72),

and color samples of Today paintings in plastic sheets

Thirty-five binders, each: 10 ½ x 12 ½ x 1 ½" (26.7 x 31.8 x 3.8 cm)

Collection the artist

Some of the best moments in Arte Povera were hardware shop moments.

—Alighiero Boetti, 1972[1]

Fig. 1. Alighiero Boetti. Invitation to Alighiero Boetti exhibition, Galleria Christian Stein, Turin, January 1967

Fig. 2. Alighiero Boetti. *Stiff Upper Lip.* 1966. Paint and varnish on wood and cork, 35 ⅜ x 27 ⅝" (90 x 70 cm). Private collection

Alighiero Boetti's first exhibition was presented in January 1967 at the Galleria Christian Stein, in the artist's hometown of Turin. The invitation itself (fig. 1) is a small wonder of what would soon be termed Arte Povera: a sampler of the materials used in the works on view, including hardware-store staples such as electrical cable, PVC tubing, and wire mesh, as well as a letter of the alphabet made of cork. Another item available at a hardware store was automobile paint; Turin, blessed with a rich cultural heritage, was also the site of the Fiat automobile company's headquarters. The city was filled with Fiat employees, and the general population was highly car-conscious. In the 1960s, when automobile bodywork was often a do-it-yourself affair, car paints were arranged at the local hardware store according to the model and year of the vehicles.

Boetti's exhibition at Christian Stein featured, among other things, a few small panel paintings made with automobile paint and featuring quirky phrases spelled out in standard cork letters painted the same color as the background, as in *Stiff Upper Lip* (1987; fig. 2).[2] In the months following the exhibition Boetti found his definitive approach to these monochromes: the cork letters would cite the color name and code number of the paint being used. The paintings (plates 37–43) saluted the poetry of the color names invented by companies such as Max Meyer and Lechler, which supplied the paint for Fiat, Maserati, Alfa Romeo, and others. Certain themes emerge in the nomenclature, such as racetracks (Oro Longchamp, Argento Auteuil, Verde Ascot, Bianco Saratoga) and names that invoke the allure of faraway places (Beige Sahara, Bleu Cannes). Boetti chose a 70-by-70-centimeter format for these monochromes, with the color name and code placed on two lines in the center of the square. Initially he made the panels from Masonite and spray-painted them himself, but for later works in the series he had metal panels fabricated at a friend's auto-body shop, where they also were painted.[3]

Rosso Gilera 60 1232, Rosso Guzzi 60 1305 (1972; plate 43) is one of several versions of the only diptych composition in this family of work.[4] It is a succinct demonstration of color as a manufactured and branded commodity: the two similar but not identical reds represent the warring houses of Guzzi and Gilera, rival motorcycle manufacturers since the 1930s, when Mussolini had declared "better yet the motorcycle" one of the slogans of his regime.[5] Boetti's pair of matter-of-fact red panels (colors manufactured for Gilera and Guzzi by Lechler) cunningly embody the fierce loyalties and passions of the Italian "guzzisti" and "gileristi."

Color would be a lifelong obsession for Boetti; his three-decade career celebrated color as joyously as that of any artist of his generation. Although by the early 1970s he had left the context of Arte Povera, he did not abandon his roots in the

Fig. 3. Alighiero Boetti. *Uno Nove Otto Otto.* 1988. Ballpoint pen on paper, 39" x 9' 1 ¼" (99.1 x 277.4 cm)

Fig. 4. Alighiero Boetti. *Tutto.* 1987. Embroidery on linen, 68 ½" x 8' 2 ¾" (174 x 251 cm). Musée National d'Art Moderne, Centre Georges Pompidou, Paris

movement. He retained the notion of color as something always to be employed in ready-made fashion, directly, with the most ordinary means available. Choices were not to be weighed—the principles of selection were limited to "any" or "all." For the most part, composition and execution of the work was delegated to others so as to avoid any recognition of a single hand, even if this hand were that of an anonymous surrogate for the artist. (The artist's opposition to the myth of the individually complete and coherent genius also underlay his decision, in 1973, to split his name in two and call himself Alighiero e Boetti.) This philosophy is evident in the large body of ballpoint-pen drawings from the 1970s and 1980s, such as *Uno Nove Otto Otto* (One Nine Eight Eight, 1988; fig. 3) made using Biro pens in one or more colors—blue, black, red, and green. Boetti's studio assistants enlisted people from all walks of life to make them, assigning separate individuals to make each panel of these multipart works and following Boetti's dictate that adjacent panels be drawn by a man and a woman. In the embroidered works entitled Tutto (Everything), made since 1971 (see fig. 4), Boetti similarly enlisted hundreds of craftswomen in Afghanistan (and later, Pakistan, where they fled, due to warfare in their country) to fabricate his and his assistants' designs, using their own judgment in the handling of color. Boetti supplied them with high-quality Italian embroidery thread, in the brand that produced the greatest variety of colors. Supplying his collaborators with the necessary chromatic resources, Boetti trusted a plurality of voices to make the colors sing with a more astonishing beauty than a single man's taste or habits could have ever produced. —*A.T.*

37. Alighiero Boetti
Fagus 511 61 95. c. 1968
Cast iron and sprayed industrial paint
27 9⁄16 x 27 9⁄16" (70 x 70 cm)
Private collection

38. Alighiero Boetti
Verde Ascot 1 288 6631. c. 1968
Cast iron and sprayed industrial paint
27 9⁄16 x 27 9⁄16" (70 x 70 cm)
Private collection

39. Alighiero Boetti
Bianco Saratoga 511 22 04. 1967
Industrial paint on cardboard and cork
28 x 28" (71.1 x 71.1 cm)
Private collection

40. Alighiero Boetti
Argento Auteuil 1 234 8287. c. 1968
Cast iron and sprayed industrial paint
27 ⁹⁄₁₆ x 27 ⁹⁄₁₆" (70 x 70 cm)
Private collection

41. Alighiero Boetti
Oro Longchamp 2 234 2288. c. 1968
Industrial paint on cardboard and cork
27 ⁹⁄₁₆ x 27 ⁹⁄₁₆" (70 x 70 cm)
Le Frac des Pays de la Loire. Long-term loan to
the Musée des Beaux-Arts, Nantes

42. Alighiero Boetti
Rosso Palermo. 511 52 27. 1967
Industrial paint on cardboard and cork
25 ⁹⁄₁₆ x 26 ¾" (65 x 68 cm)
Le Frac des Pays de la Loire. Long-term loan to
the Musée des Beaux-Arts, Nantes

43. Alighiero Boetti
Rosso Gilera 60 1232, Rosso Guzzi 60 1305. 1971
Enamel paint on iron
Two parts, each: 27 9/16 x 27 9/16" (70 x 70 cm)
Private collection

Each year the color changes, to avoid a possible significance being given to a single color as preferential, even obsessive or symbolic. —Michel Parmentier, 1967[1]

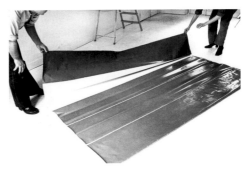

Fig. 1. A painting by Michel Parmentier in the process of being unfolded

Fig. 2. Distribution by Michel Parmentier and Niele Toroni of a pamphlet for the BMPT group, Manifestation 3, June 2, 1967, Musée des Arts Décoratifs, Paris

On January 3, 1967, four young artists made their first public appearance as a collective at the Salon de la Jeune Peinture (Salon of Young Painting): Daniel Buren, Olivier Mosset, Michel Parmentier, and Niele Toroni, all of whom had been painting independently for several years. A tract dated the first of that year, distributed as an invitation to the demonstration at the Salon, explained their common mission. Training the revolutionary spirit of the 1968 generation directly upon the field of art, the text enumerated ten reasons why painting was to be rejected—beginning with "because to paint is a game" and "because to paint is to harmonize or disharmonize colors." Finally, "because to paint is to paint as a function of aestheticism, of flowers, of women, of eroticism, of the daily environment, of art, of Dada, of psychoanalysis, of the Vietnam War," it proclaimed, "we are not painters."[2]

Nevertheless, during the course of their demonstration, each man made a painting before the assembled audience at the Musée d'Art Moderne. All four had educations in painting and backgrounds as painters, and all of them made work that had a more or less direct relation to that tradition. Parmentier's process, which he had developed several months earlier, was the most complex of the four. He stretched canvas that he had bought at the Marché St. Pierre and applied a layer of primer to the entire surface. He then removed the canvas from the stretcher and laid it on the floor to fold it, using a method of pleating that exposed bands of canvas 38 centimeters wide and obscured adjacent bands of the same width in folds underneath them. He then sprayed paint on the exposed areas of canvas, entirely covering the surface while the fabric folded underneath remained pristine white. When unfolded, the seemingly monochrome painting was transformed into an expanse of shiny colored bands alternating with white reserves (fig. 1). Parmentier signed the reverse with his name and the painting's dimensions, and stamped it with the date of its making.

Parmentier began using this method in mid-1966, employing a glossy blue automobile lacquer for all the paintings (see plate 44). In choosing an industrial source, he matched the radicality of his material to that of his method, turning to a paint as nontraditional as the processes of pleating fabric or wielding a spray gun. The choice of blue alluded to the work of Yves Klein and his profound effect on art in France during the previous decade but also starkly differentiated Parmentier from Klein: whereas Klein's blue was an ode to pure pigment, as well as to Klein himself (being named and patented "International Klein Blue"), Parmentier's color had no such implied magic or uniqueness. In his most significant deviation from Klein, Parmentier posited this blue not as a permanent signature but as a color that would be replaced annually. At the demonstration in January 1967 he switched his color to a matte gray, with which he worked exclusively throughout the rest of that year.

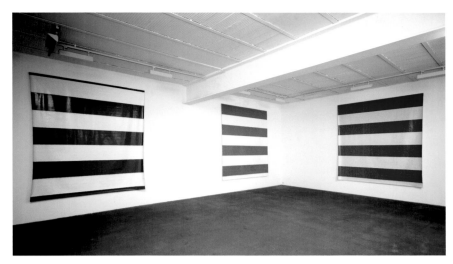

Fig. 3. Michel Parmentier's *April 5, 1966, March 15, 1967,* and *August 5, 1968* installed in the exhibition *Michel Parmentier, Rétrospective 1965–1991,* Galerie Liliane & Michel Durand-Dessert, Paris, 2002

In December 1967, after Parmentier had participated in four BMPT demonstrations (see fig. 2) and on the eve of the group's fifth, a philosophical dispute prompted him to take leave of Buren, Mosset, and Toroni. His colleagues had decided that for this occasion the four artists would make each other's paintings, swapping stylistic approaches among themselves explicitly to dissociate a particular style from a single individual. Parmentier objected to this concept; uniquely among them, he argued that an artist's work is always his or her own, even if a painting might appear virtually anonymous in its execution. He continued his project independently, returning to glossy lacquer and choosing the color red for 1968, which now reads inevitably as a prescient allusion to the political events of that year. But Parmentier was soon to renounce art altogether for what would be a fifteen-year abstention from painting. Despite the short span of his experiment, today the fewer than fifty paintings of the years 1966, 1967, and 1968 (see fig. 3) remain vivid testimony to an idealistic moment in which artistic and social change were seen as integral to one another. —*A.T.*

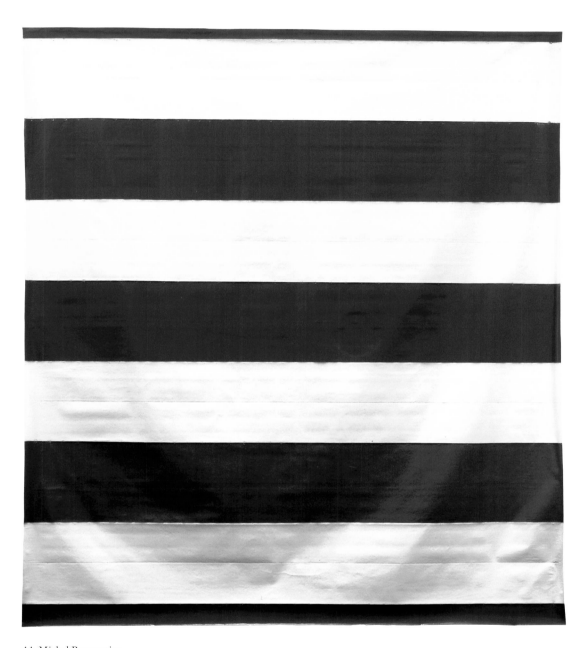

44. Michel Parmentier

April 5, 1966. 1966

Lacquer on canvas

9' 2 ⅝" x 8' ⁷⁄₁₆" (281 x 245 cm)

Collection Liliane and Michel Durand-Dessert, Paris

DANIEL BUREN *(French, born 1938)*

We can merely say that every time the proposition is put to the eye, only one color (repeated on one band out of two, the other being white) is visible and that it is without relation to the internal structure or the external form that supports it and that, consequently, it is established a priori that white=red= black=blue=yellow=green=violet, etc. —Daniel Buren, 1969[1]

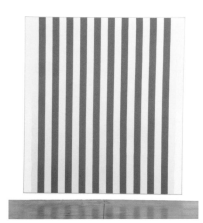

Fig. 1. Daniel Buren. *White Acrylic Painting on White and Anthracite Gray Striped Cloth.* 1966. Synthetic polymer on canvas, 7' 5 ¾" x 6' 5 ⁹⁄₁₆" (228 x 197 cm). The Museum of Modern Art, New York

In 1965 Daniel Buren began buying striped canvas at the Marché St. Pierre in Paris. The fabric, manufactured for outdoor use in café awnings and beach cabanas, came in bolts of 140 centimeters, with stripes generically 8.7 centimeters wide. At first he used the fabric as a support for painting biomorphic compositions, but by autumn 1966 he had confined himself to white paint, which he used only to suppress the stripes at or near the left and right borders of each painting (see fig. 1). By 1968 Buren had freed the canvas from paint and from the format of a painting altogether and was using it in installations that called attention to all the areas and aspects of gallery display that are usually ignored, whether within a museum or beyond its walls. The tactic was directed against painting and, implicitly, all the bourgeois values and habits that went with it, including the cult of personality surrounding the artist. This latter problem had been temporarily addressed in late 1966 by his decision to work with artists Olivier Mosset, Michel Parmentier, and Niele Toroni as the group BMPT, which lasted until the end of 1967.

Central to Buren's position was a need to "divest [color] of all emotional or anecdotal import."[2] He therefore bought and used all the available colors of the striped canvas: green, blue, orange, red, brown, black, and two grays. As the headline for the first magazine article on Buren proclaimed in 1965, "*Daniel Buren prend ses couleurs sans les choisir*"—Daniel Buren uses colors without choosing them.[3] Initially he used just one at a time. When he began to include more than one color in a work, and eventually a variety of striped materials, he maintained the same insistence on avoiding or negating his own choice by including all the available colors or engaging some form of chance or arbitrary system. When he installs a multicolored striped work, for example, the sequence of colors is determined by the alphabetical order of their names in the language spoken where the work will be seen. Further, to undo the importance of his dictate at any particular moment, Buren stipulates that the installations contained in museums' permanent collections must vary in color over the course of subsequent presentations.

Buren first did the *Gilets* (Vests) project for a group exhibition at the Van Abbemuseum in Eindhoven, The Netherlands, in 1981.[4] His contribution was to outfit the museum guards in silk vests with fuchsia stripes (plate 47), a choice of color based on the name of the museum's director, Rudi Fuchs. (The pun came full circle when Buren learned that the fuchsia plant had been named for the sixteenth-century botanist Leonhard Fuchs.) For the vests of the guards during the current exhibition at The Museum of Modern Art, Buren chose blue, yellow, red, green, and gray. The vests were made according to Buren's design, with silk produced and printed in Lyon.

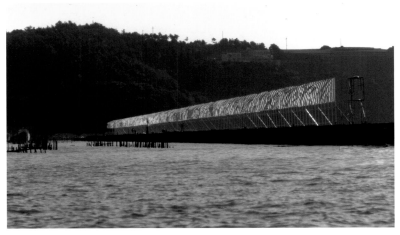

Fig. 2. Daniel Buren. *L'Arc en ciel.* Installation view, Ushimodo, Japan, 1985

Fig. 3. Daniel Buren. *Ponctuations, statue/sculpture.*

Installation view, Lyon, November 1980

The exuberant chromatics of the guards in motion belie the rigor of the project's conceptual underpinnings, which date back to the intellectual position Buren assumed in the late 1960s. The main point of the stripes is not to draw attention to themselves but to all the aspects of the museum that lie beyond the conventional framed painting hung at eye level. Buren has often commented on the subtle tyranny of the museum experience, in which a viewer is expected to look at certain things but not at others to which his or her gaze might naturally be drawn, such as other visitors or the view out the window (plate 46). For forty years he has worked to encourage a wandering eye, installing stripes on all parts of the wall, including corners and near the ceiling and floor, as well as in corridors, stairways, and other areas usually considered ineligible for art and in a variety of outdoor locations, as in *L'Arc en ciel* (Rainbow, 1985; fig. 2) and *Toile/Voile* (Cloth/Sail, 2005; plate 45). Buren's stripes signal that all these places have a role in the viewers' experience. His works have called attention to benches and pedestals, for example, both of which stress the importance of a given painting or sculpture by means of furniture that is meant to go unnoticed, as in *Ponctuations, statue/sculpture* (Punctuations, Statue/Sculpture, 1980; fig. 3).

Perhaps the most important auxiliary presence in museum galleries is that of the security guards. Their role speaks volumes about subjects seldom considered in art history, such as the works' economic values or their physical vulnerability. Aside from admissions staff, the guards are the only representatives of the institution with whom most museumgoers come in contact, and as such they enforce a host of policies and decisions in whose making they had no part. Not wishing to lecture about such issues, Buren relies on his art to reveal them: by highlighting the presence of the guards with the special vests, perhaps he will spark these or other musings on the part of the individual visitor. Meanwhile the dividing line between the works of art and those who guard them is partially eroded, as the guards themselves become as much part of the event as what is on the walls. —*A.T.*

45. Daniel Buren
Toile/Voile. 2005
Wordsworth Museum & Art Gallery,
Grasmere, England

46. Daniel Buren
"Watch the doors, please!"
Installation view, October 1980, as seen from a window
of the Art Institute of Chicago

47. Daniel Buren
Essai hétéroclite: les gilets. 1981–
Silk vests for museum guards
Installation view, 1981, Van Abbemuseum, Eindhoven

NIELE TORONI *(Italian, born 1937)*

Method: A no. 50 brush is pressed on the given support at regular intervals of 30 cm

The support: canvas, cotton, paper, waxed cloth, wall, floor (on a white ground
as a rule)

Application: " . . . to place one thing over another in such a way as to cover it,
adhere to it or leave an imprint." (translated from the Petit Robert *dictionary)*

no. 50 brush: flat brush, 50 mm wide. —Niele Toroni, 1966[1]

Fig. 1. Niele Toroni, *Imprints of a No. 50 Brush Repeated at Regular Intervals of 30 cm: Intervention*, Fontenay-Le-Comte, France, 2003. Industrial acrylic latex. Courtesy Marian Goodman Gallery, New York

Since 1966 Niele Toroni has been making what he calls *travaux/peintures*, or "works/paintings." They all have the shared title *Imprints of a No. 50 Brush Repeated at Regular Intervals of 30 cm*, and all follow the method cited above, which Toroni elaborated forty years ago and from which he has never deviated. Although he occasionally paints on canvas or on sheets of paper, most often he makes these imprints directly on the interior or exterior surfaces of a building, whether a historic facade, the white cube of a gallery, or a busy shop or café (see figs. 1–3 and plate 48). His response to a specific site determines the boundaries and expanse of his grids of marks.

As the composite designation "works/paintings" suggests, these imprints are paradoxical creations. They emphasize the traditional essentials of *painting*—brushstrokes of color on a surface—and yet ignore many of the conventional qualities of *paintings*, among them the existence of a transportable, durable object. The simplicity of Toroni's practice is breathtaking yet rife with contradictions; although his means could not be more commonplace, they are directed toward fiercely radical ends. Toroni wishes to challenge much that Western art has long held dear: the notion of a progressive development within one's career, the glorification of individual genius, the worship of the masterpiece. But his mission is hardly nihilistic. The form of his imprints is both modest and laconic, but their steady perseverance—in any one work and over the course of forty years—has become an intensely moving defense of painting during an era when its death has been much touted.

Toroni devised his method in part to serve as a steadfast guardian against admitting subjectivity into his work. The variable of color choice might seem to permit it to make a sneaky entrance, but Toroni prevents this by choosing casually and using many. "I use them all," he has noted, "so as to avoid making one more important than the others."[2] Only one color is used for an individual section of brush marks, but a multipart installation could involve several colors. Like the imprint, a readymade and uniform product of the brush rather than an expressive gesture, Toroni's color carries no creative import. As to whether a certain *travail/peinture* might have looked better in one color or another, he has simply said, "I shall never know, not having seen the work."[3] On rare occasions he will choose colors that have a conceptual link to the situation, usually with a dash of humor (an installation in Grenoble, for example, birthplace of the great nineteenth-century novelist Stendhal, used the title colors of his novel *The Red and the Black*). In general, however, Toroni reserves his exercise of judgment for pragmatic issues such as the selection of an acrylic house paint that is viscous enough to prevent running, so as not to spoil the clean rhythm of the self-contained marks.

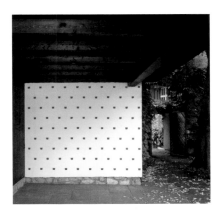

Fig. 2. Niele Toroni. *Imprints of a No. 50 Brush Repeated at Regular Intervals of 30 cm:*
Red Painting. Yellow Painting. Blue Painting. Black Painting. Each 1997. Synthetic polymer
on canvas, each: 9' 10 ⅛" x 55 ⅛" (300 x 140 cm). Installation view, Marian Goodman
Gallery, 1997

Fig. 3. Niele Toroni. *Imprints of a No. 50 Paintbrush*
Repeated at Regular Intervals of 30 cm: Painting in a
Garden. Acrylic latex on paper. Galerie Tschudi,
Glarus, Switzerland, 1993

The paradoxical nature of Toroni's work is perhaps most apparent in the
matter of individuality and anonymity. The announcement for his first solo show,
at Galerie Yvon Lambert in Paris, in 1970, did not contain his name but simply
invited the public to see "imprints of a no. 50 brush, repeated at regular inter-
vals (30 cm)." The wall text for a show the following year explained that the work
on display was by Toroni but could be made by anyone applying the prescribed
method, which would create "a work by X." But few if any people have chosen to
avail themselves of this opportunity, and so, forty years later, the brush marks are
signature "Toronis" no less than dripped lines of paint are "Pollocks." Although
Toroni initially intended the brush mark as an alternative to—and implicit critique
of—the autographic value that might be signaled by a fingerprint, the opposition
has evaporated. The very quality of anonymity that attracted him to the imprints
of a no. 50 brush has been lost, a victim of the consistency and persuasiveness of his
work despite its utter lack of pretense. But his principles remain intact, a situation
that will be most apparent posthumously. The vast majority of his work exists only
in documentary images (they usually are painted over at the end of an exhibition),
and no more will be made after his death. Immortality, it seems, is one more myth
of Western painting that Toroni can do without. —*A.T.*

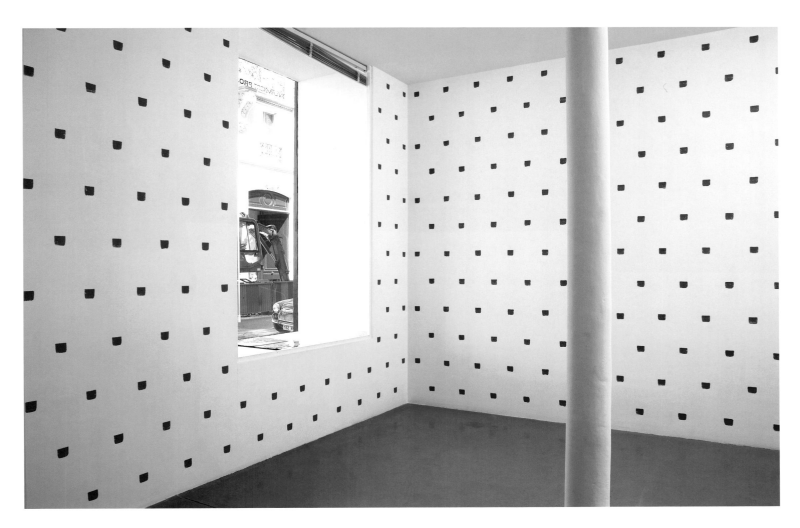

48. Niele Toroni

Imprints of a No. 50 Brush Repeated at Regular

Intervals of 30 cm. 2004

Acrylic latex on wall

Installation view, Galerie Yvon Lambert, Paris, 2004

I still don't trust any kind of lush solution, which painting was, and so I decided—it was a conscious decision at some point—that I was not going to be a painter. The decision was hard, but I was young enough that it wasn't that hard. —Bruce Nauman, 1988[1]

Fig. 1. Cover of color chart for Pittsburgh Paints Sun-Proof house paint, 1965

P.P.G. Sunproof Drawing No. 1 (1965; plate 49) is inscribed with a precise date: 9/7/65. The date marks the beginning of Bruce Nauman's second year in the M.F.A. program at the University of California, Davis, which he had entered as a painter. By autumn 1965 he had begun to abandon his paintings in a gradual development that had first included attaching sculptural forms to them, and "then I stopped making the paintings altogether and just made the shapes."[2] In his first year of graduate school, Nauman had not only created his earliest fiberglass sculptures but also ventured into performance, using his body "as a piece of material."[3]

 P.P.G. Sunproof Drawing No. 1 is at some level a performance, one that could be considered Nauman's farewell to the "lush solution" of painting. He took as his point of departure a Pittsburgh Paints color chart for Sun-Proof paint (figs. 1 and 2).[4] The original chart had three columns of four body colors and one column of six coordinating trims. Nauman eliminated one column of body colors and then placed the color chart in the photocopy machine at the U.C. Davis library.[5] Originally, the drawing would have featured the shades of gray produced by the machine. By now, though, the colors have shifted to a range of chocolates, coffees, and tans. The names of the colors, from "everglade green" to "redwood" as well as the parenthetical trim colors in the last column, remain clearly legible.

 Nauman is an exquisite draftsman, and drawing would play a vital role in his work, but this "drawing," as the title declares it, is almost entirely hands-off, technically more of a print. The artist's presence is felt only in the inscribed title, signature, and date, all placed in a narrow margin next to the color columns, which he had turned on their sides. Yet the concerns it reveals closely relate to Nauman's work in general. Its deadpan irony matches that of the early films and sculptures, in which he often enlisted both language and image to confuse or complicate meaning. Since his days as a painter Nauman has been interested in the power of ambiguity—of saying, doing, or making something that could mean either one thing or another. Art historian Coosje van Bruggen has noted that "Nauman often involves his audience in his work by keeping information from them, by setting up expectations that are not fulfilled, by creating discrepancies between what the viewer knows and does not know, sees and does not see."[6]

 This spirit owes much to Marcel Duchamp, who used a similar approach in works such as *With Hidden Noise* (1916), a small sculpture containing within it an object of unknown identity. Nauman notes that he found his path to Duchamp via Jasper Johns, whose work he knew first.[7] Johns's *False Start* (1959; page 64, fig. 1), while admittedly lush, anticipates Nauman's in its creation of a distance between what is seen and read in terms of color. Nauman shared with Johns a deep interest in the

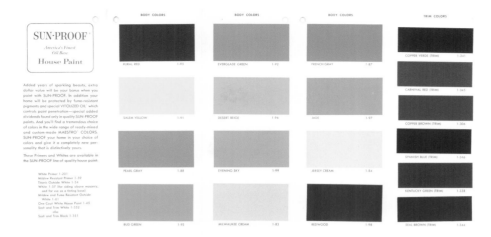

Fig. 2. Color chart for Pittsburgh Paints Sun-Proof house paint, 1965

writings of Ludwig Wittgenstein and Samuel Beckett, which provide a fundamental background to his work of this period. For both authors the matter of language in general and word play in particular have profound ramifications.[8] Here Nauman enjoys a pun at the expense of the claim implicit in the Sun-Proof brand name; its resistance to color loss has collapsed under Nauman's intervention at the photo-copy machine.

Color, like language, would continue to play an important role in Nauman's work, an interest that was already evident in the fiberglass sculptures he made in 1965 and 1966. Unlike the comparable work made in the mid-to-late 1960s by artists such as Eva Hesse, Robert Morris, and Richard Serra, these sculptures were produced in a variety of oddly off-key tones achieved by mixing the paint into the liquid plastic. In 1966 art critic and curator Lucy Lippard, an early champion of Nauman's work, neatly described the color of his sculptures as "spiritlessly urban, but not commercial—like a shrimp pink house badly in need of a paint job."[9] —*A.T.*

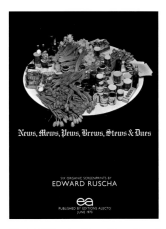

Fig. 2. Ed Ruscha. *News, Mews, Pews, Brews, Stews & Dues.* 1970. Cover of prospectus

Fig. 3. Ed Ruscha. *News, Mews, Pews, Brews, Stews & Dues.* 1970. Back cover of prospectus

as "a little treasure chest of overlooked things, disregarded or something. Stains have always been scorned, I guess."[8]

Ruscha went on to deploy his palette of stains in the silkscreen series *News, Mews, Pews, Brews, Stews & Dues*, produced in 1970 at Editions Alecto (plate 52). The six words of the series' title, which are also the subject matter of the six prints, were chosen by Ruscha for their association with things British, connotations he reinforced by using an Old English type font.[9] The cover of the prospectus announcing the portfolio (fig. 2) draws attention to Ruscha's unconventional methods with a large color photograph of his materials that conflates artist's worktable with kitchen table. What at first appear to be pots of paint turn out to be jars and cans of foodstuffs, arrayed on a tabletop amid piles of flowers, eggs, and strawberries; Ruscha used a mortar and pestle to crush these ingredients into ink, as if grinding pigment or, in one writer's words, "making pesto."[10] As he had with *Stains*, Ruscha flaunted the store-bought character of his materials, noting on the colophon page the manufacturer of each item (chocolate syrup by Hershey Foods, Pennsylvania; axle grease by Total Limited, London), as well as the name and address of the market and—in the case of the axle grease, the garage—where he had purchased it. Other photographs in the prospectus further highlight shopping as a crucial stage of the creative process, showing Ruscha at the supermarket, perusing the shelves for Tabasco sauce (fig. 3).

With *Stains* Ruscha had accepted the results without editing, but in the case of *News, Mews, Pews* he spent weeks of trial and error determining what materials could be silkscreened satisfactorily. He eliminated substances that chipped or bled but accepted unpredictability when it came to color. That he found it "very difficult" to guess what hue an ingredient would yield was part of the fun for him; he was interested, not disappointed, when tomato paste dried to a "grey dust."[11] Composing the bizarre recipes for his prints seemed to gratify him as much as the visual results: "The pleasure of it is both the wit and the absurdity of the combination. I mean the idea of combining axle-grease and caviar!"[12] Writing in *Artnews* twelve years after *News, Mews, Pews* was made, Patricia Failing noted that the colors in the prints were "rather mundane considering their origin" and that several of them had changed in appearance over time.[13] Neither observation would have disturbed Ruscha, who, as Failing pointed out, "tended to regard [color] changes as bonuses," and liked his mundane vocabulary of stains enough to continue its intermittent use for about a decade. As he had told a reporter at the time of making *News, Mews, Pews*, "What I'm interested in is illustrating ideas. I'm not interested in color; if color suits me I use it intuitively . . . either it works or it does not work."[14] —*M.H.*

51. Ed Ruscha

Stains. 1969

Portfolio of stain prints using various mediums, plus one

stain print on the inside cover of the box

Inventory page and seven of seventy-five stain prints, each sheet:

11 ⅞ x 10 ¾" (30.2 x 27.3 cm)

The Museum of Modern Art, New York. Gift of Iolas Gallery

52. Ed Ruscha

News, Mews, Pews, Brews, Stews & Dues. 1970

Screenprints on paper (printed using chocolate syrup, tomato paste, Bolognese sauce, cherry pie
filling, coffee, caviar, axle grease, daffodils, tulips, raw eggs, and other store-bought materials)

Six sheets, each: 23 x 31 ½" (58.4 x 80 cm)

The Museum of Modern Art, New York. Purchased through the generosity of Kathy and
Richard S. Fuld, Jr.

Brews

Stews

Dues

What the work of art looks like isn't too important. —Sol LeWitt, 1967[1]

In "Paragraphs on Conceptual Art," his landmark text from 1967, Sol LeWitt mentions color only twice, both times in describing the kind of "expressive" and "perceptual" art his own work opposes. Reacting against the heroic ideals of post-war American painting, LeWitt advocated art that was "mentally interesting" but "emotionally dry," turning to modular and serial permutation to define his program. His first wall drawing, made in 1968, used a simple vocabulary of vertical, horizontal, and 45-degree diagonal lines, rendered in hard black graphite and overlapping in systematic combination. In such serially determined work, wrote LeWitt, "The idea becomes a machine that makes the art."[2] With few exceptions, he left the execution of his wall drawings to others. The artist's role was to conceive the idea and provide instructions for a draftsman to follow: "The artist [selects] the basic form and rules. . . . After that the fewer decisions made in the course of completing the work, the better. This eliminates the arbitrary, the capricious, and the subjective as much as possible."[3]

Color, like line, could be handled objectively, as an elementary visual unit rather than an expressive device. LeWitt introduced color to his wall drawings in 1969, using Koh-I-Noor pencils in black, red, yellow, and blue (plates 53 and 54). Until the early 1980s, when he expanded his palette to include the secondary hues, he continued to limit himself to black and the three primaries—the colors, he pointed out, of mechanical printing.[4] And like mechanical reproductions, the early wall drawings achieve an astonishing chromatic and tonal range through the variation and superimposition of these few elements. The lesson from Albers was that color is relational; red looks different with blue than with yellow. From LeWitt we further learn that red will look different if, as the instructions say, the lines are drawn straight or not straight, touching or not touching, crossing or not crossing. Color mixtures were not devised to please the eye but, as always, generated automatically, according to predetermined plan.

If LeWitt used plan to suppress the subjective, he still appreciated, even courted, the irrational and the unexpected. The idea as "machine" notwithstanding, LeWitt's art relies on human contingency. As he points out, "Conceptual art is not necessarily logical. . . . Some ideas are logical in conception and illogical perceptually."[5] Take this piece from 1971: "Lines not short, not straight, crossing and touching, drawn at random using four colors, uniformly dispersed with maximum density, covering the entire surface of the wall" (plate 53). The plan is coherent, but the results are unpredictable. LeWitt not only accepted the decisions the draftsman made within the parameters of the plan as "part of the plan,"[6] he brought attention to them by incorporating his directives in the title. Checking visual outcome against verbal

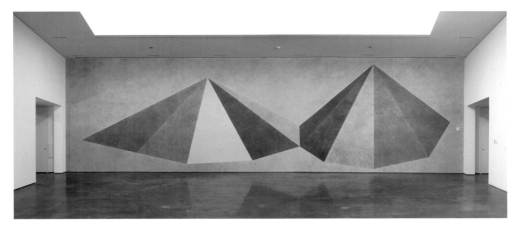

instructions instantiates LeWitt's art; the uncanny effect is that the wall drawings at once broadcast clarity of procedure and startling complexity of form. In the end, LeWitt's art is perceptual as well as conceptual, sensory as well as linguistic. As he noted, "Ideas of wall drawings alone are contradictions of the idea of wall drawings."[7] Only once a plan is actualized in color and line is it "open to the perception of all, including the artist."[8]

Yet as LeWitt knew, "Perception is subjective."[9] He was unperturbed when his wall drawings were criticized for being too ugly—or, as was more usual in recent decades, for being too beautiful. In 1970, the critic Lucy Lippard, a friend of LeWitt, wrote to him to say that she disliked the appearance of a wall drawing that had been created by "four draftsmen . . . employed at four dollars per hour for four hours a day and for four days [drawing] straight lines four inches long randomly, using four different colored pencils"[10]—presumably because the results were four squares of muddy color. LeWitt replied, "Don't particularly care whether it is beautiful or ugly or neither or both . . . if I give the instructions and they are carried out correctly, then the result is ok with me."[11] His reaction was similar when asked about the "visually aggressive"[12] direction his wall drawings took in the 1980s (see fig. 1): "To be truly objective one cannot rule anything out. All possibilities include all possibilities without pre-judgment or post-judgment."[13] LeWitt was no puritan when it came to color, as the opulence of his later work attests (see page 25, fig. 20). Removing personal expression from color did not mean rejecting its dramatic range and unpredictable perceptual nature. Color was in fact the perfect vehicle for an artist whose method was only ever quasi-mechanical and left plenty of room for paradox and intuition. Near the end of his life LeWitt commented, "I never tried to arrange the color or the other forms to please the eye. In fact, I tried to use the system or randomness to avoid preconceived notions of aesthetic 'beauty' or other color statements."[14] He also said, "If it turns out to be beautiful, I don't mind."[15] —*M.H.*

53. Sol LeWitt

Wall Drawing #65 (Lines not short, not straight, crossing and touching,
drawn at random using four colors, uniformly dispersed with maximum
density, covering the entire surface of the wall). 1971. Detail

Red, yellow, blue, and black pencil on wall

Dimensions variable

National Gallery of Art, Washington, D.C. The Dorothy and Herbert

Vogel Collection, Gift of Dorothy and Herbert Vogel, Trustees

54. Sol LeWitt

Wall Drawing # 95 (On a wall divided vertically into 15 equal parts,
vertical lines, not straight, using four colors in all one-, two-, three-,
and four-part combinations). 1971

Red, yellow, blue, and black pencil on wall

Dimensions variable

Musée National d'Art Moderne, Centre Georges Pompidou, Paris

My requirements for a story can be brief: "I'm going to count, and I'm going to have one color expand and dominate the situation." That's a great story, to me.

—Jennifer Bartlett, 2005[1]

In late 1968, Jennifer Bartlett began making paintings on one-foot-square steel plates. She got the idea from seeing the metal signs in New York City subway stations—"They looked like hard paper."[2] Bartlett had her plates manufactured by an industrial supplier in New Jersey, and enameled white by a company that usually worked on household appliances. The steel squares were then silk-screened with a light-gray quarter-inch grid, indeed yielding a durable version of graph paper. The plates allowed Bartlett to work and rework her ideas, both because they could be wiped clean and repainted, and because their modular nature facilitated endless shifting and addition. Their gridded surface perfectly suited the systematic method that preoccupied Bartlett at the time. Using Testors brand enamel paint—intended for use by hobbyists on model airplanes and cars—Bartlett applied dots of color to the squares of the grid according to simple mathematical schemes. Like many young artists at the end of the 1960s, Bartlett was inspired by the example of Sol LeWitt, whose "Paragraphs on Conceptual Art" she read in 1967 and describes as "one of the great mid-century poems."[3] Like LeWitt's wall drawings, Bartlett's early plate paintings were determined by plan. For example, in *1 Dot, 2 Dots* (1973), a series of nine plates, the first plate was painted following the pattern dot-space-dot-space. The second plate: dot-dot-space-dot-dot-space. The third: dot-dot-dot-space-dot-dot-dot-space; and so on. Making art this way appealed to Bartlett because it meant she didn't need to wait for inspiration to strike but could simply go to work: "I was looking for a way to get work done without the burden of having to do anything good."[4] Compulsive in her studio habits, Bartlett enjoyed the well-defined labor of counting and applying thousands of dots of paint.[5] She also took pleasure in the visual patterns that unexpectedly emerged from her recipes. She still marvels at how a simple counting scheme produced parabolic shapes: "I don't know why. I understand the visual phenomenon but would not understand the explanation. But chaos theory made absolutely perfect sense to me."[6]

Color was a powerful tool in conveying the "chaos theory" at play in Bartlett's simple assignments to herself. Testors paint came in twenty-five colors, but she usually limited herself to six: white, yellow, red, blue, green, and black. When employing this palette, Bartlett put the colors on in that order, straight out of the bottle. She recently commented, "I was just going to use white, black, yellow, red, and blue, but if you use a children's crayon box, there would be green in there."[7] In *Equivalents* (1970; plate 55), Bartlett applied her sequence of colored dots in an orderly row on one enameled steel plate and then in a random arrangement on another. She doubled the number of dots with each pair of plates she painted, starting with six dots per plate and ending with 1,536. The contrast between the two columns of plates—

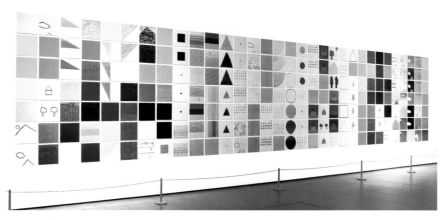

Fig. 1. Jennifer Bartlett. *Rhapsody.* 1975–76. Enamel on 987 steel plates, each: 12 x 12" (30.4 x 30.4 cm), overall: c. 7' 6" x 12' 9" (2.28 x 46.63 m). The Museum of Modern Art, New York. Gift of Edward R. Broida

one showing neat blocks of color growing predictably bigger and the other, a scintillating, ever-busier proliferation of dots—is testimony to how different results are possible from the same constituent parts with only minor changes to procedure. *Binary Combinations* (1971; plate 56) likewise provides a compelling internal comparison, one that focuses on the systematic creation of color. Here Bartlett paints a color chart of all of the two-color combinations possible using her customary vocabulary of white, yellow, red, blue, green, and black. But she achieves her combinations in two different ways: by applying the two colors in alternating dots and by mixing equal amounts of the two paints to make a new hue. "Yellow plus red" thus has two distinct incarnations: a lively checkerboard of red and yellow and a solid grid of bright orange dots. Color to be mixed in the mind and color mixed on the palette are displayed side by side.

Bartlett did not work in a strictly programmatic mode for long. In 1976, she debuted *Rhapsody* (1975–76; fig. 1), an enormous work that resulted from Bartlett's challenge to herself to make a painting with "everything" in it.[8] Consisting of 987 plates, encompassing both abstract and representational imagery and involving multiple, overlapping narratives, *Rhapsody* has been compared to a novel, an encyclopedia, and an opera.[9] Yet this sprawling epic can still be broken down to its basic parts—the twenty-five Testors colors Bartlett used to paint it, for instance. On the flip side, a supposedly dry work like *Equivalents* can be seen to contain elements of drama: the sequential growth of color and dots would no doubt qualify, in Bartlett's mind, as "story." Narrative has never been entirely absent from Bartlett's work. The story it has consistently told is of how an artist makes a painting, colored dot by colored dot. —*M.H.*

55. Jennifer Bartlett
Equivalents. 1970
Enamel over grid silkscreened onto baked enamel
on steel plates
9' 8" x 25" (294.6 x 63.5 cm)
Collection Robert Magoon

56. Jennifer Bartlett
Binary Combinations. 1971
Enamel over grid silkscreened onto baked enamel on steel plates
64" x 7' 4" (162.6 x 223.5 cm)
University of California, Berkeley Art Museum and Pacific Film
Archive, Gift of Penny Cooper and Rena Rosenwasser

And there are sentiments that are involved with [color]. The only way Albers used to really talk about it was in terms of wet and dry. But when he gets to wet and dry, he's getting into a very tricky area. He's talking about a certain emotive readout. And all of a sudden we're getting into subjectivities. . . . And I thought, "Whoa, Josef, we're getting off here." —Richard Serra, 2007[1]

Fig. 1. Josef Albers. Illustration from *The Interaction of Color*. New Haven and London: Yale University Press, 1963

Richard Serra's thirty-six-minute film *Color Aid* (1970–71; plate 57) could be considered his belated rejoinder to Josef Albers's magnum opus, *The Interaction of Color* (1963). Color-aid paper, a product initially developed in 1948 to provide photographers with background hues, had quickly been adopted by Albers as an ideal teaching tool. The 220 colored sheets in each box offered a uniform basis for the students' color exercises, was mess free, and obviated the need for the technical skill demanded by paint. Gone, however, in Serra's film, are Albers's careful experiments in color juxtaposition, presented in *The Interaction of Color* as thoughtfully arranged and explained configurations (fig. 1). In *Color Aid* the interaction of color has nothing to do with an artist's compositional work in space but merely with the entrance and exit of different colors over time. The viewer witnesses a parade of 220 individual colors, their order of appearance dictated by how they were packaged in the box of Color-aid paper.

Serra had spent many hours using Color-aid paper as a student at Yale from 1961 to 1964, where he excelled in Albers's color course and then taught it in his third year. "I have an eye for it. And I liked it. I used to do thousands of [color studies]. I used to stay up all night and do them. And because I was so into it, they thought, 'Let the guy teach it.'"[2] When *The Interaction of Color* was en route to publication, during the summer of 1963, he was hired to color-proof the reproductions, an exacting task that involved the rejection of any pages in which imperfect color printing scrambled the message a particular study was meant to convey.

Despite his excellence in this realm, Serra's ambitions eventually led him elsewhere. During a Fulbright year in Florence, in 1965–66, he experimented with chance procedure as a way to accommodate his distrust for the subjectivities of color composition. His last paintings, made in that period, were grids that he arbitrarily filled with colors from an array of buckets, using a stopwatch to equalize the amount of time spent on each square. After some library research proved that the project was not as original as he had thought, Serra concluded that even Cageian methods were not going to help him resolve the issue of post-relational color. He threw the paintings in the Arno River (which had received a dejected Robert Rauschenberg's works thirteen years earlier), and with them his plans to become a painter. Whereas an early sculpture such as *Belts* (1966–67), made after his return to New York, still addresses the question of color, by the end of 1967 he had largely dismissed it from his work.

Color Aid was one of seventeen films that Serra made between 1968 and 1979. His interest in the medium highlights the central importance of process and performance to post-Minimal sculpture, and it reflects the close community of artists,

Fig. 2. Richard Serra. *Hand Catching Lead.* 1968. Film: 16mm, black-and-white, 3 mins. 30 secs. The Museum of Modern Art, New York

choreographers, dancers, composers, musicians, and filmmakers in downtown New York at that time. Like Serra's other films and works such as *Splash Piece: Casting* (1969), *Color Aid* was not scripted or rehearsed. It made use of an unopened box of Color-aid paper that Serra had in his New York studio, left over from his school days. Filmmaker Robert Fiore served as the cameraman, as he had for several of Serra's earlier films. Serra did not know how long *Color Aid* would last, but he knew that he would start with the top sheet and use every one until he reached the bottom, and that he would not edit the film's real-time duration. As is usual in Serra's work, *Color Aid* has a succinct self-referential quality, with the sequential passage of the colored sheets evoking the progression of frames of film.

The two protagonists of the film are Serra's hand, which wipes each sheet off the top of the stack, and the paper itself. (Serra's darkened fingernails are the only clue to his more usual work with metals.) The time that any given color fills the screen was governed by the whim of the artist, who did not know which color would follow in the sequence or what its afterimage might be in relation to the next color. Each color's time on camera ranges from one second to more than twenty. The context of the film exaggerates the difference between these spans of time; and the suspense of whether a particular color will vanish quickly or linger keeps the viewer in a state of constant tension, even as the repetition tests his or her patience. Sound also plays an important role in the film's strong psychological impact. The scraping noise picked up by the microphone as Serra's fingers pull a sheet of paper from the top of the stack is excruciating, and it is all the worse for its continual recurrence. The intentional aggression of the film was not lost on Serra's early viewers. Serra showed *Color Aid*, along with *Hand Catching Lead* (fig. 2) and his other "hand" films from 1968, as a visiting artist at Yale in the early 1970s. He recalls that although the students didn't mind the other works, they became quite anxious when they watched *Color Aid*, "like, '*stop* already.' I think it debunked a lot of what they were still attached to."[3] —A.T.

57. Richard Serra
Color Aid. 1970–71
16mm color film with sound, 36 mins.
The Circulating Film Library of The
Museum of Modern Art, New York

Green as Well as Blue as Well as Red

Red and Green and Blue More or Less

Red Over and Above Green Over and Above Blue

Red in Relation to Green in Relation to Blue

Red in Lieu of Green in Lieu of Blue

—Lawrence Weiner, 1972

Fig. 1. Lawrence Weiner. *Many Colored Objects Placed Side by Side to Form a Row of Many Colored Objects.* 1979. Installation view, Raas van Gaverestraat, Ghent. Collection Annick and Anton Herbert

Lawrence Weiner's *Green as Well as Blue as Well as Red . . .* (1972; plate 58) fills the mind with color, even though its form is generally black text on a white wall. The seemingly descriptive statements are precise and yet not. As in his later and more well-known work *Many Colored Objects Placed Side by Side to Form a Row of Many Colored Objects* (1979; fig. 1), these phrases do not provide a recipe for any one correct image or set of images. Weiner deliberately provides colors without dimension or shape, without specific value or hue. Rather, he offers open-ended ambiguity— "more or less," "in relation to," "over and above"—and thereby infinite possibility. The whole is self-contradictory: in the first statement the colors coexist, and in the last they replace one another. As the color names repeat over the course of the five statements (and each statement is considered by Weiner to be an individual work, although they are generally installed together), the cadence of the memory-resistant phrases gives the work a power as aural as it is visual.

Green as Well as Blue as Well as Red is the only of Weiner's works to exist in multiple forms—as a wall work, an artist's book (fig. 2), and a video of the same name (fig. 3). The artist's book consists of the five phrases in the wall work along with five other phrases that sometimes include parentheses and underlines used as punctuation or as ancillary symbols. The video uses the statements as a point of departure for an emotionally charged performance piece that speaks most clearly to the works' origins in the sociopolitical and artistic climate of the early 1970s.[1]

Weiner's choice of green, blue, and red for these five statements corresponds to the RGB panel of analog color television and video projection; every image seen on a monitor is the product of three separate images in green, blue, and red, refracted to project the properly colored result onto the screen. *Green as Well as Blue as Well as Red* shares its link to television with the first paintings that Weiner exhibited after he began working as an artist, in his early twenties. The Propeller paintings, 1963–65 (fig. 4), were based on the television test patterns of the time, which were broadcast repeatedly through the night after programming had ceased. The test patterns provided Weiner with a ready-made motif that eliminated expression, emotion, and other subjective elements, options that he felt the work of Jasper Johns and Andy Warhol had rendered obsolete.

The road from the Propeller paintings to *Green as Well as Blue as Well as Red* maps out Weiner's determination to alter the power relation between the artist and the audience. In his spray-painted Removal paintings (1966–69; named for the rectangular notch removed from one corner) the purchaser dictated the work's color and intensity, as well as the size of the painting and the notch. With the establishment of his language-based practice, first introduced in the book *Statements* (1968),

Fig. 2. Lawrence Weiner. *Green as Well as Blue as Well as Red*. 1972. Artist's book, 6 ¾ x 4 ¾" (17 x 12 cm)

Fig. 3. Lawrence Weiner. *Green as Well as Blue as Well as Red*. 1976. Video, 18 mins., color, sound. Video Data Bank, Chicago

Fig. 4. Lawrence Weiner. *Propeller*. 1964. Gouache, ink, and varnish on canvas with wood frame, 7 ⅞ x 6 ¾" (20 x 17 cm). Private collection

Weiner offered the viewer enormous freedom of interpretation not only with regard to a work's meaning but also its form.[2] Language-based work also allowed him to discard the countless assumptions and judgments that went along with the appreciation or ownership of a work of art: its meaning, its prestige, its value, its authority, its fragility.

The democratic spirit that motivated this practice was echoed in Weiner's attitude toward color when he made *Green as Well as Blue as Well as Red*. Showing a color rather than merely saying it was already a way in which an artist dominated a viewer, a role he was determined to avoid: "In painting a canvas red, I implicitly say to you that my red is better than yours."[3] As readers of his statements, however, all viewers have the same power as the artist to produce in their mind's eye any shade of red (or blue or green). Like Weiner's work as a whole, the art becomes a conduit for an infinite number of associations between the work and its receivers, with any medium, installation, or reading as good as another, as simply as green is as good as blue is as good as red. —*A.T.*

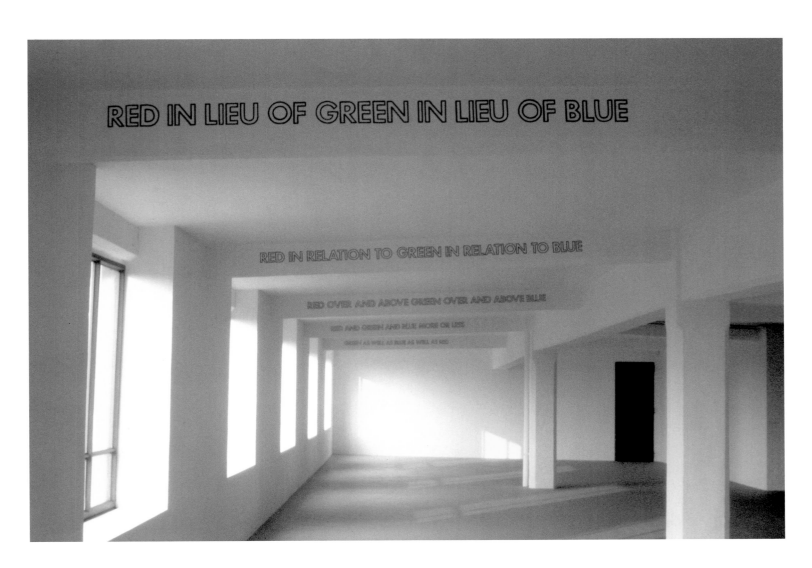

58. Lawrence Weiner

Green as Well as Blue as Well as Red

Red and Green and Blue More or Less

Red Over and Above Green Over and Above Blue

Red in Relation to Green in Relation to Blue

Red in Lieu of Green in Lieu of Blue. 1972

Five sentences

Dimensions variable

Installation view, Raas van Gaverestraat, Ghent

Collection Annick and Anton Herbert

If you open a transistor, you will see groups of wires inside. They are not different colors to make the inside of the transistor pretty, but to show that they have different functions. —André Cadere, 1974[1]

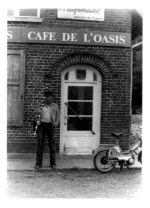

Fig. 1. André Cadere with *Round Bar of Wood*, presentation at the Café de l'Oasis, Kain, Tournai, Belgium, December 12, 1975

André Cadere was a wanderer for whom color was a constant companion, in the form of portable works of art that merged sculpture and performance, and, though created using seemingly objective means, were inseparable from their maker's identity. Born in Warsaw and raised in Romania, Cadere emigrated to Paris in 1967. While walking through the city in the 1970s, he always balanced on one shoulder a *Barre de bois rond*, or "round bar of wood," one of a series of long, narrow rods composed of multicolored segments equal in length and diameter (fig. 1 and plates 59–61). The brightly painted cylindrical bars have a childlike simplicity, with hand-made segments reminiscent of kindergarten blocks or chunky beads. Cadere's titling system similarly bespeaks a child's delight in secret codes—each Bar is subtitled with an elaborate sequence of letters and numbers detailing the quantity and color pattern of its segments. But the seriousness of this enterprise was anything but child-like: he consistently maintained this system for more than six years (until his death, from cancer, at forty-four) and used it in the mapping and making of almost two hundred sculptures. The Bars were as much a lifestyle as an artistic practice; he carried one with him wherever he went and was a familiar sight to art-world denizens not only in Paris but in cities as distant as Munich, Milan, and New York.

Trained as an abstract painter in Bucharest, Cadere maintained an attitude toward color that was firmly entrenched within the conceptual framework of his time. The colors for the Bars, which he considered "paintings on wood," could vary in shade but always stayed within his palette of black, white, yellow, orange, red, purple, blue, and green.[2] Each Bar was composed of three to seven colors and was ordered in one of two permutations that he had devised to unleash a full run of color combinations; its length was dictated by the number of colors and the permutation selected for it. The patterns were based on the progressive switching of adjacencies, and Cadere played out a chosen permutation within a Bar until the pattern brought him back to his initial sequence, which was repeated in a final passage. But he always inserted an error into each Bar by switching two segments with each other, subtly interrupting the pure flow of logic. This engendered another rule: he rejected any error that made neighbors of two same-colored segments, which would have produced too obvious a flaw.

Cadere's use of his Bars was as unorthodox as his method of making them. In the spirit of such contemporaries as Daniel Buren and Lawrence Weiner, he challenged the conventional framework for the presentation and distribution of art, as well as the values that implicitly accompanied those conventions. Cadere believed that art was made for display not only in the pristine white cube of a gallery but in the street; it was something to be actively used rather than passively admired. He

Fig. 2. André Kertész. *Chez Mondrian.* 1926.
Gelatin silver print, 4 ¼ x 3 ⅛" (10.8 x 7.9 cm).
The Museum of Modern Art, New York.
Thomas Walther Collection. Purchase

André Kertész in his 1926 photograph *Chez Mondrian* (fig. 2), was artificial, and colored by Mondrian to match the studio setting.

Ader chose his *Primary Time* bouquet to match Mondrian's primary colors, but the dispirited hues of his flowers stand in sharp contrast to the "pure" color that came to comprise Mondrian's entire palette. Like the homely flowers ushering imperfection into the studio, Ader's project, rather than replacing one mode of modernist purity with another, refutes the very possibility for purity in contemporary art. —*N.L.*

62. Bas Jan Ader
Primary Time. 1974
Color video, silent, 26 mins.
Museum Boijmans van Beuningen, Rotterdam

JAN DIBBETS *(Dutch, born 1941)*

Color was supposed to be kitsch, bad taste. Serious art was black-and-white.

—Jan Dibbets, 2006[1]

Fig. 1. Jan Dibbets. *Stack of Paintings.* 1967. Oil on eight canvases, each: 17 15/16 x 17 15/16 x 15/16" (40.5 x 40.5 x 2.3 cm). Bonnefanten Museum, Maastricht, The Netherlands

When Jan Dibbets completed his Colorstudies (plate 63) in 1976, he was certain they were a breakthrough.[2] He had spent all his money printing them at the largest scale then possible for color photographs. Their color was even richer than he had expected, and he felt he had discovered a way to allow photography to operate at the level of painting. But few people liked them, and Dibbets was so devastated that he stopped making art, only regaining the courage to work a year later. Over the years curators remained resistant to the Colorstudies, and several preferred to exclude them from survey exhibitions of Dibbets's work.

It is fruitful to examine this rejection because the photographs are sumptuous. In part it was their apparent departure from what Dibbets had taught his audience to expect over the course of the previous seven years: rigorously conceptual photographs concerned with the logic and mechanics of perception and representation. The Colorstudies diverged just as dramatically from the documentary parameters for photography widely respected at the time. In the two worlds of Conceptual art and fine-art photography, color itself remained suspect. But Dibbets felt otherwise; his interest in color dated back to his early work as a painter, although he had bid the medium farewell in 1967 by stacking a set of canvases and leaving them on the floor as a sculpture (fig. 1). And when he saw the Barnett Newman retrospective exhibition at the Stedelijk Museum, in Amsterdam, in 1972, it "hit him in the neck," and he knew that he had to respond to it through the medium of photography.[3] His logic was similar to that expressed by Donald Judd a decade earlier:

> Pollock, Newman, Rothko and Still were the best artists and could not be matched in painting, which therefore could not continue at that level. . . . The achievement of Pollock and the others meant that the century's development of color could continue no further on a flat surface. . . . Color to continue had to occur in space.[4]

Judd turned to three dimensions to explore color further; for Dibbets, photography offered another potential solution to the problem. The Colorstudies were his explicit attempt to use photography, a medium predicated on realism, to face the issue of color and abstraction, to use photography to "represent nothing, but present a lot."[5] (Even the leaves and water in his most recent photographs had provided too ready an association between colors and natural structures.) And as Judd had done before him, Dibbets turned for his new project to automobile paint, which offered a kind of color entirely different from anything that had come before. For Judd, the automobile colors were irrefutably contemporary; for Dibbets they were

Fig. 2. Jan Dibbets. Contact sheet of photographs for *Colorstudies.* Detail from *Archive.*
8 x 10" (20.3 x 25.4 cm). Collection Stedelijk Museum, Amsterdam

"anonymous" and "made for something totally different than being a painting." In the resulting photographs there is just the right amount of mutual canceling-out between car and image to let the color be color.

The entire series was photographed during the course of one morning in 1975 and two mornings in 1976. Dibbets sought out colored automobiles on the streets around his Amsterdam studio and snapped the photographs about a meter away from each parked car. In 1975, in a nod to Newman's *Who's Afraid of Red, Yellow and Blue III* (1966–67; Stedelijk Museum), he limited himself to cars in those three colors. Ultimately he found that strategy too direct a response to Newman, as well as too much an incidental reference to Piet Mondrian, and the 1976 photographs reflect a random selection of a variety of colors. His initial thought was to avoid any hint of the car he was photographing, but by the end he abandoned that stricture, and viewers may glimpse the occasional telltale strip of metal or outline of a door. "The less I cared," he found, "the better they came out."[6]

The care came in the printing of the photographs and their grouping in sets. Dibbets made thirteen series of Colorstudies (subtitled A–M) in which he combined two, three, or four different photographs, in deliberate sequences. The contact sheets for the 1976 photographs (see fig. 2) reveal that there was tremendous variation in such factors as the evidence of automobile features, the reflections of the city in the fields of color, the flatness or convexity of the surface area, and even the weather (one morning had been sunny, one rainy). The photographs were first printed on a small scale, but when larger sheets of photographic paper for color printing became available, Dibbets reprinted them at this new scale (see plate 63). Despite the public indifference to the series, Dibbets remained committed to it, and when he discovered Cibachrome paper—"the ideal material in the ideal size"[7]—he returned to his negatives. His three monumental sets of Colorstudies in an 80-inch-by-80-inch format are little-heralded but greatly influential precursors to the widespread rise of large-scale color photography in the 1990s.[8] —*A.T.*

63. Jan Dibbets

Colorstudy. 1976

Color photographs

Four photographs, each: 32 ¾ x 32 ¾" (83.2 x 83.2 cm)

Gladstone Gallery, New York

That's one of the reasons I stopped painting. I couldn't spend the rest of my life making different combinations of color. You think back on the old adage "Twenty feet back, all paintings look the same." —John Baldessari, 1981[1]

Fig. 1. John Baldessari. *Prima Facie (About Face): Enigmatic/Sounds of Nature/Hot Lips/Dream I Can Fly/Golden Glimmer/ Fruity Cocktail.* 2005. Archival pigment print on Ultra Smooth Fine Art paper mounted on museum board, 11' x 35 ³⁄₁₆" (335.28 x 89.38 cm). Courtesy Marian Goodman Gallery, New York

John Baldessari was one of many artists who at the end of the 1960s gave up painting as one would give up smoking. Nevertheless, for four decades color has been a key aspect of his art, a prominent feature in his diverse body of work in all mediums. He recalls the response of MoMA curator Jenny Licht to his first show at the Sonnabend Gallery, in New York, in 1972, which included photographs, films, and videos: "John," she said, "I see you're still painting."[2] The same observation could be made today, and even more literally. In 2006 Baldessari presented Prima Facie, a series of paintings conceived but not executed by him, which feature large fields of color accompanied by enigmatic phrases (see fig. 1). Each phrase turns out to be the manufacturer's name for the house-paint color shown with it, and it is the often-ridiculous name—Happily Ever After, Green with Envy—that attracts Baldessari to the color as a suitable subject for a painting.[3]

Baldessari's questions about the distinction between the housepainter and the artist, the paint chip and the work of art, have been a constant in his work. *Six Colorful Inside Jobs*, a thirty-minute film from 1977 (plate 65), specifically considers the relative identities of two types of "painter," with a young man painting a small room six times in succession: red, orange, yellow, green, blue, violet. Between each color he leaves the room through a discreet door and then returns to begin anew, painting over the previous coats. Each coat takes approximately five minutes, sped up from ninety.

The film chronicles a series of six evenings that Baldessari organized as the inaugural project for the Foundation for Art Resources in Los Angeles in 1977 (fig. 2). Each evening of the project brought a new color, starting on a Monday and progressing through the primaries and secondaries, and leaving Sunday as the traditional day of rest. Baldessari had a mock room built for the event, complete with a peephole for observers, and hired one of his students to be the painter-performer. Baldessari recalls that he did not coach the student about procedure but did choose the colors himself. His initial focus was the live event, but he soon decided to make the work the occasion for a film, so he asked some CalArts film students to design a room without a ceiling, in which a camera mounted above would film the entire affair.

The project has deep roots in Baldessari's life and art. Its direct predecessor was his proposal for Documenta V, in 1972 (which was rejected in favor of a selection of photographs). He had wanted to hang a framed reproduction of the Egyptian pyramids on a gallery wall and have a painter come in every day and paint the wall a different color—to create "eternity surrounded by flux."[4] Baldessari had become experienced in house painting as a teenager, when he earned money by painting

Fig. 3. John Baldessari. *All Cars Parked on the West Side of Main Street, Between Bay and Bicknell Streets, Santa Monica, at 1:15 p.m., September 1, 1976.* 1976. Mounted color photographs, 17 ¼ x 82 ¼" (43.8 x 208.9 cm). The Museum of Contemporary Art, Los Angeles. Gift of Margo H. Leavin

Fig. 2. Announcement for performance of John Baldessari's *Six Colorful Inside Jobs.* Foundation for Art Resources, Los Angeles, October 10–15, 1977

apartments in buildings owned by his father. All through college he sold paints at a hardware store. The love of paint nurtured by these experiences carried through when he began making paintings. He mixed his own colors and packed them in ointment tubes from a pharmacy, eager to have a custom palette rather than "the same old art store colors."[5]

Baldessari's experience as a housepainter was matched by a strong grounding in the techniques and pedagogy of fine arts. His art training had included the Munsell color system and such traditional tasks as setting a palette with a gradation of hues. As a young instructor he had taught traditional color theory, but by the 1970s his interest in classification had taken an entirely different turn. Received wisdom was replaced by the sheer pleasure of seemingly arbitrary but internally logical systems. The so-called laws of color relations were ones Baldessari especially wished to recast, a mission to which the medium of photography easily lent itself. *Car Color Series: All Cars Parked on the West Side of Main Street, between Bay and Bicknell Streets, Santa Monica, at 1:15 p.m., September 1, 1976* (1976; fig. 3) is exactly that—a row of photographs faithfully recording the cars in a row of parking spaces across from his studio. Relational color was wholly determined by who parked where (three spaces were empty at the moment of recording, and those positions were duly left blank in the printed set).[6]

In the set of photographs constituting the work *Common Memory Colors* (1976; plate 64), Baldessari let a Kodak brochure dictate his chromatic composition. The title appropriated Kodak's term for the colors that people remember best, such as those of sky, grass, and sand. Kodak explained that these "common memory colors," and the neutrals (white, gray, black), are those that film is designed to produce well; in fact, though, these are the colors with which customers are often dissatisfied. Baldessari therefore gave himself the assignment to leave the studio and document this sequence of tones by photographing his first sighting of each, starting with the back of his own hand. The finished work assembles the photographs in an orderly row, a deadpan litany of colors usually considered somehow wrong. Kodak had found in Baldessari an easy customer—there could be no wrong for this most genial of colorists. —*A.T.*

64. John Baldessari
Common Memory Colors: Flesh, White,
Gray, Black, Sky, Grass, Sand. 1976
Color photographs
Seven photographs, each: 11 x 14" (27.9 x 35.6 cm)
Collection Carol and Arthur Goldberg

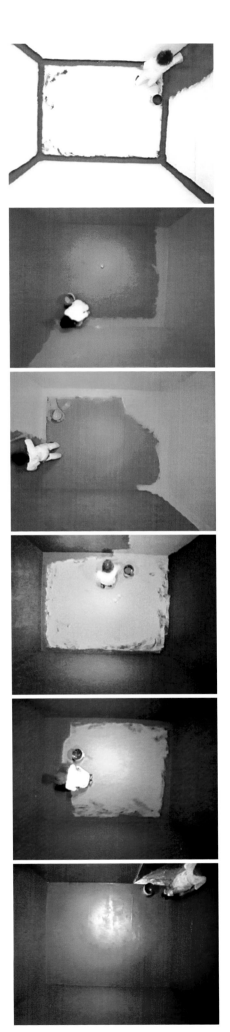

65. John Baldessari
Six Colorful Inside Jobs. 1977
16mm color film transferred to DVD, 30 mins.
Without sound
The Museum of Modern Art, New York. Purchase

Someone saw one of my Green Gallery installations, and said to me, "Oh, it's like going to church." That sounded like a non sequitur to me. Robert Rosenblum once charged me with an influence out of the subway system. He was more on the ball. It's all in there; and I don't want to sort it out. —Dan Flavin, 1972[1]

Between 1963 and 1996 Dan Flavin created nearly seven hundred works exclusively using standard-issue fluorescent lightbulbs—most of them thin cylinders 2 feet, 4 feet, 6 feet, and 8 feet long. For his palette he employed ten industry-standard colors, often working in series that methodically remade different configurations using all the colors. *The diagonal of May 25, 1963* (1963; fig. 1), Flavin's first work composed entirely of fluorescent tubing, and which he eventually made in nine of his ten working colors (excluding ultraviolet), was "a common eight foot strip of fluorescent light in any commercially available color. At first, I chose gold."[2]

Commercial materials, Flavin felt, were central to contemporary art: "The contents of any hardware store," he observed, "could supply enough exhibition material to satisfy the season's needs of the most prosperous gallery."[3] He took a casual attitude toward slight variations in diameter, and substituted the European standard—about 5 feet—when necessary in place of his 8-foot staple. The ten widely available bulb colors that made up his palette consisted of six spectrum colors—red, green, yellow (sometimes called "gold"), pink, blue, and ultraviolet—plus four variations of white: warm white, daylight, cool white, and soft white. Flavin preferred to work with these restricted means; he found that "inside this restrained plastic order I have amazing latitude to comment on what touches me."[4]

Flavin did not work with any one brand of fluorescent light, requiring instead that bulbs be purchased locally when his works were being installed. Although the exact shades of fluorescents sometimes vary slightly by manufacturer, the colors are generally standardized across the industry. Blue, green, and pink lights are created from a chemical reaction of phosphors inside the bulb, so their tones are consistent; this type of chemical interaction cannot produce strong yellow or red light, so those colors are created through a coating applied by the manufacturer to the bulb's glass. Flavin disliked the frequent confusion of his oeuvre with works made in neon; neon signs are individually made to order, and the fluorescent bulbs that Flavin used were mass produced.[5] "I find I want to do what I can within the limitations of the instruments I have come to prefer," Flavin said. "I don't like to add too much. I like the resistance involved, and coming back again and again to these instruments and making them perform."[6]

Twenty-four years after *the diagonal of May 25, 1963*, Flavin created the magnificent *Untitled (to Don Judd, colorist)* (1987; plate 66). The chromatic virtuosity of this series shows that Flavin could well have paid himself the title's compliment; the works underscore the serial exploration of permutations of color and form, a little-noticed dimension of Flavin's art. Each work is a post-and-lintel configuration of 4-foot bulbs, with four vertical bulbs topped by a horizontal bar of two pink bulbs.

Fig. 1. Dan Flavin. *the diagonal of May 25, 1963.* 1963. Yellow fluorescent light, 8' (244 cm) long on the diagonal. Edition of three. Dia Art Foundation

The vertical bulbs are a different color in each work and together represent Flavin's entire palette of colors. Flavin dedicated this series to Judd, his longtime friend, who in the second half of the 1980s had begun to create works that combined more than two colors. Both Judd and Flavin had already been exploiting the glories of industrially produced color for more than twenty years, contradicting their accepted characterization as Minimalists. Like Judd's late works in polychrome, *Untitled (to Don Judd, colorist)* shows a Minimalist artist reaching for the furthest and most dazzling possibilities of his materials in the last decade of his career. —N.L.

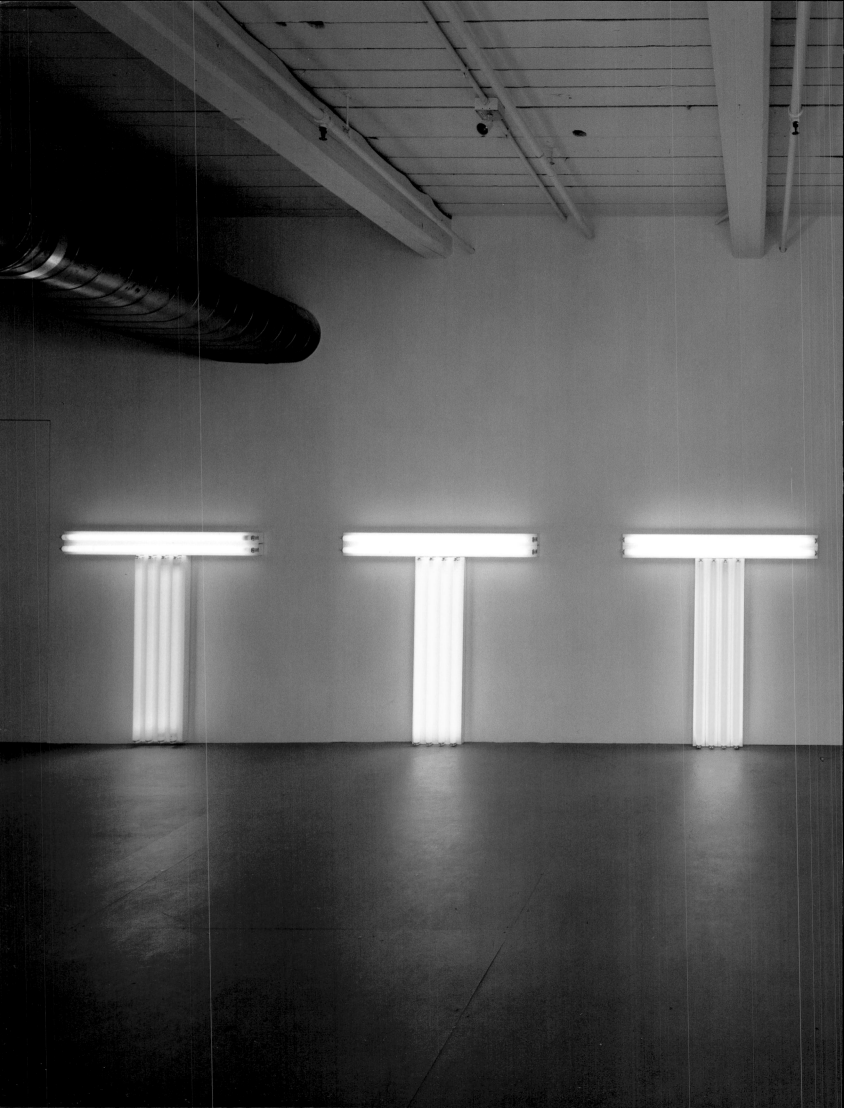

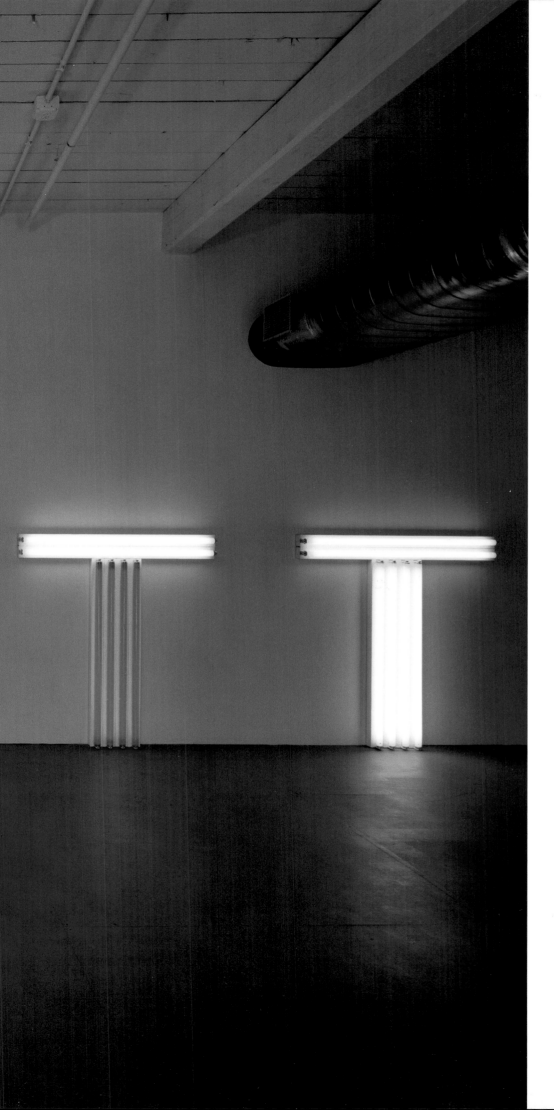

66. Dan Flavin
Untitled (to Don Judd, colorist), 1–5. 1987
Pink, red, yellow, blue, and green fluorescent lights
Five parts, each: 4 x 4' (122 x 122 cm)
Exhibition copies courtesy Stephen Flavin

DONALD JUDD (American, 1928–1994)

With the creation of science in the seventeenth century the study of color has been part of science. And like astronomy it has been cursed with its own astrology.

—Donald Judd, 1993[1]

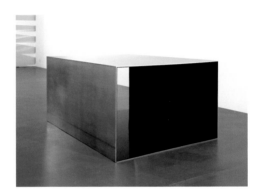

Fig. 1. Donald Judd. Untitled. 1969. Anodized aluminum and brown Plexiglas, 33 ⅞ x 48 x 68 ⅛" (86 x 122 x 173 cm). Courtesy Simon Lee Gallery

Donald Judd had no patience for the symbolic meanings or projections of feeling that generations of artists and writers persistently ascribed to different colors in a fervent quest to present color as a universal language. "As with God and patriotism," he wrote, "I didn't take the attributions of color seriously enough to contemplate."[2] Judd's no-nonsense attitude to color gave him a solid respect for the paintings of Josef Albers. In *Arts Magazine* he gave thoughtful reviews to Albers's exhibitions at the Sidney Janis Gallery in 1959 and 1963 (both warmly positive), and in 1964 (less so); he also reviewed Albers's *Interaction of Color*, published in 1963, approvingly noting that "Albers's approach is practical and sensible and free of cant and obscurities."[3]

These reviews were contemporaneous with the beginnings of Judd's work as one of the most innovative colorists of our time. During the early 1960s he developed a use for color that would have been unthinkable to Albers, abandoning painting and with it the artists' materials that to the elder artist offered infinite potential. Judd rejected on principle the colors found in European painting of the last few hundred years; these were associated with the values and philosophy of a tradition he believed essential to leave behind. Instead, he turned to the industrial materials and paints that precisely reflected the moment and place in which he lived.

In 1963 Judd began to use lacquers such as the motorcycle paints Harley Davidson Hi-Fi Red and Hi-Fi Purple—paints thin enough to reveal the texture of the metal on which they were applied—as well as Plexiglas, which provided the satisfaction of material and color as a single entity. Both the paints and the Plexiglas came in vividly artificial colors, urban in flavor, newly invented for commercial and industrial use. Judd combined them with brass, steel, and aluminum (see fig. 1), which provided a range of opaque and reflective foils. As artist and writer David Batchelor has noted, "The colors of the modern city are almost entirely new and completely unnatural. Most of the colors we now see are chemical or electrical; they are plastic or metallic; they are flat, shiny, glowing or flashing."[4] They were colors often considered vulgar or garish, colors that had nothing to do with a traditional artist's palette.

Until 1984 Judd generally combined no more than two colors in a given work—nonetheless achieving vibrant results—but in the last decade of his life he widened his palette and brought his use of color to new heights of virtuosity. This is evident in a series of sheet-aluminum sculptures, both freestanding and wall relief, made first in Switzerland, in 1984–86, and then at Lascaux Conservation Materials, in Brooklyn, in 1987–93. These works are composed of five-sided

Batchelor's *Found Monochromes* lace together the contemporary city and the artistic monochrome, and in so doing they question the validity of the separation between everyday life and high art. Flat planes of color have come to signify purity in painting; in the work of Kazimir Malevich (see fig. 1), Piet Mondrian, or Aleksandr Rodchenko, they show painted color released from the burden of representation, extracted from the busyness of the real. Batchelor's monochromes take this association and turn it on its head, bearing evidence of a particular time and place rather than staking a claim to universal significance. He records the date and neighborhood in which he photographs each monochrome, creating a record of his travels through London. Batchelor originally photographed different-colored monochromes for the series but decided that he liked the whites because "they're more like holes in the visual fabric, occasional voids," and because he feels that most successful artistic monochromes are either white, black, or gray.[5] The void at the center of each photograph draws the viewer's attention outward, away from the nominal subject, to the colorful city at the periphery. —*N.L.*

68. David Batchelor
Found Monochromes of London. 1997–2003
Lambda digital prints
Eight from a series of 81 photographs,
each: 19 ¾ x 13 ¾" (50 x 35 cm)
Collection the artist, London

Deep Black, Ashy Black, Pale Black, Jet Black, Pitch Black, Dead Black, Blue Black, Purple Black, Chocolate-Brown, Coffee, Sealskin-Brown, Deep Brown, Honey Brown, Red Brown, Deep Yella Brown, Chocolate, High-Brown, Low-Brown, Velvet Brown, Bronze, Gingerbread, Light Brown, Tan ,Olive, Copper, Pink, Banana, Cream, Orange, High Yella, Lemon. Oh, and yeah Caramel.

—Carrie Mae Weems, 1990[1]

In her Colored People series (1987–90; plates 69–74) Carrie Mae Weems literalizes a verbal expression by chromatically tinting black-and-white photographs of single individuals through a hand-dying process. Her subjects, primarily children, all would be considered black in contemporary American society, and the obvious fabrication of the photograph—the overlay of magenta, burnt orange, or blue—parodies the simplistic construct of applying a color term to any human being, no one of whom is actually white or black. She photographed her models at an age "when issues of race really begin to affect you, at the point of an innocence beginning to be disrupted."[2]

The term "colored people" goes back at least to the early nineteenth century. Like "Negroes," it fell out of favor around 1960 and was variously replaced with such alternatives as "blacks," "African Americans," and "people of color." Henry Louis Gates Jr. has wryly noted the cycles of preferred terminology, writing, "I don't mind any of the names myself. But I have to confess that I like 'colored' best, maybe because when I hear the word, I hear it in my mother's voice and in the sepia tones of my childhood."[3] Gates's remark brings up a crucial issue in Weems's work: the powerful role of personal memory. Both the hand-dyed tints and the prevalence of children as subjects situate these photographs in a hypothetical past tense, full of the complicated emotions that accompany it.

The musicality of the works' three-word titles, one word placed under each image, particularly when read in combination with one another, plays an important part in their effect. The viewer's instinctive enunciation of the titles emphasizes the silence of the images above them—the sitters' customary role as the subjects of the gaze and the labels of others. Weems's work, highly conscious of photography's documentary tradition, raises important questions about the history of artistic point of view. During the making of this series, she wrote:

> I'm feeling extremely colored now days, and I'm happy about my "conditions." For much too long, I've placed great emphasis on being European and Western. Often at the expense of overlooking the value of Afro-American culture, I've used European aesthetics and standards as a starting point for creating my own work. So this notion of "feeling colored" has to do with drawing upon Afro-American culture as a foundation for creating art.[4]

The works invite multiple interpretations. Do they celebrate the polychromatic beauty of African American skin tones, particularly of children? And/or do they critique, as many writers have argued, African Americans' own biases on the subject of

skin color and the manner in which they have adopted a white perspective by regarding lighter skin tones more highly?[5] Weems's art cannot be reduced to a straightforward political point. It is much more about personal—and universal—sensations of memory and desire, the workings of which are tangled up in one's self-identification and one's identification by others. Weems's gumdrop colors—standardized hues that she applies to her black-and-white photographs—seduce viewers into what she calls "the complicated discussion I want to have with the audience and myself."[6]

The mix of text and image characteristic of all Weems's work rejects the modernist orthodoxy that prized purity in visual art. In so doing, Weems also dismisses a whole set of modernist taboos, such as that of dealing in one's art with issues that are historically and culturally specific rather than supposedly timeless and universal. There is an implicit parallel between exploding the monolithic character of art and expanding our notion about who can make and view it.

The three identical images in each of these works are varied only by the staccato tap of the single word applied in adhesive capital letters beneath it. This repetition makes an obvious nod to the Minimal and Conceptual traditions of the 1960s and '70s, which were largely the province of artists who were both white and male. Weems does not isolate her practice from those traditions but rather complicates it with the inclusion of issues they have ignored, such as race, class, and gender—issues that fall outside an art-about-art discourse or a discourse that did not recognize itself as one conducted by a specific subset of the population. Weems considers it her mandate as an artist to show that in American society the idea of what color charts is far more complex than a range of hues along a spectrum. —A.T.

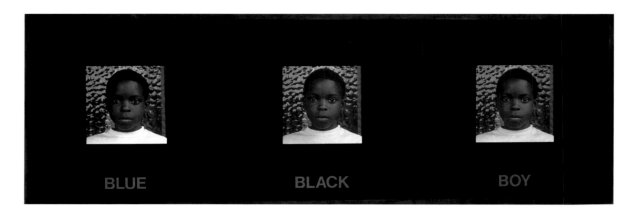

69. Carrie Mae Weems
Blue Black Boy. 1987–88
Three toned gelatin silver prints with Prestype and frame
Overall: 16 x 48" (40.6 x 121.9 cm)
Whitney Museum of American Art, New York. Purchase,
with funds from the Photography Committee

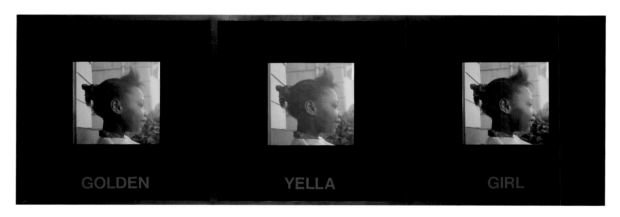

70. Carrie Mae Weems
Golden Yella Girl. 1987–88
Three toned gelatin silver prints with Prestype and frame
Overall: 16 x 48" (40.6 x 121.9 cm)
Whitney Museum of American Art, New York. Purchase,
with funds from the Photography Committee

71. Carrie Mae Weems
Red Bone Boy. 1988
Three toned gelatin silver prints with Prestype and frame
Overall: 16 x 48" (40.6 x 121.9 cm)
Collection Michael Lynne

72. Carrie Mae Weems
Low Brown Boy. 1987–88
Three toned gelatin silver prints with Prestype and frame
Overall: 16 x 48" (40.6 x 121.9 cm)
Whitney Museum of American Art, New York. Gift of the artist

73. Carrie Mae Weems
Moody Blue Girl. 1988
Three toned gelatin silver prints with Prestype and frame
Overall: 16 x 48" (40.6 x 121.9 cm)
Hort Family Collection

74. Carrie Mae Weems
Magenta Colored Girl. 1988
Three toned gelatin silver prints with Prestype and frame
Overall: 16 x 48" (40.6 x 121.9 cm)
George Eastman House, Rochester, New York. Purchased with
funds from Charina Foundation

"Why are you making abstract paintings?" The "you" meaning Asian-American artist, artist-of-color, artist-with-something-to-say. —Byron Kim, 1992[1]

When Byron Kim began the paintings that would eventually constitute *Synecdoche* (plate 75), in 1991, his aim was both to bury the monochrome and to praise it. An admirer of no less an absolutist than Ad Reinhardt, Kim nonetheless knew that for artists of his own generation, "purity in abstraction is an anachronism."[2] So he set out to make a new kind of Color Field painting. Rather than reaching for the sublime, Kim grounded his project in the concrete: each oil-and-wax panel was painted from life, based on the skin tone of an individual. He was not after the chromatic nuances or anatomical details of human flesh. Instead he aimed to capture a single color as representative of one person's skin. As a young "artist of color," Kim had felt inhibited by the sense that abstract painting was an exclusive club of white male practitioners. By taking on skin color as his subject matter, Kim's questioning of his position in the tradition of abstraction became part of the work itself.

Kim first painted family members and friends but soon began approaching strangers in the park or at the library, spending perhaps twenty minutes with each to match paint to skin tone. He also accepted commissions, making "portraits," for example, of family groups and of artists he respects, including Brice Marden and Vija Celmins. Such subsets of paintings are subsumed by the larger group, which is exhibited with its elements in alphabetical order by sitter's first name, a complete list of which is also displayed. At its first major showing in 1992, *Synecdoche* comprised approximately two hundred parts, and it now consists of nearly four hundred. The artist has yet to declare the work complete and continues to make additions.

A chart of skin tones bears implicit reference to the range of nineteenth-century imagery that attempted to gradate classifications of race. Yet *Synecdoche* is made in the spirit of inclusiveness rather than categorization, and its turf is aesthetic, not taxonomical. It no more lays claim to any ranking of human beings than commercial color charts assert hierarchies of color. Kim's vast polychromatic grid looks as random as a Gerhard Richter color chart of the 1970s, suggesting a heterogeneous society in which friend and stranger, passerby and luminary, mingle on equal footing.

The 10-by-8-inch dimensions of *Synecdoche*'s panels deliberately mimic the format of a photographic headshot, but—flattening individual identity as it does to a series of color chips—the work functions as portraiture only ostensibly, a fact announced by its title. A synecdoche is a figure of speech in which a part signifies the whole—saying "hands" to mean "workers," for example. But so little do the brown and pink rectangles tell us about the individuals who supplied each shade that *Synecdoche* serves instead as a reductio ad absurdum of the notion that skin color can stand proxy for a person. With this elegant rebuke of essentialist conceptions of race, Kim was perfectly in tune with the cultural concerns of the late 1980s and early '90s.

Synecdoche's inclusion in the 1993 Whitney Biennial (famous as the "multicultural" Biennial) earned the young artist critical attention and ensured that the work's political implications received special emphasis.

Less often noted is the work's personal content. Like On Kawara's Today paintings, *Synecdoche* has an air of programmatic detachment that disguises its subjectivity. With its chartlike structure, it presents color as truth, but—as Kim is well aware—observed color is anything but straightforwardly factual. The painter's concept of intrinsic local color notwithstanding, a color cannot be isolated either from its immediate context or from its perceiver. Kim wrestled with the inherent instability of color each time he faced a new sitter, "staring at [his or her] arm while trying to see its local color while wondering whether local color was what I was after, after all . . . What is the right color? Is there any meaning in it?"[3] Eschewing the lofty ambitions of monochrome painters before him, Kim had chosen a project with a seemingly well-defined procedure—yet this led him back to the central metaphysical challenge of painting. Kim was still, as Barnett Newman had said, "trying to paint the impossible."[4] His struggle to capture skin color suggests larger questions: What are the limits of representation? How can we hold onto felt experience? Each of Kim's monochromes is a kind of diary entry, with color standing in for what cannot be described. —M.H.

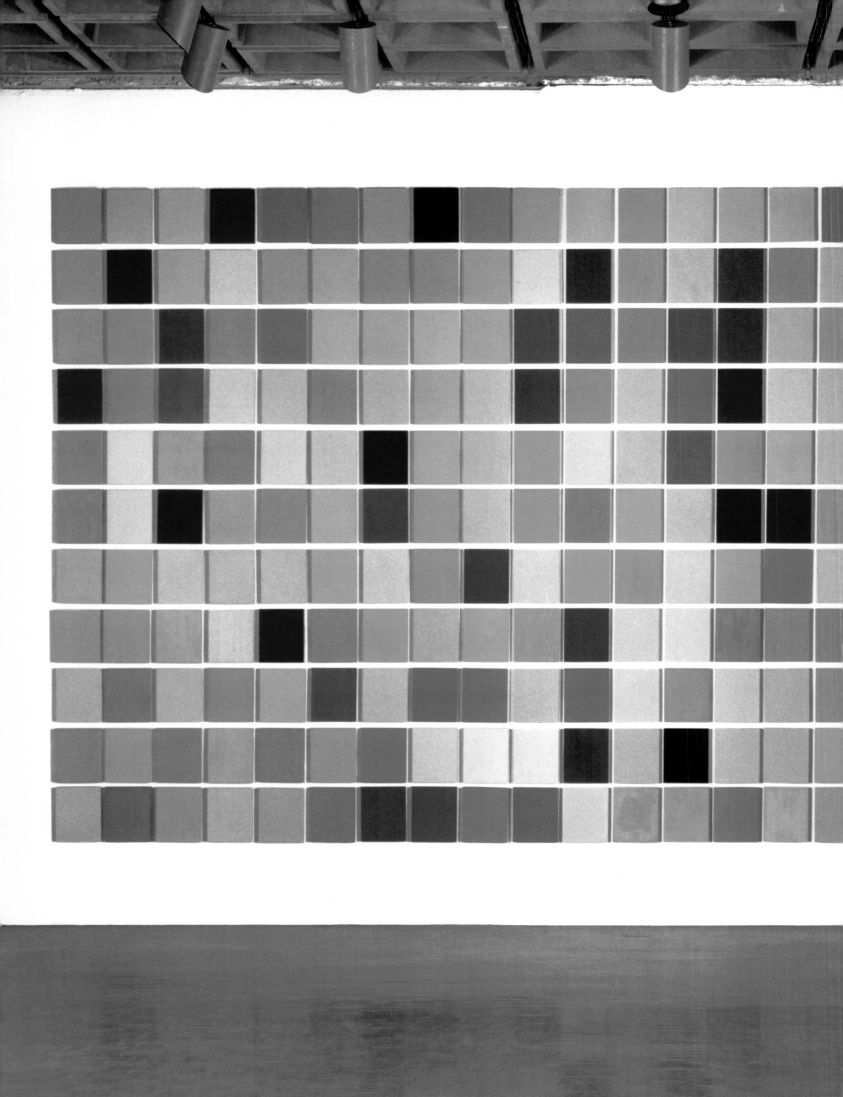

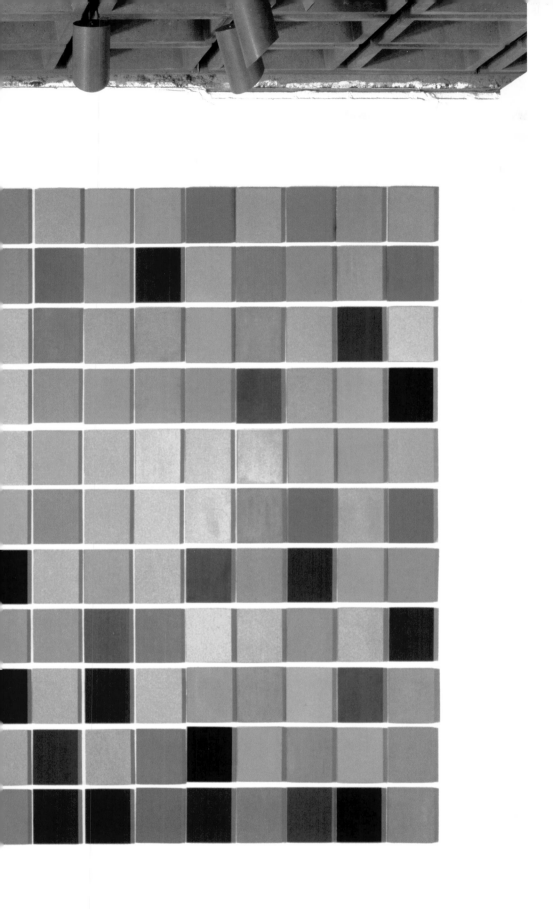

75. Byron Kim
Synecdoche. 1991
Oil and wax on panel
265 panels, each: 10 x 8" (25.4 x 20.3 cm)
Collection the artist, New York

KATHARINA FRITSCH *(German, born 1956)*

When you're a child standing before a paintbox for the first time, you feel like you can grab the colors in the boxes. —Katharina Fritsch, 2007[1]

The joy of color is fundamental to childhood. Early color memories often center on the infinite potential promised by virgin color—a new box of still-pointy crayons in immaculate rows, fresh tubs of finger paint with unbroken surfaces. As a child Katharina Fritsch was fortunate enough to have special access to such wonders: Her maternal grandfather was a salesman for the venerable German writing and art-supply manufacturer Faber-Castell. An invitation to his garage, stocked with countless boxes of colored pencils, meant a visit to paradise.

The nature of such memories informs Fritsch's *Eight Paintings in Eight Colors* (1990–91; plate 76). These works are the result of Fritsch's desire to "make sculptures that were paintings and paintings that were sculptures."[2] Each presents a rectangle of glossy color set within a shiny gold border that reads as a frame. She has prescribed a fixed color sequence for installation as well as intervals to equal the width of the paintings, two conditions that emphasize the absolute frontality and symmetry of the entire work. Fritsch points out that color is, on the one hand, a very physical thing and, on the other, very abstract. She says that she had wished to make "empty paintings," and, indeed, their powerful aura results from the odd tension between their mute vacancy and the lush fullness of their color.[3]

Fritsch's work has the uncanny quality of looking like it has just materialized, with no evidence of human effort. The road to that achievement is a long one, and in the case of *Eight Paintings* involved repeated applications of acrylic paint sprayed onto a wooden support. The acrylic clogged the inhospitable spray gun, which needed to be dismantled and cleaned between applications. The frames were made separately, by wrapping the lengths of wood in foil and spraying them with yellow varnish. The tension between messy back story and pristine appearance is fundamental to Fritsch's work. "There are always protracted periods of thought, concealed quotations, long motif traditions, a great deal of technical effort," she has said, "and that leads to sights that seem natural straightaway."[4]

As a young student, Fritsch initially wanted to be a painter. She had hoped to study with Gerhard Richter when she enrolled at the Kunstakademie Düsseldorf in 1979, but was deemed unqualified; instead she enrolled with another artist, Fritz Schwegler, and soon switched her focus to sculpture. Nevertheless, painting has remained a key reference point for her. The cool splendor of Richter's Color Chart paintings certainly makes up part of the DNA of her *Eight Paintings*, but even though she accepted the premise of Richter's charts, Fritsch felt a need to reach beyond them, to add something new. As part of the generation that followed Richter, Fritsch wanted to extend rather than contradict his work. "I see the development of art as a continuous process," she has said of this relationship, "and not so much as a

Fig. 1. Katharina Fritsch. *Madonnenfigur.* 1982.
Plaster and paint, 3 ⅛ x 2 ⅜ x 11 ¾" (8 x 6 x 30 cm)

sequence of antireactions."[5] What Fritsch has added is a personal element, one that factors in memory and fantasy.

Eight Paintings in Eight Colors exemplifies the extraordinary role of color in Fritsch's work as a whole. Her use of color has long contributed to the startling clarity and exactitude of her sculptures, allowing them to become images indelibly fixed in the viewer's memory bank. A sight as strange as a lemon-yellow Madonna (1981; fig. 1) has no explanation, but it has absolute certitude. While the images and memories that inform Fritsch's work are uniquely hers, her ingenious strategy is to achieve an absolute precision of detail that paradoxically invites a reading that is entirely and magically open. —*A.T.*

76. Katharina Fritsch
Eight Paintings in Eight Colors. 1990–91
Wood, foil, lacquer, untreated cotton cloth, and paint
Eight parts, each: 55 ⅛ x 39 ⅜ x 3 ⅛" (140 x 100 x 7.9 cm)
Collection the artist, Düsseldorf

Along with material itself, color is one of the most loaded signs of the quotidian.

—Mike Kelley, 2004[1]

Fig. 1. Mike Kelley. *Arena #10 (Dogs).* 1990. Stuffed animals on afghan, 11 ½" x 10' 3" x 32" (29.2 x 312.4 x 81.3 cm). Private collection

Fig. 2. Mike Kelley. *Educational Complex.* 1995. Acrylic, latex, foamcore, fiberglass, and wood, height variable (51" max.) x 8 x 16"

For his work in the mid-1990s Mike Kelley adopted the concept of "missing time," an expression referring to the abduction of humans by aliens.[2] Missing time, which signifies a victim's inability to remember the traumatic abduction, is a variant of what is known as "repressed-memory syndrome," a phenomenon widely and controversially linked to childhood sexual abuse. Kelley's interest in the subject was a response to his critics; they had misread his recent sculptures of old and dirty stuffed-animal toys (see fig. 1) as references to child abuse, so he decided to pursue their reasoning. In *Educational Complex* (1995; fig. 2), a large architectural model combines all the schools the artist had attended, with sections of the buildings he could not recall left blank, thereby shifting the traumatic realm from sex to education: the damage inflicted by his formal art training was to blame for his inability to remember the architecture of his schools.

Kelley's art education returns as the theme of his Missing Time Color Exercises, of 1998 and 2002. Here he revisits the rigorous color training he received at the University of Michigan during the 1970s, doing the meticulous work of color matching again for the first time in nearly thirty years, almost as if he were in therapy for repressed-memory syndrome—but toward decidedly peculiar ends. He took as a departure point his partially complete set of the men's humor magazine *Sex to Sexty*, which had first caught his attention as a teenager.[3] The impetus for his project, Kelley wrote, was that "the missing issues, like those rooms in my old schools that are lost to memory, seem especially pregnant with meaning."[4] In an effort to redress their absence, he formed various grid arrangements of the covers of the magazines he owned, leaving empty panels identical to the dimensions for what he assumed to be the number and sequence of missing issues. Kelley then devised colors for the empty panels based on neighboring covers, either pulling a specific color from a cover or mimicking its overall tonality, going to great lengths to mix his acrylic paints to coordinate with the magazines nearby. Making sure that the colors of the panels produced an overall balance involved many intermediate attempts, rejections, and further modifications when the grid was almost finished.[5] When all the groupings were complete, Kelley put them in white frames custom-made to accommodate the rows of magazines and monochrome panels (plate 77).

This project forges an absurd link between the modernist pedagogy of color relations and a magazine that is a rich index of low class and high sex. This unlikely coupling serves as a stark reminder of how modernist attitudes to color purged it of cultural associations, leaving it in a vacuum of idealism. In both his art and his writings, Kelley has been an eloquent opponent of the artificial isolation of color from the context of real life. In the Missing Time Color Exercises, he conjoins

Fig. 3. Mike Kelley's *Sublevel* exhibition, Jablonka Galerie, Cologne, June 5–July 31, 1998. Installation view

the monochrome—"the sign for the timeless"—with not one but two antithetical idioms, thanks to a rupture in the series itself: the earlier covers of *Sex to Sexty* were designed in a psychedelic Op art manner, but starting in 1969 the covers featured hillbilly illustration instead.[6] Kelley additionally complicated pedagogy's clean and systematic view of color with an installation in which he used the leftover paints for messy finger paintings on blob-shaped canvases and grouped the yogurt cups in which he mixed his paints into chromatically clustered Bouquets (1998; see fig. 3). These were exhibited together with the Missing Time Color Exercises, first at the Jablonka Galerie, in Cologne, in 1998 and then at the Kunstverein Braunschweig the following year.

As it turned out, these exhibitions would not mark the end of Kelley's involvement with the Missing Time Color Exercises. Soon thereafter a well-meaning admirer procured on eBay a complete set of *Sex to Sexty* and gave the issues to Kelley. He did not really care about having his "missing time" restored but felt obliged to redo the series in reverse, creating new grids with the magazine covers missing from the 1998 work, replacing with painted panels those magazine covers that originally had been included, and encasing the results in black rather than white frames (plate 78). He was dismayed to learn that his assumptions about the number and sequence of missing issues were not wholly correct (special issues and double issues, for example, disrupted the predictable order), but he remained true to his self-imposed rule of featuring every issue of the magazine missing from the original work, and therefore the new series is not a perfect mirror of the first.[7] Together the two series handily refute the fiction of color as a realm of ideal purity. —*A.T.*

77. Mike Kelley

Missing Time Color Exercise No. 3. 1998

Acrylic on wood panels, magazine covers, wood, and Plexiglas

7' 8 ¹⁵⁄₁₆" x 46 ¹⁄₁₆" (236 x 117 cm)

Glenstone Museum Foundation

78. Mike Kelley
Missing Time Color Exercise (Reversed) No. 2. 2002
Acrylic on wood panels, magazine covers, wood, and Plexiglas
47 ¾ x 92 ¼" (121.3 x 234.3 cm)
Gian Enzo Sperone, New York

We used the chemicals of the American and Japanese companies to render the German company's colors correctly. —Christopher Williams, 2007[1]

As Christopher Williams knows well, there is virtually no limit to the visual effects that a Hollywood film director can achieve. Williams has said of the film industry, "People can make anything for you."[2] Highly specialized professionals furnish sets, create special effects, and calibrate exact lighting and atmospheric conditions for films. Williams has spent most of his career working in Los Angeles, and he has taken advantage of the industry specialists locally available to aid him in the creation of his photographs. Although now widely recognized for his self-critical consideration of the medium of photography in his work, Williams began his career as a painter. He studied at CalArts under John Baldessari in the late 1970s, and was also influenced at that time by such artists as Sherrie Levine and Richard Prince. But in the early 1980s, having become skeptical of the worth of the individual artist's authorial control, Williams abandoned the solitude of his painting process in favor of a collective working method in the medium of photography. In contrast to the traditional idea of a photographer, in which a person, acting alone, sets the scene, chooses the shot, and depresses the shutter, Williams likens himself to a film director, who collaborates with commercial experts in order to achieve his vision.

To create *AGFA Color*, *Kodak Color*, and *Fuji Color* (plates 79–81), Williams hired a Hollywood shopper, whose job is normally to purchase products to make period film sets authentic, to go to the store armed with color swatches that matched the logos for the three major photographic companies, as displayed in their boxes of film. Many photographers who work primarily with color film see the colors on a film's box as helpful signifiers of the brand's tonal merits. Fuji's green box indicates that the film produces prints with cool, precise hues. The yellow-and-red Kodak box carries within it, as Williams has noted, a promise of "warmth, sunshine, spring, domestic bliss."[3] AGFA's deep orange color advertises success for outdoor photography and the accurate rendering of pastel shades. Williams instructed the Hollywood shopper to find sets of eleven pieces of dishware to match the colors of each brand's identity, in proportion to how much each is used in the logo. For example, nine yellow dishes and two red dishes represented Kodak. The dishware that the shopper found in the AGFA and Fuji colors were made by the same manufacturer; the Kodak sets were Fiestaware, and thus slightly different. One at a time, each set was loaded into a dishwasher and photographed among several pieces of clear glassware that remained in the dishwasher throughout the process. Each set was photographed using film, chemicals, and photographic paper produced by the company that the colors represented.

One goal that Williams set for these photographs was to maintain the accurate corporate colors for each brand in each printed photograph. As color was of prima-

Fig. 1. Christopher Williams. *Kodak Three Point Reflection Guide, © 1968 Eastman Kodak Company, 1968. (Meiko laughing), Vancouver, B.C., April 6, 2005.* 2005. C-print, frame: 34 x 37 ¾ x 1 ½" (86.4 x 95.9 x 3.8 cm), print: 20 x 24" (50.8 x 61 cm).

ry concern, Williams enlisted a commercial photographer who was known for his specialization in color manipulation to operate the camera on this shoot. They were able to re-create the corporate identity of Kodak and Fuji, but there was a problem with AGFA. As Williams recalled, "The orange would oversaturate and turn into a kind of red." The irony of this was not lost on Williams: "I got interested in the idea that their own product couldn't represent their corporate identity."[4] This photograph is labeled *AGFA Color (Oversaturated)*. With his color specialist, Williams took up the task of trying to represent the true AGFA color. Ultimately they were successful, but only by using a combination of Fuji and Kodak's photographic products. Their results are on display in the photograph titled *Erratum* (plate 82).

AGFA Color, Kodak Color, Fuji Color, and *Erratum* are four from a series of more than eighty photographs that Williams has been working on since the late 1980s, titled *Die Welt ist Schön,* after a 1928 book created by photographer Albert Renger-Patzsch. The "branding" of color that Williams's dishwasher prints draw to the fore is also addressed in very recent works from *Die Welt ist Schön,* such as *Kodak Three Point Reflection Guide, © 1968 (Meiko laughing), Vancouver, B.C., April 6, 2005* (fig. 1). The golden color of the towel that the model has wrapped on her head has been calibrated to exactly match the dominant yellow of Kodak's packaging. These are color photographs about color photography, which Williams visually posits as a postwar phenomenon. Both the dishwasher series and *Meiko laughing* evoke Cold War–era domestic life: for the dishwasher photographs, Williams secured a dishwasher from the late 1970s, and *Meiko laughing* includes a 1968 Kodak color bar. (Other photographs of this model, which show her shampooing her hair behind a shower door, situate her distinctly in the bathroom of a 1960s home.) Before World War II, color film technology was too expensive to be practical for the average consumer; the war years saw a competitive and nationalistic race for cheaper alternatives.[5] After the war, the market for color photographic film boomed, and advertising targeted the nuclear family unit. Williams makes explicit the connection between the industry of color photography and postwar society by transforming dishware—and a happy housewife—into direct iterations of commercial color. —*N.L.*

79. Christopher Williams

Fuji Color Negative Film FUJI NPL 160T Process C-41 Printed on: Fujicolor
Professional Crystal Archive RA-4 Color Paper Type C Glossy Process RA-4. 2000
C-print
11 x 14" (28 x 35.5 cm)
Martin Friedman and Peggy Casey-Friedman, Chicago

80. Christopher Williams

AGFA Color (Oversaturated) Negative Film: OPTIMA 100 Professional,
Daylight Converted to Tungsten Balance with Kodak Wratten Filter 80A Process
C-41 Printed on: Agfacolor RA-4 Paper Process RA-4. 2000
C-print
11 x 14" (28 x 35.5 cm)
Collection Don Hanson, New York

81. Christopher Williams

Kodak Color PORTA 100T (PRT) Process C-41 Printed on Ultra III Paper, Process
RA-4 Surface F, Glossy. 2000

C-print

11 x 14" (28 x 35.5 cm)

Museum of Contemporary Art, Los Angeles. Gift of Councilman Joel Wachs

82. Christopher Williams

Erratum: AGFA Color (Oversaturated). Camera: Robertson Process
Model 31 580 Serial #F97-116/Lens: Apo Nikkor 455 mm Stopped
Down to f90/Lighting: 16,000 Watts Tungsten 3200 Degrees Kelvin/
Film: Kodak Plus-X Pan ASA 125 / Kodak Pan Masking for Contrast
and Color Correction/Film Developer: Kodak HC-110 Dilution B
(1:7) Used @68 Degrees Fahrenheit/Paper: Fujicolor Crystal Archive
Type C Glossy/Chemistry: Kodak RA-4/Exposure and development
times (in minutes): Red Filter Kodak Wratten PM25 2'30" 4'40"
Green Filter Kodak Wratten PM61 10'20" 3'30" Blue Filter Kodak
Wratten PM47B 7'00" 7'00"/Paper: Fujicolor Crystal Archive Type
C Glossy/Chemistry: Kodak RA-4/Processor: Tray/Exposure and
development times (in seconds): Red Filter Kodak Wratten #29 8
Green Filter Kodak Wratten #29 15,5 1'10 @92 degrees Fahrenheit
Blue Filter Kodak Wratten #98 30,5/October 7, 2000. 2000

Contact print

13 ¾ x 12 ½" (34.9 x 31.8 cm)

Collection the artist

I think of myself as a colorist, and people laugh when I tell them that, but it's true.

—Sherrie Levine, 2007[1]

Fig. 1. Sherrie Levine. *Untitled (After Joan Miró).* 1985.
Watercolor and pencil on paper, 14 x 11" (35.6 x 27.9 cm).
The Museum of Modern Art, New York. Bequest of Bill
Olander and Chris Cox

Recognition of Sherrie Levine as a colorist or a sensualist of any kind has been pushed aside by the focus on her project's rigorous conceptualism: making work "after" great modern artists or using the primary tropes of modern abstraction, such as the grid. Her photographs, watercolors, and paintings of the 1980s, which seemingly forswore the central modernist ambition of originality, profoundly rattled commonplace artistic assumptions. Levine's work acknowledges the simple truth that today our visual imaginations are nurtured far more on reproductions than on original works of art. Her watercolors, for example, were made after bookplates—in other words, they are reproductions of reproductions (see fig. 1). The colors that she copied were less those of early-twentieth-century art than of mid-century color printing; she enjoyed the fact that her Mondrian watercolors had hints of green, a color he famously detested.[2]

But Levine's conceptualism is just part of the story. Like many American artists of her generation, she studied with a teacher who had studied with Josef Albers, and this made its mark on her artistic outlook. Her deep pleasure in color came to the fore in 2007 with *Salubra*, an exhibition featuring three sets of fourteen mono-chrome paintings (see plate 83). Each set was inspired by a horizontal band from a series of color charts that accompanied the line of wallpaper (*Oelfarbenanstrich in Rollen,* or "oil paint on rolls") that Le Corbusier designed, in 1931, for the Swiss wallpaper company Salubra (see fig. 2). Levine had bought a copy of a book docu-menting the series, and decided to use it as the basis for a project.[3] She chose three of Le Corbusier's bands of color—numbers four, five, and seven—and isolated each color as an individual painting, in contrast to the original color cards, which abut the colors in narrow strips.

Levine's task was relatively straightforward, because the Swiss company kt. COLOR had recently begun to produce interior house paint in Le Corbusier's colors. Like all of Levine's monochromes, they are painted by a conservator on mahogany panels, a support she uses because it is one of the few woods that comes in widths wide enough for a painting; she also likes the way its grain shows through the membrane of paint. Each set of fourteen paintings was conceived as an installation, and the wall behind them must be painted to match a background color that Le Corbusier used on his color cards.

Levine's source material constitutes an extraordinary moment in the dialogue of modern art, architecture, and design. Le Corbusier's position on color was highly complex, one that embodies the rich contradictions enveloping color's history in twentieth-century art. This was, after all, the man who in 1925 had happily imag-ined a "law of Ripolin" that would force everyone to coat the walls of their homes

Fig. 1. The *Freeze* exhibition, curated by Damien Hirst,
London Docklands, July 1988. Installation view

that's who I am. Totally. That's what I do. The color gets in my way. So I take it out and just put it in the spots."[3] And there, too, it can be tamed; the spot paintings were partly inspired by photographs of the moon overlaid with grids charting its surface.

Hirst's frankly commercial attitude to his art accommodates the spot paintings as products and even personal logos. He attaches no stigma to their abundant supply or to his own distance from their manufacture; rather, he has said that he needs the comfort of mass production in addition to the room to make unique works.[4] His openness was evident in the sale of the first paintings from the *Freeze* exhibition. Hirst had not planned to sell them, but when he received offers he quickly invented certificates for paintings of variable colors and dimensions to be made by an authorized representative. He went still further in the D.I.Y. direction with a limited edition of fifteen, produced in 2000, that included brushes, paints, and a compass.

Although the spot paintings are generally perceived as happy paintings, or even dismissed as mere eye candy, Hirst is equally aware of the project's uneasy side, evident in the paintings' refusal to provide the satisfaction of tonal reverberations—their lack of a stable chromatic anchor despite the reassuring illusion of the grid. He nurtures a fantasy of an exhibition that would unite dozens of the paintings in one place, an event that at long last would fully reveal the nightmarish character of the project. And only then, he says, would he decide that it was time to stop making them.[5] —*A.T.*

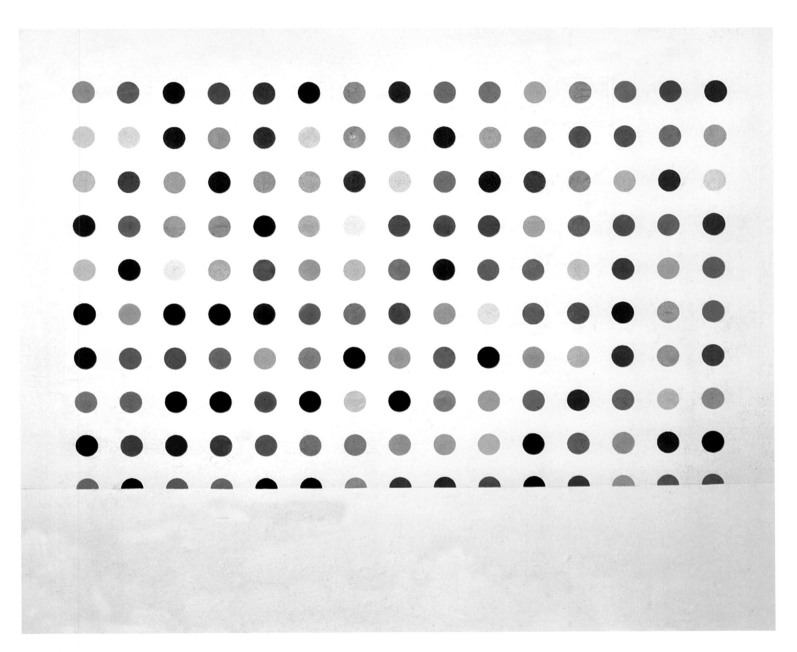

84. Damien Hirst
Spot Painting in the exhibition *Freeze*. 1988
Household gloss on wall

LIZ DESCHENES *(American, born 1966)*

Screen and screen technologies have changed the way we view color. —Liz Deschenes, 2007[1]

Fig. 1. Liz Deschenes. *Green Screen #1.* 2001. UV laminated Fujiflex print mounted on Plexiglas, 26 x 19" (66 x 48.3 cm). Courtesy Miguel Abreu Gallery

In 2000 photographer Liz Deschenes saw, at the annual convention of the National Association of Broadcasters in Las Vegas, a green screen, which became her source material for five in a 2001 series of seven photographs, including *Green Screen #5 (with Cube)* (plate 85). Green screens are widely used in film and television production to fabricate realities within the confines of the studio. Actors are filmed in front of a green backdrop that is later replaced with footage of another background, either real or artificially created. This is typically a warm, bright green because of its dissimilarity to human skin tones—which makes the background easier to replace—and Deschenes exclusively used Fuji film for her film-based works because that brand has a characteristically cool hue that complements the green.[2] In this series, she uses the green screen both as the subject of representational photographs, in images that depict the green screen installed at the broadcaster's convention (see fig. 1), and as the source material for photographic monochromes, in photographs that simply focus on the screen as a flat, abstract color.

The sample green screen, rather than one utilized in a production studio, appealed to the artist. "I really liked that it was in Las Vegas," she has said, "and not in Hollywood."[3] In practice green screens make possible death-defying feats and daily weather forecasts, but they are always only substitutes for footage yet to come. This particular screen existed for no other reason than to display itself; no actors have been or ever will be shot against it. It was another product to be sold, not a fundamental behind-the-scenes tool. The color, usually present just to be replaced, took center stage.

This photographic series revisits the green screen as an object of contemplation and in so doing aestheticizes a manifestation of a utilitarian color never meant to be seen. Deschenes appropriated the green from a non-art source, and even before her appropriation of it, the color was chosen on the basis of its effectiveness rather than aesthetic criteria. Although blue screens are also used in film production, green is the more effective of the two colors for digital processing, and her choice of green is evidence of the shifting terrain in photography and cinema. Deschenes's work self-critically investigates digital and analog photographic processes—the tools that allow us to look at our world—and *Green Screen #5 (with Cube)* was created using a composite of digital and film photography.

Deschenes is fascinated by the history of the photographic process. Her *Elevations* series (see fig. 2), based on the range of colors in a topographical map, pays homage to dye transfer, an analog process that Kodak discontinued in 1993, because digital retouching software could achieve the same effects at a lower cost. The change from analog to digital methods has reduced the range of color pos-

Fig. 2. Liz Deschenes. *Elevations #1–7.* 1997–2003. Dye transfer prints, each: 19 ¾" x 11' 6 ⅜" (50.2 x 351.5 cm).

Courtesy Miguel Abreu Gallery

sibilities in photography; as Deschenes explains, "Analog color is continuous, like the spectrum. Digital color is discontinuous, and involves separations determined by the pixels."[4] She feels that dye-transfer colors are both more stable and more sumptuous than digital colors, and she celebrates these colors in the Elevations monochromes.

Deschenes's consistent interest in monochrome has led her to appreciate that "making a monochrome is probably the hardest thing to do."[5] The Elevations works, like the green-screen photographs, concentrate on colors that are functional and impersonal: they approximate the colors of a map, symbols for real space that indicate variations in altitude. Although her colors are ready-made, they are more than just "found colors," being the end-result of complex scientific and technological research; they carry some residual suggestion of the precise measurements and mathematical calculations involved in making a map, as well as the technological aura of the elaborate image-transfer process. For Deschenes, when she makes (or sees) a color in a photograph, she finds it beautiful because of its perfection as a color and because of the level of complexity that she knows is involved in achieving it. —*N.L.*

How can I make a painting without having to lift a paintbrush? —Jim Lambie, 2001[1]

ZOBOP! (1999; plate 87) is a series of floor installations that Jim Lambie has created in several versions in museums and galleries using the widely available vinyl tape produced by American companies such as 3M and Oracal. The tapes' boldly unnatural hues connect them to a world of everyday office products, making them inherently familiar and contemporary. 3M's vinyl tape, which comes in ten colors, is intended for industrial use; it can be used for lane and aisle markings, industrial color coding, and paint masking. Oracal tape comes in more than eighty colors and is more specifically intended for design use, such as architectural graphics, signage, and the pin-striping of cars. At different times Lambie has created *ZOBOP!* in flat multicolor, in metallic palettes, and in black-and-white.

Lambie, one of the leading artists practicing in Glasgow's vibrant art community, conceived the idea for *ZOBOP!* in 1999, when he was granted his first solo exhibition at The Showroom Gallery in London. He initially envisioned the work as a small collage of vinyl tape. A rock musician before he became a visual artist, Lambie relates the undulating rhythm of color and line in *ZOBOP!* to the progression of a song, and he wanted to create a work of art that, like music, could fill a room with its ambience while also leaving the room empty. *ZOBOP!* takes up no space—it does no more than cover the floor. Installations of *ZOBOP!* habitually include sculptures by Lambie or other artists on top of it.

Lambie works with assistants to cover the floor with tape for each installation. As he has explained, "I select the color, the width of the line and outline a basic pattern of alternation. Beyond that, the work makes itself. . . . You follow the edge of the room, which is basically controlling the piece. You find a rhythm building naturally."[2] The installation work is done in long, concentric bands that move from the outer perimeter of an area to the center. Each ring is composed of a single color; each laid-down line of tape overlaps the one outside it by two millimeters, ensuring tight, parallel lines of color. The effect of any irregularities or interruptions (such as architectural columns) in the shape of the space is magnified as the units of tape get shorter and approach the center, resulting in unique, site-specific patterns. Although Lambie is involved in the creation of each iteration of *ZOBOP!*, a trusted assistant often directs the installation, and Lambie never leaves his mark on it. "It's not personal like that," he has said. "The system makes the work."[3] Moreover, when he can no longer supervise installations of *ZOBOP!* himself, he will authorize others to continue to produce the work.

For Lambie it is crucial that the architecture of a given space dictate the size of the work of art. The perimeter of *ZOBOP!* should extend to the natural boundaries of a given area of floor; the piece should not be truncated arbitrarily. The tape

Fig. 1. Jim Lambie. *Plaza.* 2000. Plastic bags and enamel paint, dimensions variable. Courtesy Anton Kern Gallery

should extend to every inch of a space, so that the installation has the free-roaming feeling of paint poured directly onto the floor. This feeling, the liquid reality of paint, appears frequently in Lambie's works, as in *Plaza* (2000; fig. 1), for which he hung plastic bags filled with brightly colored paint in a row on a wall and then slashed the bottoms of the bags to let the color onto the wall and the floor. Works such as ZOBOP! and *Plaza* show that, although Lambie has abandoned the traditional tools of painting in favor of non-art materials, he has not had to forfeit a painterly love of color play. —N.L.

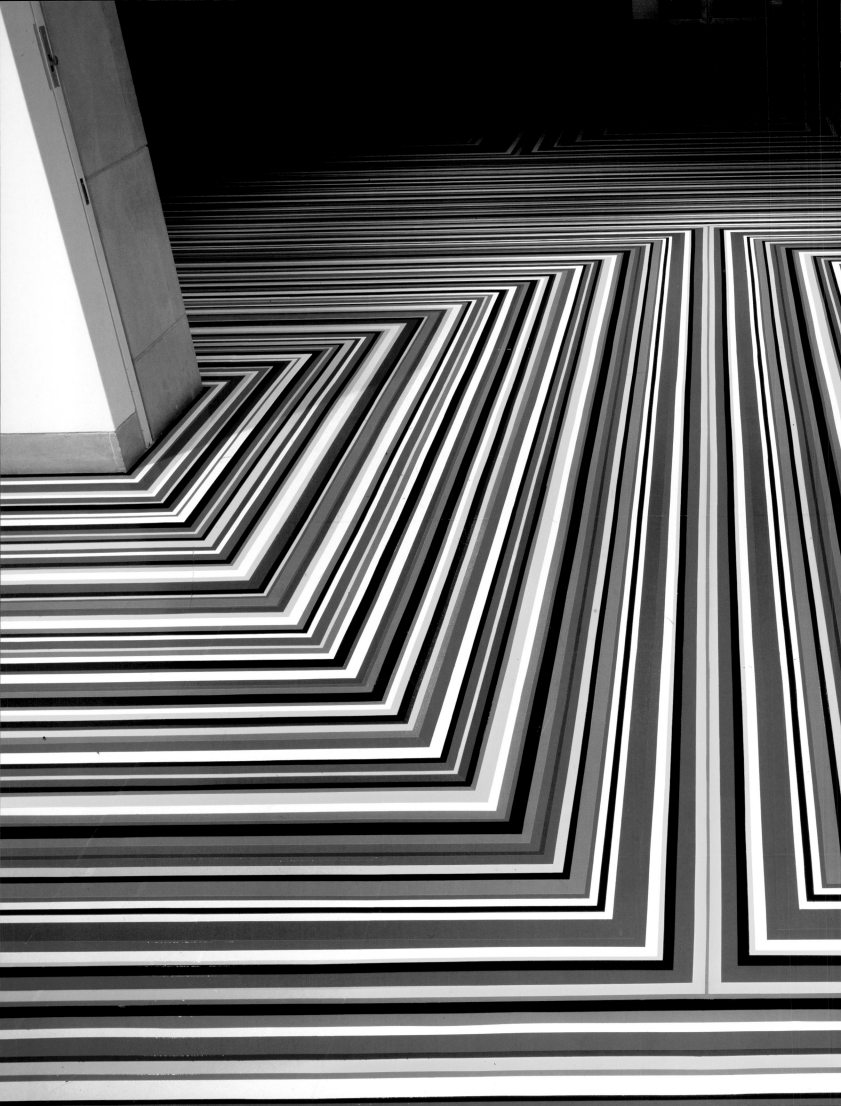

89. Cory Arcangel

Colors. 2005

Projection from digital source

Dimensions variable

Collection Holly and Jonathan Lipton